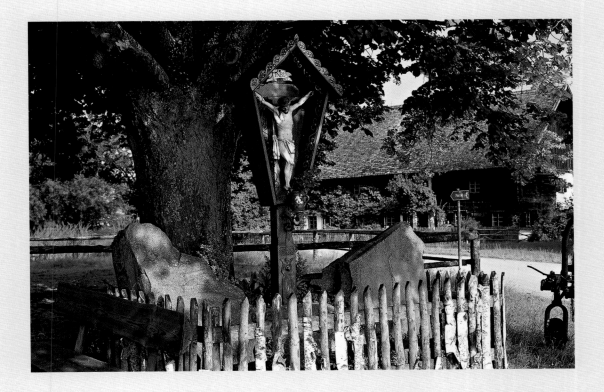

Journey through

UPPER BAVARIA

Photos by
Martin Siepmann

Text by
Ernst-Otto Luthardt

Stürtz

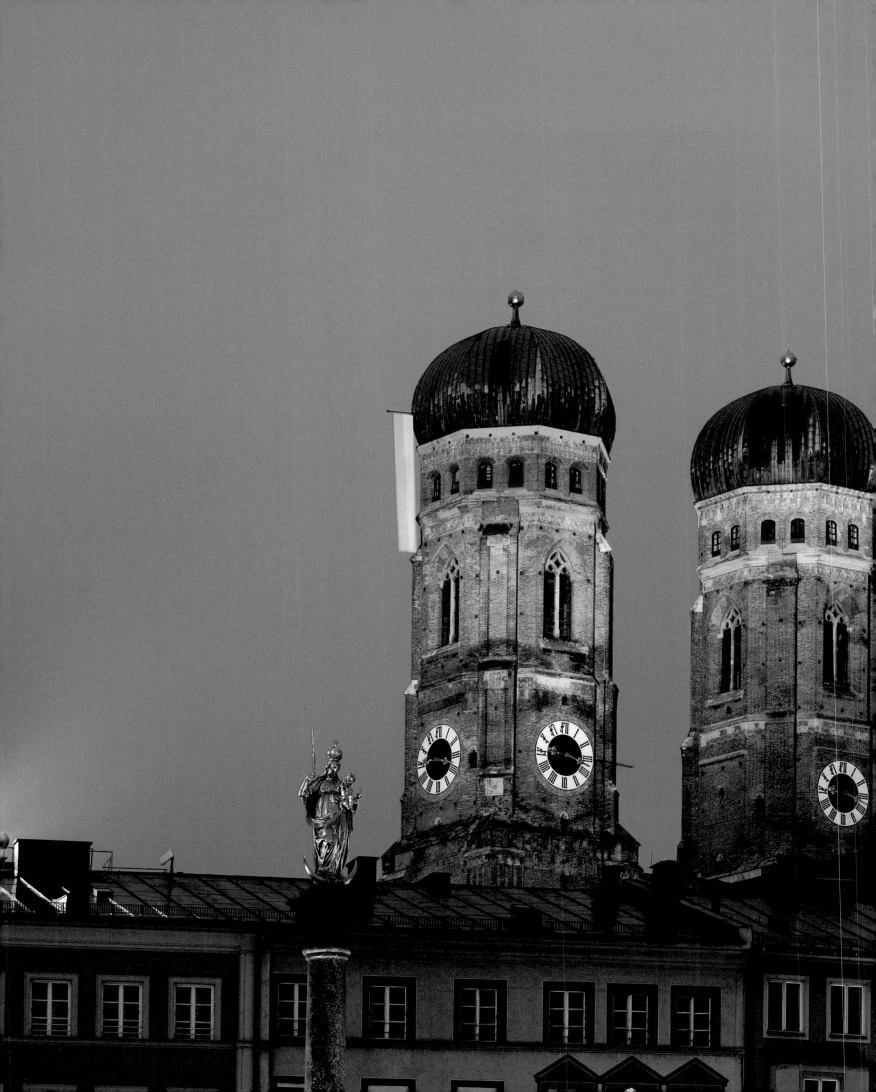

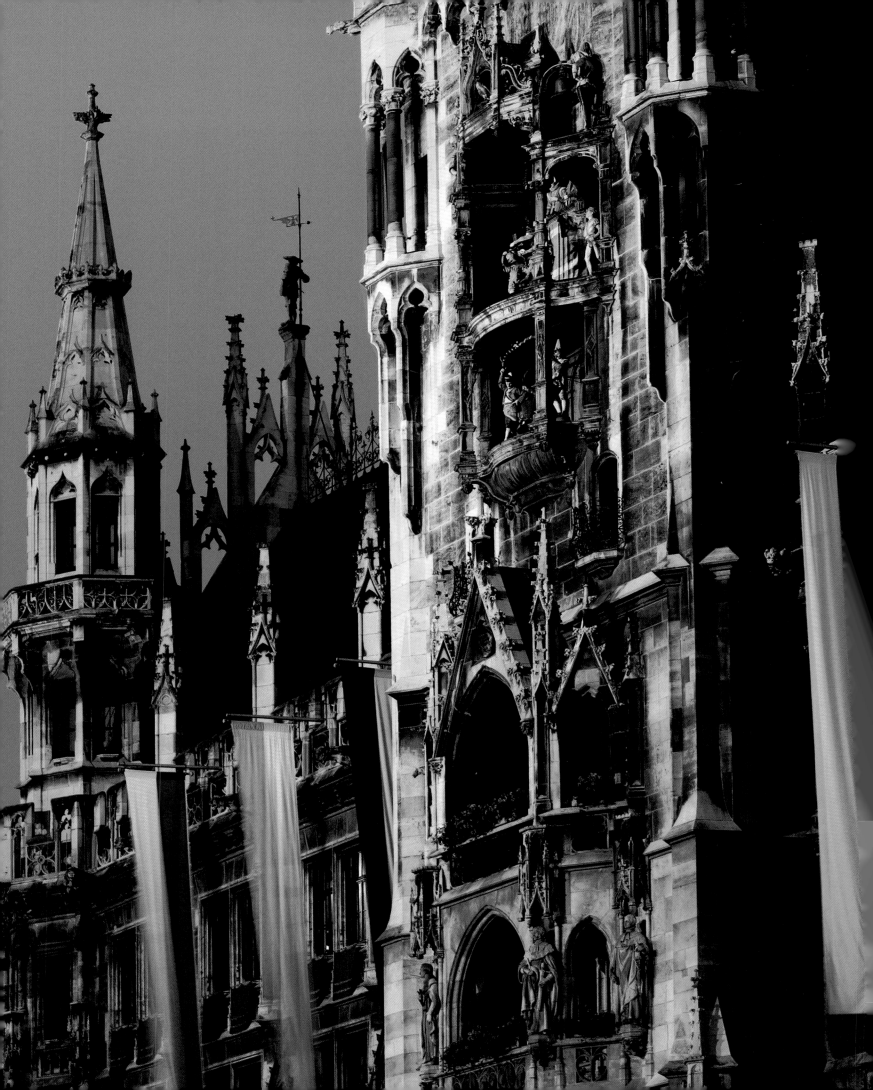

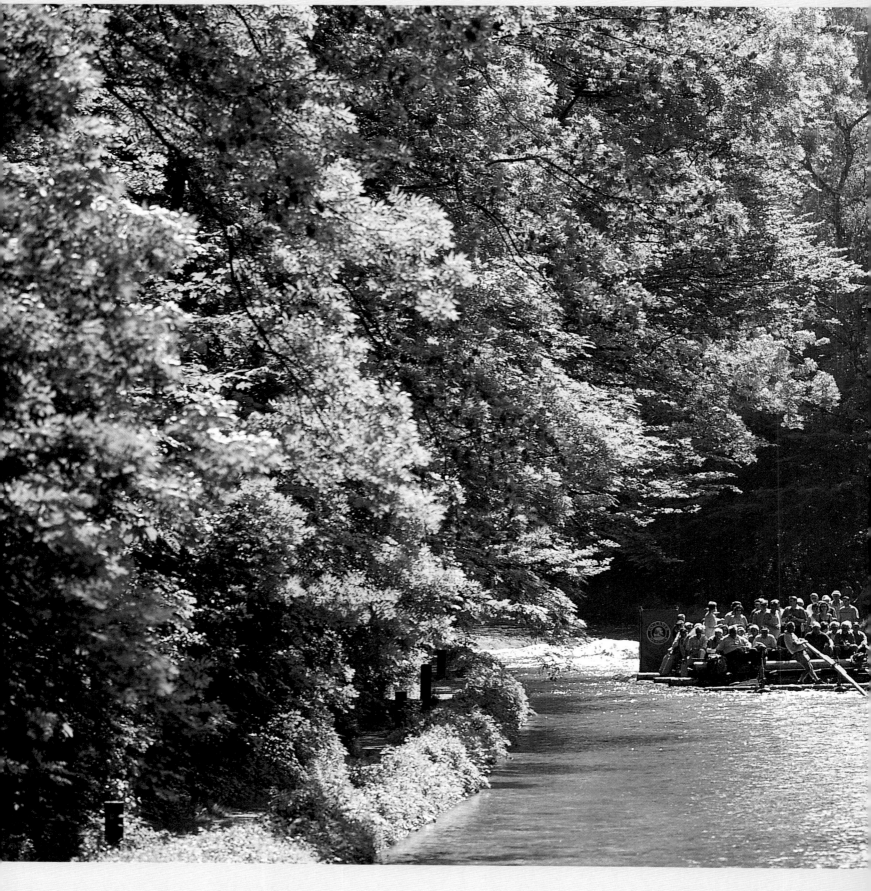

First page:
This lime tree with crucifix stands in the little village of Schlitten, now part of Wessobrunn. Its counter- *part is in Wessobrunn itself, with the famous Wessobrunn Prayer inscribed on a stone slab under the tree.*

Previous page:
In the evening light the statue of Mary, the Frauenkirche and the *Neues Rathaus with its tower and chimes effuse a magical charm.*

Below:
The rafts used on the River Isar – seen here between Wolfratshausen and Thalkirchen – now no *longer transport goods such as wine, chalk, plaster or marble but visitors from near and far.*

Inhalt

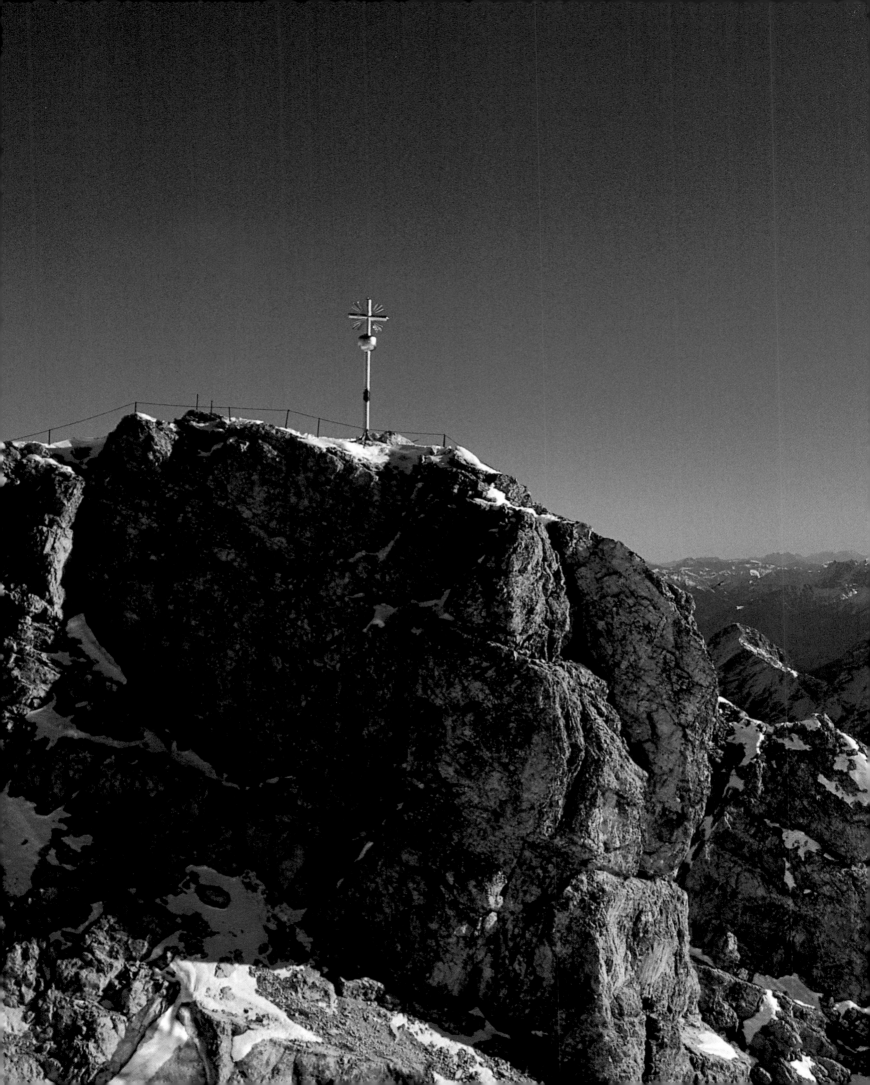

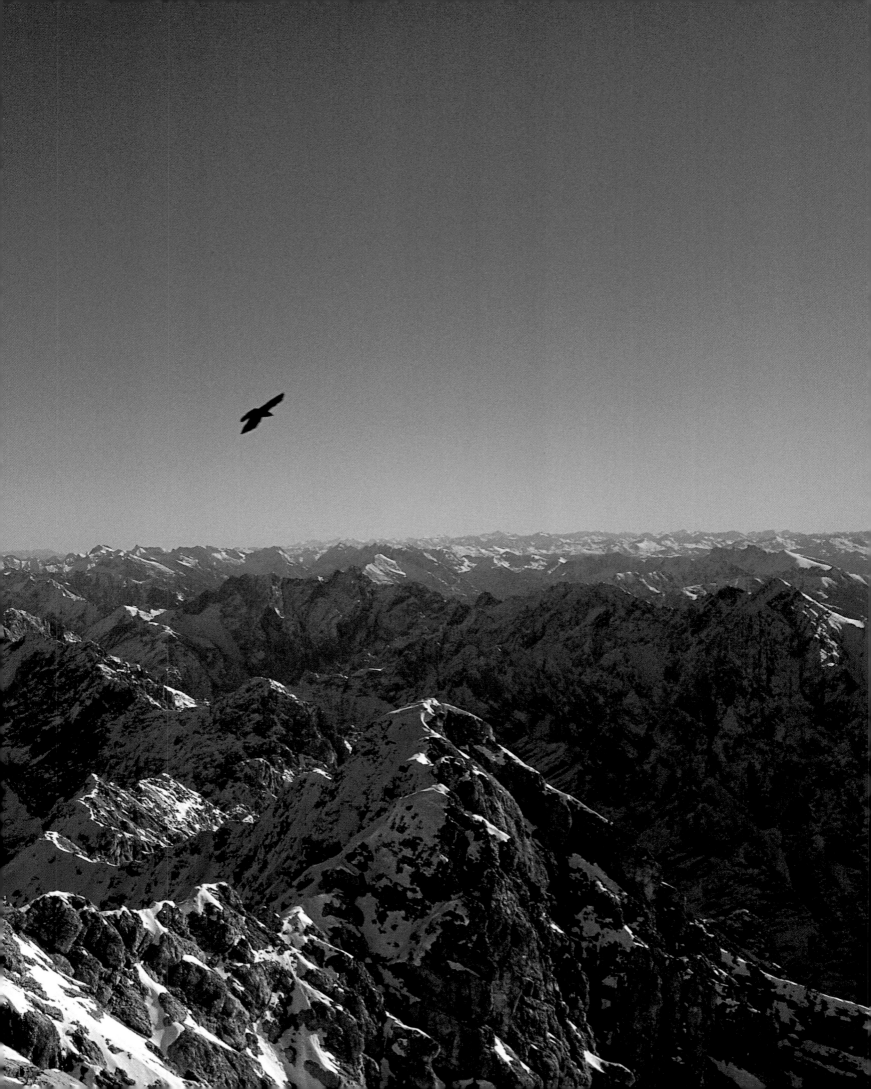

Pretty as a picture – Upper Bavaria

Farm near Feldkirchen-Westerham. Although each has its own stamp of individuality Upper Bavarian houses have much in common, their design dictated by the weather, economic considerations and available building materials. Many have the characteristic flat roof traditionally decked with shingles and wooden balconies running round the upper storey.

It's the year 1255 and the two sons of a Bavarian duke are at it hammer and tongs. The cause of their brotherly feud is the age-old question of power. As neither is willing to give ground, the object of their desire – the duchy of Bavaria – is split down the middle. Lower Bavaria or Niederbayern, with Landshut as its provincial capital, goes to Henry XIII. His brother, Ludwig II the Stern, gets Upper Bavaria and chooses Munich as his royal seat. Six centuries later King Ludwig I restructured his kingdom on this "venerable historic basis", rejuvenating ancient territorial divisions. With only a few minor alterations (Eichstätt was incorporated in 1972) Upper Bavaria or Oberbayern has retained its historical makeup to this very day.

Between the Alb and the Alps

The administrative district of Upper Bavaria is big to say the least. It covers 17,530 square kilometres (6,770 square miles) – a quarter of Bavaria – and is larger than many of Germany's federal states. Mountains and rivers form its natural boundaries: to the north the River Altmühl, to the west the Lech and to the east the Salzach. Upper Bavaria begins in the Fränkische Alb in Franconia. The valley of the Altmühl, with its gleaming white cliffs, dark slopes of juniper and mighty ruined fortresses, is wildly romantic, the stuff dreams are made of. Then come the undulations of the Jura and the torrents of the Danube, opening out onto lush fields of hops south of Ingolstadt in the Hallertau, its fertile loess soil blown here by ancient winds. Past the moors surrounding Dachau and

Erding the landscape around the provincial capital of Munich is moulded by glacial scree. The terrain then becomes higher, with many lakes dotted about the prehistoric moraine. The Chiemsee, Ammersee and Staffelsee are embedded in rolling hills, while further south the Schliersee, Tegernsee and Königssee are sheltered by the precipitous inclines of the Alps.

The first settlers in the area between the Alps and the Danube were Celts. They came here in the 8th century BC. In 15 BC they were defeated by the Romans and swallowed up by the new Roman provinces. During the migration of the peoples Germanic tribes infiltrated the area, interbreeding with the indigenous Celto-Roman population. The new ethnic amalgam of the Baiuvarii soon rose to fame and power. The Agilolfing dynasty were the first local magnates, ruling until 788 when Emperor Charlemagne sent Duke Tassilo III into exile. After a period of Carolingian rule the Luitpoldings governed for half a century. Upper Bavaria then fell to the Salians and later the Welfs. One of their rank, Henry the Lion, is credited with being the founder of Munich. He had little time to enjoy his new home, however; just a few years later he fell out of favour with Emperor Barbarossa and had the duchy of Bavaria – including Munich – taken away from him.

Dynastic endurance: the house of Wittelsbach

Catapulted to power in 1180 the house of Wittelsbach clung to its supremacy over Bavaria until 1918, enduring many threats to its sovereignty – not least from the folly of its less diplomatic members. The first duke was Otto I; the first elector was Maximilian I in 1623. The latter initiated the Catholic League and called for the Counter-Reformation from Bavaria. His careful calculation – of being on the right side at the right time – was rewarded by both the king and the emperor, resulting in the political rise of Bavaria. Around 200 years later another elector used the same method to even greater effect. After currying favour with Napoleon Maximilian Joseph I was made king by the Little Corporal's grace in 1806, the Wittelsbachs managing to hold onto their coveted crown long after Bonaparte had been deposed.

Many of Bavaria's rulers did great service not only to local politics but also to art and architecture. The arts in the late Gothic period positively blossomed under Duke Albrecht IV, with the Renaissance experiencing a boom during the reign of Albrecht V and William V. Elector Maximilian I heralded the dawn of

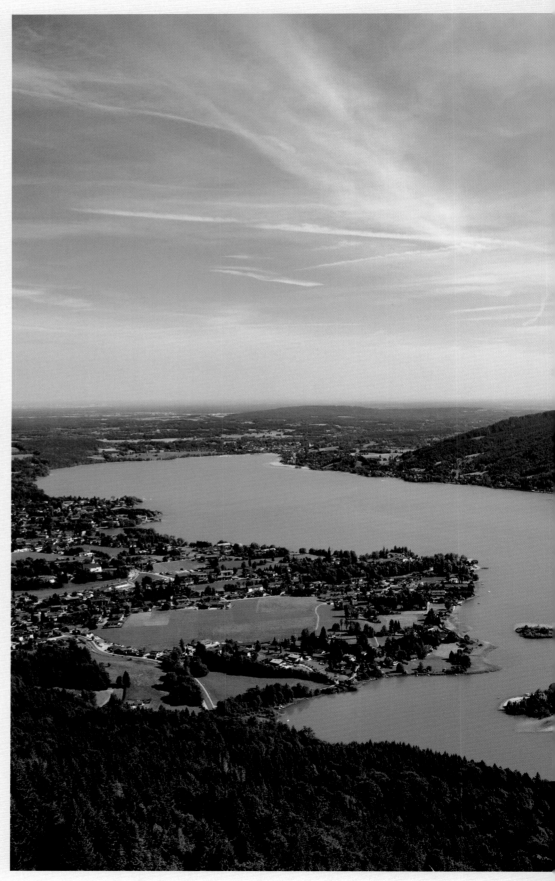

From the top of the Ring-spitz there are fabulous views of the Tegernsee. One famous place after another lines the shores of the lake: the town of Tegernsee, Rottach-Egern and Bad Wiessee.

the baroque which spiralled to giddy, cherub-filled heights under Max Emanuel II. What Elector Charles Albrecht and his successor Max Joseph III were to the Rococo, King Ludwig I was to neoclassicism. And perhaps the most popular and famous Wittelsbachs of all are "Mad" King Ludwig II of Bavaria with his fairy-tale castles and his cousin Sissi, Empress Elisabeth of Austria.

The free state

Following the defeat of the German Empire in the First World War Bavaria, like the rest of Germany, was racked by revolution. On November 7 1918 journalist Kurt Eisner proclaimed the "democratic and social Republic of Bavaria" in Munich; the monarchy was usurped by the free state. The murder of Eisner in February 1919 sparked off a furious chain reaction of events. The proclamation of the "Munich soviet republic" a few weeks later ended in military combat. When in 1923 Hitler and Ludendorff tried to putsch their way to power in Munich the free state found itself facing a new and dangerous challenge. Although the city managed to quash the rebellion in its fascist infancy, just a decade later the prophecies were again bleak. In 1934 Bavaria was forced to cede its sovereignty to the Third Reich, only recovering it in 1945 under the Americans. One year later the people of Bavaria approved the new constitution – the state's third. In 1949 Bavaria became part of the Federal Republic of Germany.

Built by God for God

In Bavaria there's an old saying which goes: "The Bavarian loves Heaven". Local potentates – the Agilolfings being the first – have always been quick to turn this to their advantage. Christianity, recently introduced to the region, proved an excellent means of both uniting the various ethnic groups of Bavaria's multicultural society and of boosting territorial gain and political power. The 7th century was the age of the great missionaries, Emmeram and Rupert, Korbinian and Willibald the names of the saints

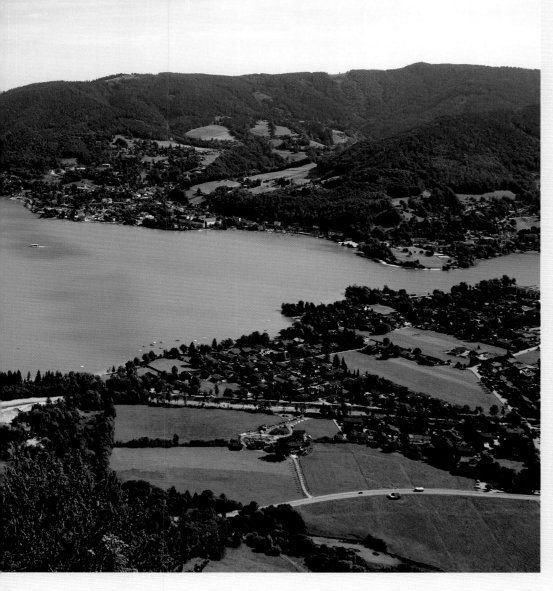

imprinted on the pious minds of the population. The man who contributed the most to the setting up of Bavaria's religious infrastructure was St Boniface who in 738 and 739 founded the bishoprics of Regensburg, Passau, Salzburg and Freising. The first monasteries were established during the 8th century: Benediktbeuern in 739, Schlehdorf in c. 740, Eichstätt in 741, Tegernsee in c. 746, Polling in 750, Wessobrunn in 753 and Herrenchiemsee and Frauenchiemsee in 765. The religious orders not only promoted their "new" religion but also proved a source of great wisdom; monasticism was fronted by the intellectual elite. The Benedictines of Wessobrunn were particularly industrious in many academic disciplines. The scribes and illuminators of the Middle Ages were succeeded by the scientists and stuccoers of the 18th century. The School of Wessobrunn became synonymous with architectural and ornamental excellence. The Zimmermann brothers in particular created masterpieces of unparalleled beauty; what is perhaps the most magnificent secular building of the period, Schloss Amalienburg, was built by Johann Baptist, with its sacred counterpart the Wieskirche (now a UNESCO World Heritage Site) a collaboration with his sibling Dominikus.

The birthplace of German poetry

One of the most significant artefacts from medieval Wessobrunn is the Wessobrunn Prayer contained in a manuscript from 814, heralding both the beginning of the world and the dawn of German poetry. In the middle of the 11th century a monk at Tegernsee Monastery wrote the first fictitious novel. Centred around the knight Ruodlieb, after whom the epic verse is named, and written in Latin with many German references, the narrative describes for the first time not just the lives of courtly nobles but also of simple peasants living in an Upper Bavarian village. About 100 years later another monk from Tegernsee called Werinher penned one of the most simple and beautiful German poems of love of all time:

Dû bist mîn, ich bin dîn:	You are mine, I am thine:
des solt dû gewis sîn.	This you should know.
Dû bist beslozzen	You are locked away
in mînem herzen:	In my heart:
verlorn ist das slüzzelîn:	Lost is the key.
dû muost immer drinne sîn.	There forever you shall be.

The poem was discovered centuries later during the secularisation of Bavaria. The manuscript was moved from Benediktbeuern Monastery to the Munich state library in 1803 and edited in

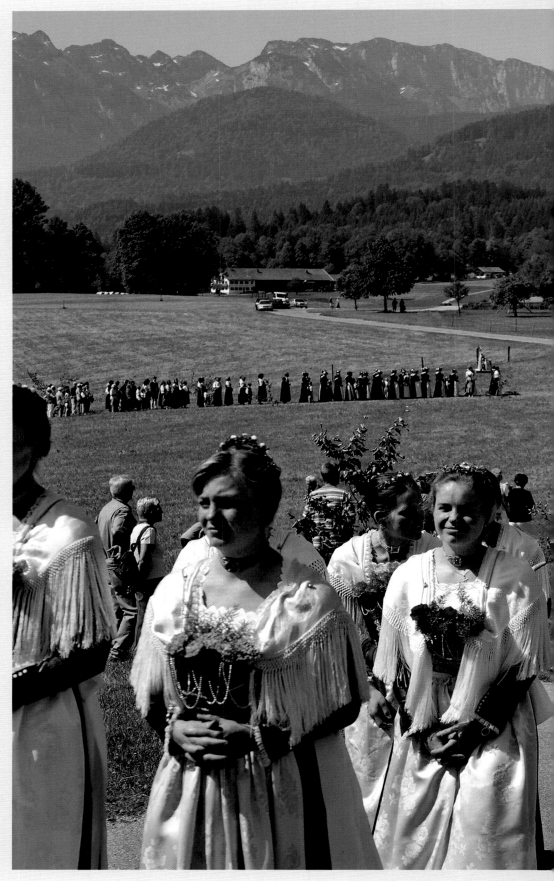

Tradition is fervently upheld in Upper Bavaria. In Wackersberg not far from Bad Tölz, for example, a special Corpus Christi procession takes place each year, at which the locals proudly don their festive finery.

1847, bringing about a revival of the vagabond poetry of the Middle Ages, of the drinking ditties, love songs, satirical verse and odes to nature of travelling minstrels and scholars. In 1937 the entire collection of ballads, the legendary Carmina Burana, was set to music by Carl Orff, cementing its popularity.

The salt of the earth

Upper Bavaria has very little in the way of mineral resources besides salt – which it has in abundance. Tucked away on the northern edge of the eastern Alps is the richest source of salt in Central Europe. Extracted by both Celts and Romans, salt mining enjoys a tradition going back two thousand years in places such as Bad Reichenhall and was of the utmost economic importance not just for the Berchtesgadener Land but for Bavaria as a whole. Along the salt route prosperous towns sprung up, among them Tittmoning, Mühldorf, Wasserburg am Inn, Burghausen, Rosenheim and Munich. It's thus not surprising to learn that the region's mine owners, monastic chiefs and secular rulers – i.e. the dukes of Bavaria and arch-bishops of Salzburg – were literally prepared to go to war over a few grains of salt. Bad Reichen-hall hasn't just concentrated on salt, however; since 1864 it has been an established spa, one of its major restorative attractions the gradua-tion works or thorn house from 1912. The mysteries of salt mining can also be explored underground at the mine in Berchtesgaden, no less than 500 years old.

Working with wood

If you go for a walk or do a little cross-country skiing on December 21, St Thomas' Day, and come across a man in the woods hitting tree trunks with an axe and putting his ear to the bark, don't worry. Neither he nor you have gone mad. On the contrary; this is how skilled craftsmen go about choosing the best wood for the manufacture of musical instruments. The famous violinmakers of Mittenwald, for example, who have practised their traditional craft for over 300 years, swear by this ancient

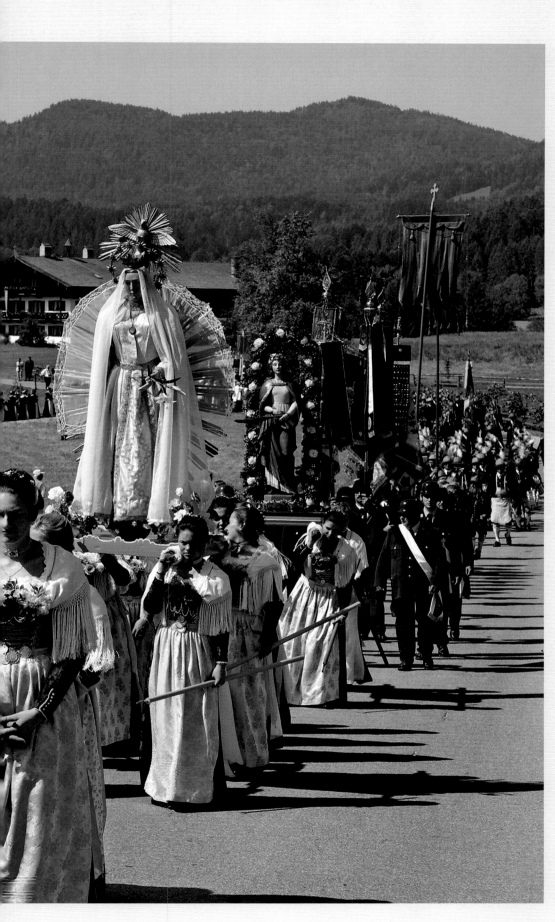

selection of materials. This trust and familiarity is the result of centuries of experience with and financial dependence on one of the oldest and most universal commodities in the history of mankind. Wood could be turned into houses, wagons, sledges, boats, furniture, barrels, bowls, shoes, gadgets, cooking utensils and workman's tools. The leaves were used as bedding for animals and the bark to tan leather and heal various ailments. It's no coincidence that the old country saying "He who fells trees at Christmas has a house which will stand forevermore" originated in Upper Bavaria. The Berchtesgadener Land is well-known for its toys, boxes and other useful objects made of wood, the craftsmen of Oberammergau for their elaborate sacred carvings.

Messing about in boats

Weary of life in the country, in the 16th century the court of Bavaria took to the water for their regal entertainment – as they had done in the Middle Ages, spending their summers on Starnberger See. The idea for this new attempt to combat royal boredom came from Duke Albrecht V the Magnanimous. Compared to the magnificent regattas staged by Elector Ferdinand Maria and his wife Adelheid of Savoy 100 years later, however, Albrecht's idea of messing about in boats seems like child's play.

In their endeavour to recreate their adored Mediterranean in their own part of the world the royal pair went to enormous trouble. They imported not only baroque art and architecture from the south but also an entire ship – or rather a replica. Named Bucentaur after the resplendent galley of the Venetian doge, the craft was 100 feet (ca. 33 metres) long and 25 feet (ca. 8.3 metres) wide. 150 rowers were needed to move it through the water. The enormous vessel was accompanied by an entourage of gondolas and rowing boats; over 2,000 people could be found out on deck when the elector took the helm. Then a great spectacle on the grandest scale, now all this seems fairly tame. The elector would turn in his grave if he knew just how much traffic crosses the lakes today. Pleasure boats, steamers, surfers, swimmers, water skiers and the occasional fisherman all now navigate the waters of the Ammersee, Chiemsee, Königssee, Schliersee, Staffelsee, Tegernsee and Starnberger See.

Legendary mountains

At the beginning of the 19th century travellers were astonished to discover "wild mountains" not only in Austria but also in Bavaria. The Alps were long unexplored territory where

This house in Oberammer-
gau is where satirist
Ludwig Thoma came into
the world on January 21
1867. The great fondness
he felt for his Upper
Bavarian home and its
people is clearly expressed
in his books which include
the popular "Lausbuben-
geschichten" (Scallywags'
Tales) and "Briefwechsel
des bayrischen Landtags-
abgeordneten Jozef Filser"
(Letters from Bavarian
MP Jozef Filser).

dragons, devils and the like went about their
evil deeds. The most terrifying of all was King
Watzmann who stopped at nothing when he
went out on one of his dreaded demon hunts.
God himself finally put a stop to his rampaging,
turning the fiend and his entire family to stone.

Watzmann's plagued contemporaries were not
the only ones to profit from this act of God;
today the mountain range – with the central
ridge, Watzmannweible and five Watzmann
children – is undoubtedly the most impressive
in Germany and a major tourist attraction.
Although the king still holds his head high, he
doesn't quite get as near to the heavens as the
Zugspitze. Maybe it's sheer frustration at being
second best which makes him so intimidating
even now; with a sheer drop of 1,800 metres
(5,900 feet) down into the depths the east face
of the mountain is higher and more perilous
than any other in this part of the Alps.

The Zugspitze is much more accommodating.
There are no less than four railway and cable
car systems (one is in Austria) waiting to trans-
port over half a million people a year up to the
top of Germany's highest peak. At almost
3,000 metres (ca. 9,840 feet), with the world at
your feet, you can look down on four countries,
400 mountain summits – and the Watzmann
fuming silently in the distance.

The city of Munich

The provincial capital of Munich is the nucleus
of Bavaria, a place of art, history and culture,
of politics, booming economy and scientific
innovation. Over 1.3 million permanent residents
and three times as many visitors a year are
drawn to it like a magnet; even the mountains

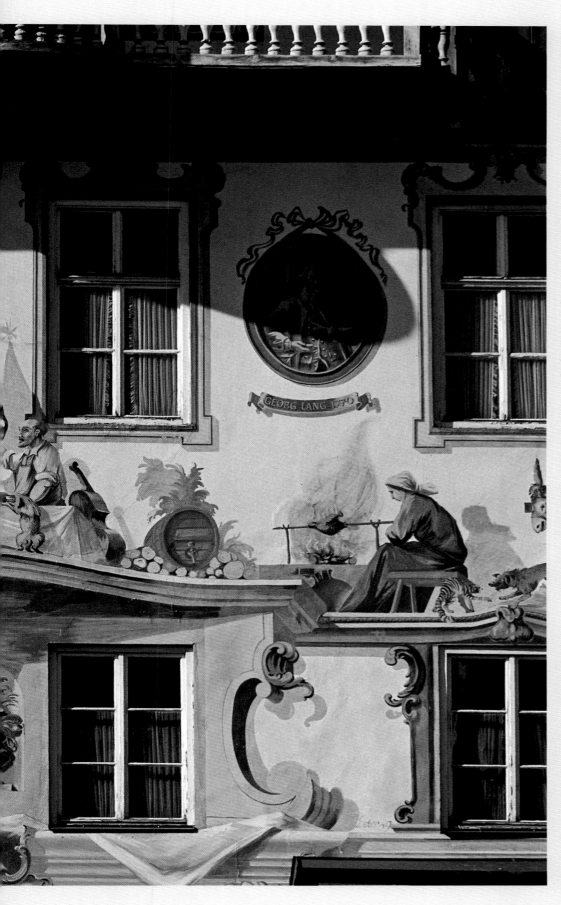

seem to home in on the metropolis when there's a föhn wind. There are around 250 churches, 70 theatres, 80 cinemas, just under 4,000 sports centres, well over 4,000 pubs and restaurants, 7,000 shops, 120,000 seats in beer gardens, the one and only Oktoberfest, two football clubs and even an emperor ("Kaiser") in former footballer Franz Kaiser to entertain and delight all who come here.

There are few cities which are as convincing and which boast as many surprises and superlatives as Munich. Art and architecture fans are particularly spoilt for choice here. The Alte and Neue Pinakothek and new Pinakothek der Moderne, the Glyptothek and city gallery in the Lenbachhaus house some of the most famous collections of art and sculpture in the world. And then there are the architectural gems of the city with their sumptuous interiors: the Residenz or old residential palace with the largest secular Renaissance room north of the Alps, the high baroque church designed by the Asam brothers and the enchanting palaces of Nymphenburg and Schleißheim.

We also shouldn't forget that there's no other city in Europe which has such a large green open space at its core as Munich has with its Englischer Garten. And there's no other museum of technology on the Continent with such a vast and varied range of exhibits and such heavily frequented facilities (the Planetarium and IMAX big screen cinema) as the Deutsches Museum. Yet Munich's biggest plus is the absolutely charming manner in which it wins over its guests. To echo a local sentiment: follow your heart and you could well end up in Munich.

The watery north

If the Alps are its head, then Upper Bavaria has its feet stuck firmly in water – namely in the Altmühl and Danube rivers. And like many things in our dog-eat-dog society, it's what's (or who's) on top that counts. The Alps definitely steal the show here but it's all a question of perspective. The Altmühltal up north, for example, is one of the most romantic river valleys in Germany and a hiking and cycling paradise. It also has the spectacular Jurassic Museum in Eichstätt where you can come face to face (or nose to beak) with the prehistoric bird Archaeopteryx and many other plants and animals from the dawn of time. Eichstätt itself is an ancient diocesan town which played a major role in the conversion of Bavaria to Christianity. In 741 St Willibald set up a monastery here; a second convent in Heidenheim

The Roseninsel in the northwest Starnberger See dates back to Roman times. The magnificent Pompeiian villa builtby King Maximilian II was to become one of Ludwig II's favourite spots. The park with its thousands of roses – hence the name "rose island" – was laid out by the famous German landscape gardener Peter Joseph Lenné.

was founded by his sister, St Walpurga. The name Walpurga is also associated in folk legend with something far less sacred; Walpurgis Night, the eve of May 1, is when witches and demons come out to play and do their magical worst.

Bavaria's own personal devil incarnate was Luther, according to Johann Mayer von Eck. The professor of theology at the university in Ingolstadt was one of the most fanatical and influential players of the Counter-Reformation. The university in Ingolstadt was the first in Bavaria and became its chief provincial seat of learning. It was moved to Landshut in 1800 and finally to Munich in 1826. Court was held at Ingolstadt for just half a century; in 1447 the town fell to Landshut and Lower Bavaria. Now Upper Bavaria's second largest community, it became an industrial stronghold after the First World War. Audi AG in particular has put Ingolstadt firmly on the commercial map.

Page 22/23:
The popular spa and ski resort of Lenggries in the winter in the Alpine Foreland. Brauneck Mountain in the background is serviced by cable car.

Page 24/25:
The Loisach in Kochel am See with the Herzogstand in the background, where the river exits the lake.

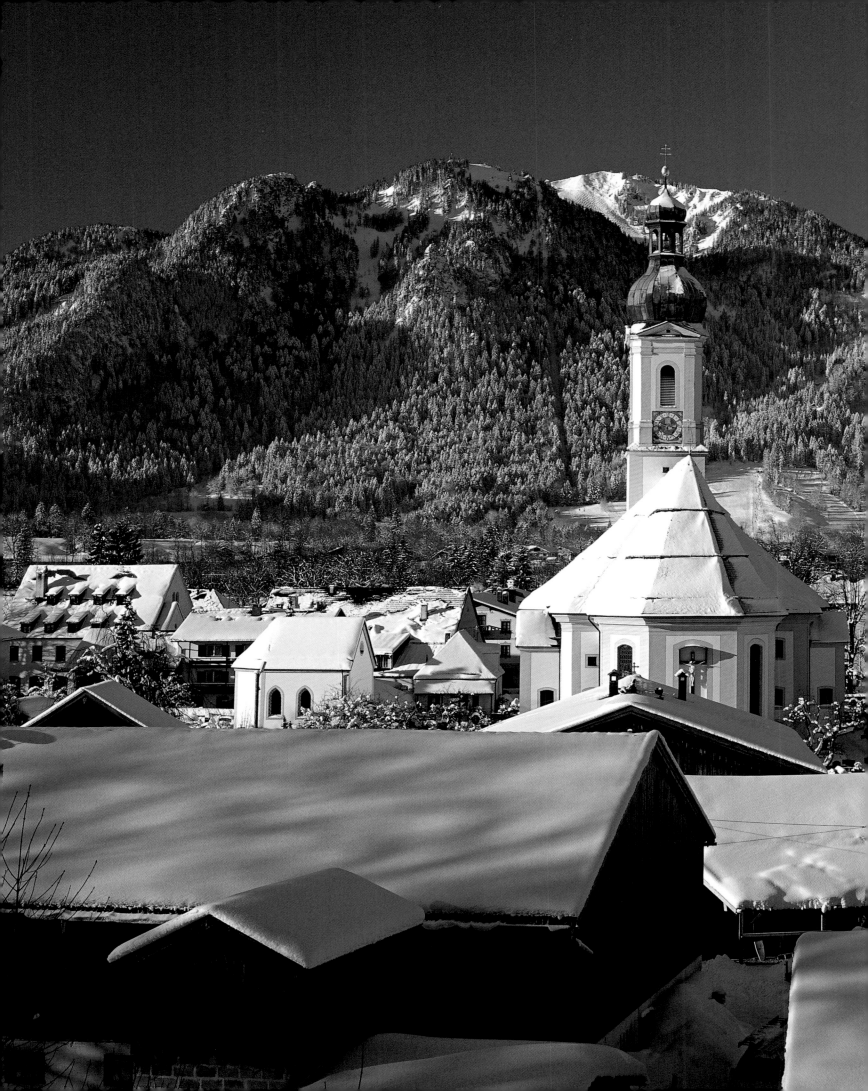

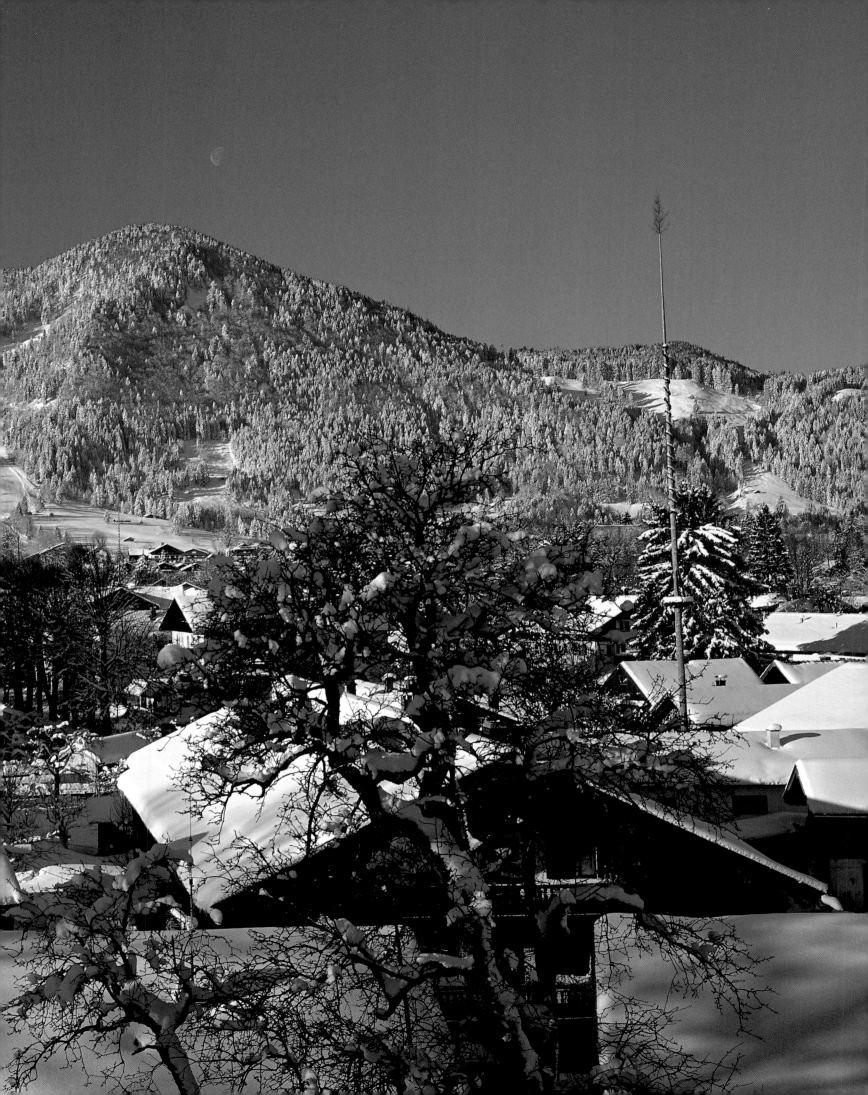

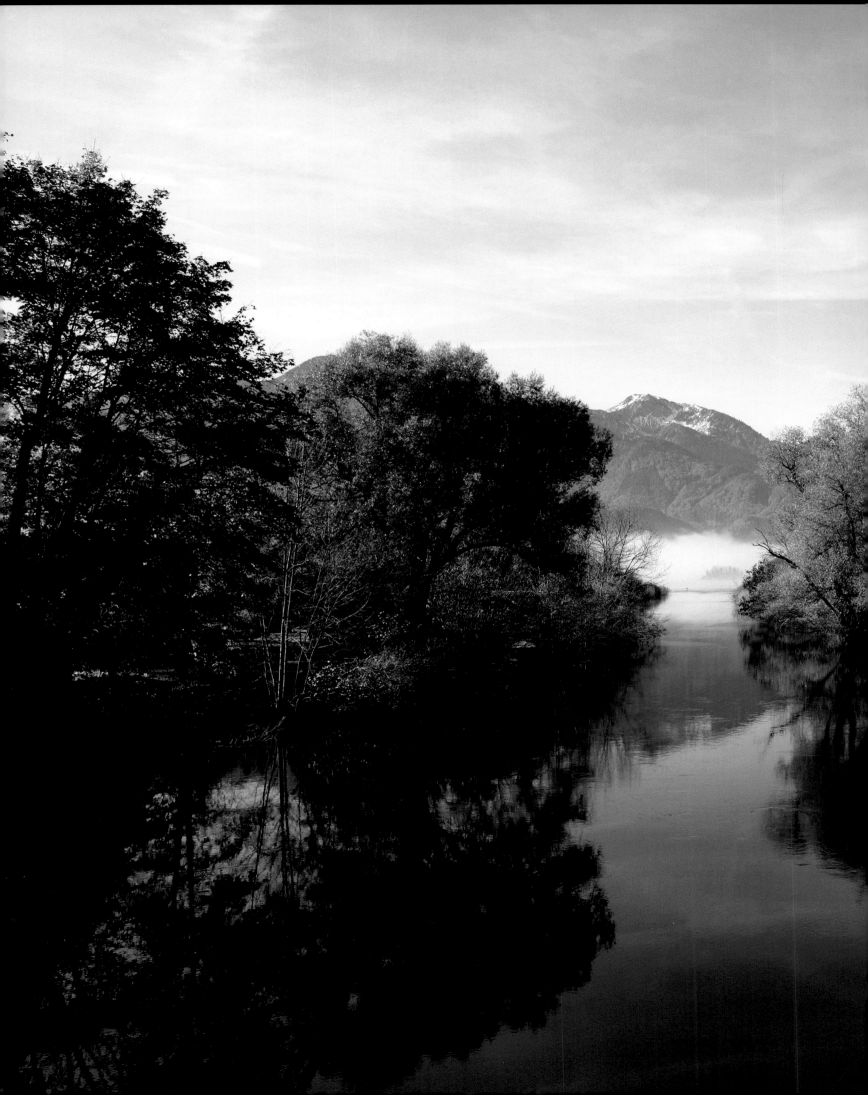

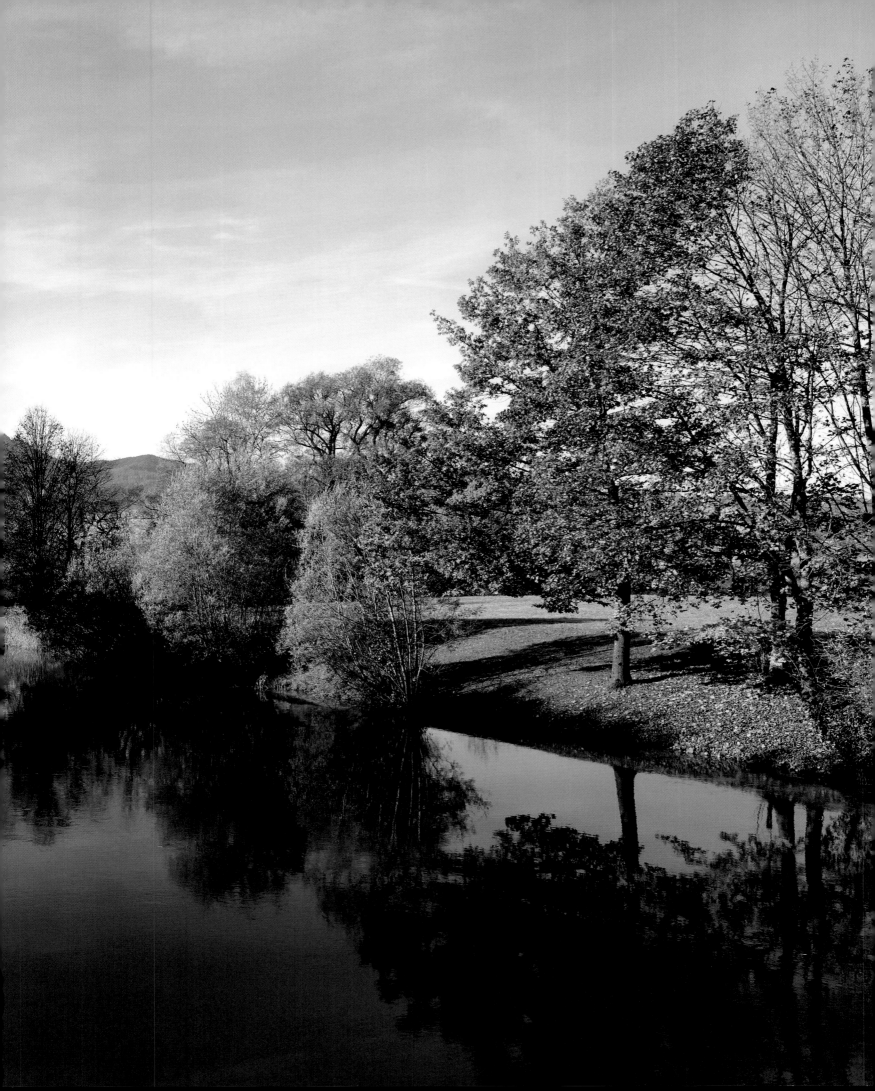

Between the Altmühl and the Fünf-Seen-Land

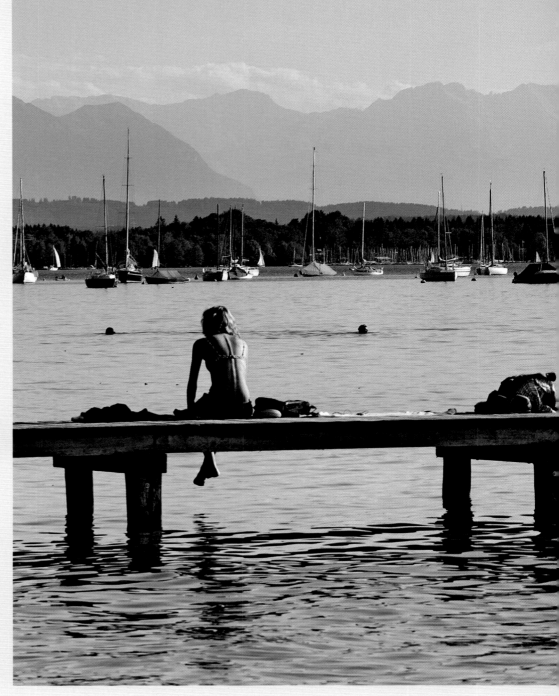

View of the Starnberger See near Münsing, up to 127 metres (417 feet) deep and 20 kilometres (12 miles) long. In summer steamers leisurely puff across the lake, interspersed with surfers and sailors keen to try out their nerve and prowess.

Eichstätt and Ingolstadt are the names of the two urban centres in the north of Upper Bavaria. Where the ancient diocesan town is now at the heart of one of the largest and most beautiful river valleys in Germany, the Altmühltal national park, the former royal seat of Ingolstadt has become the hub of local industry. Although sections of the long-awaited motorway bypass are now finished and motorists are spared the tedious journey through the middle of town, Munich still exerts a strong magnetism on all who come here. Its sparkling glory refuses to fade with age, with regular visitors amazed to find their favourite city becoming more attractive from year to year – maybe due to the "good country air", as Ludwig Thoma once joked. Whether true or not, the metropolis certainly draws on the traditions and mannerisms of the surrounding countryside, sometimes to the point of narrow-mindedness, yet always spirited and vivacious.

This includes the Fünf-Seen-Land with the lakes of Ammersee and Starnberger See. The latter in particular has long been Munich's most popular country lido. Karl Valentin, local comic and eccentric, once ridiculed a fish race held here "followed by a firework of jewels... in which twelve dressed ten-pound carp" allegedly swam "from Starnberg to Seeshaupt".

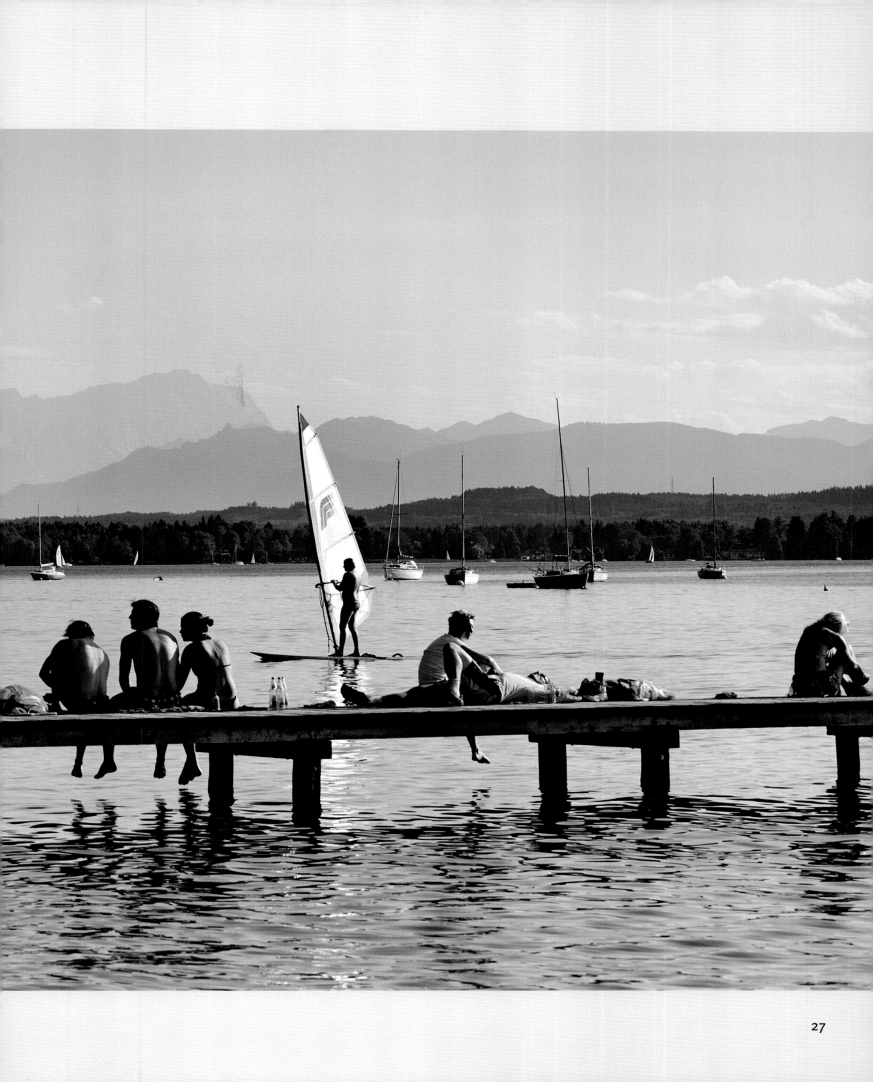

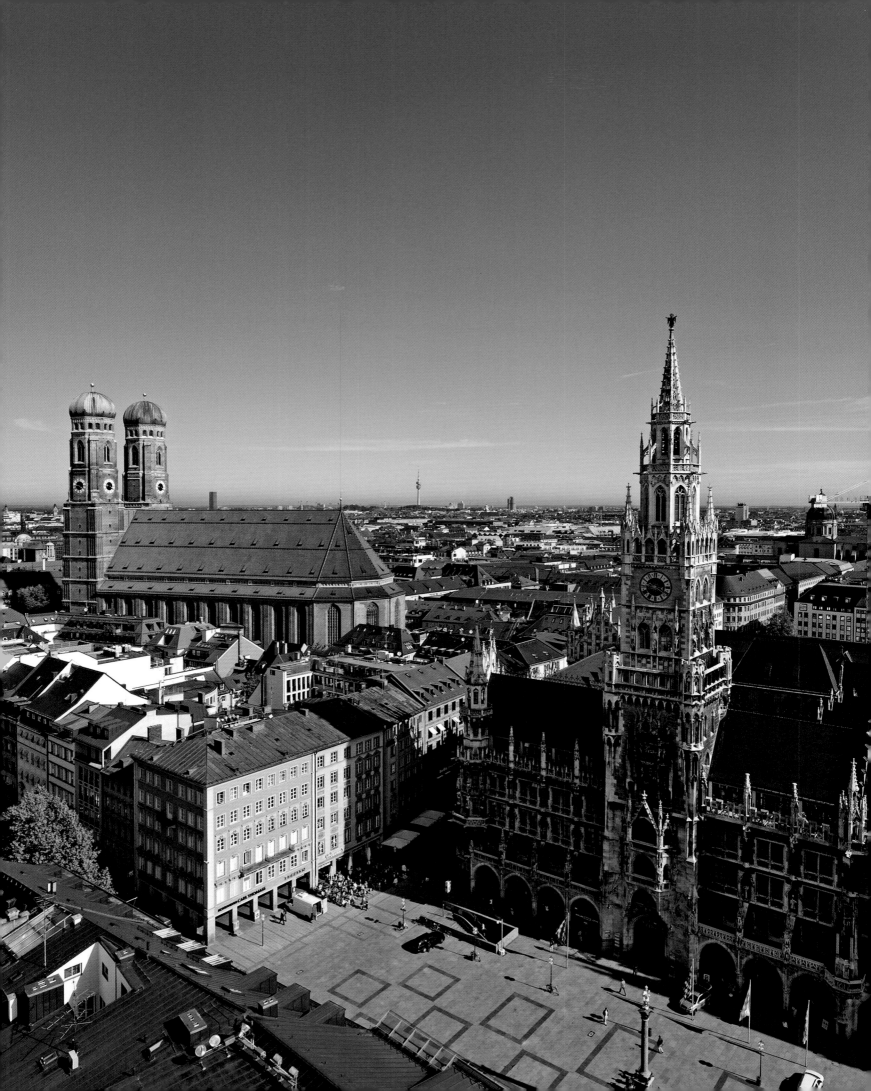

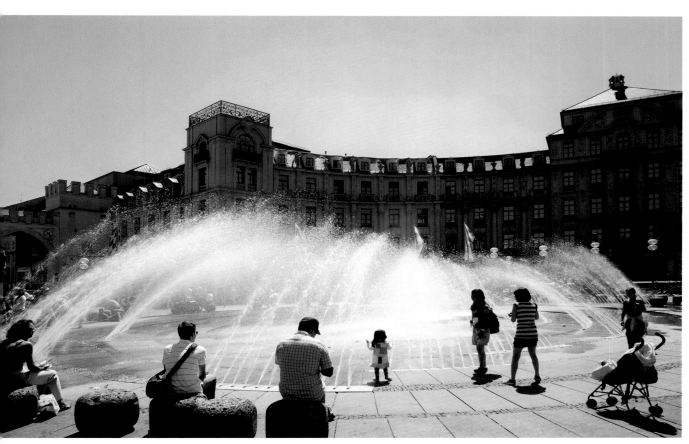

Left page:
In order to enjoy this splendid view of Marienplatz, the Neues Rathaus and Frauenkirche a certain amount of effort is required – namely climbing the 302 steps to the top of the steeple of St Peter, the oldest parish church in Munich.

Karlsplatz, known as Stachus by the local populace, was named after Elector Karl Theodor, who in 1791 ordered the medieval city walls which ran past this spot to be torn down. The fountain is an addition from 1972.

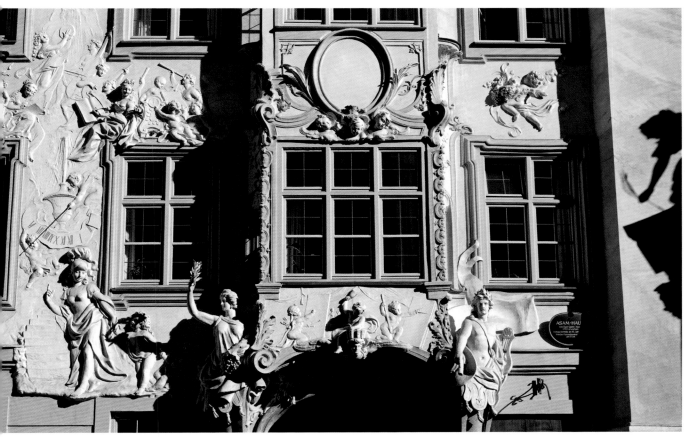

This 16ᵗʰ-century house on Sendlinger Straße was embellished with ornate stucco in the 17ᵗʰ century by its extremely proficient inhabitant, sculptor, stucco artist, painter and architect Egid Quirin Asam. Here on the bottom half of the façade Asam depicts man's creative activities and the material world. Next door to the Asam house is the equally famous Asamkirche, the church built and decorated by Egid Quirin and his brother Cosmas Damian.

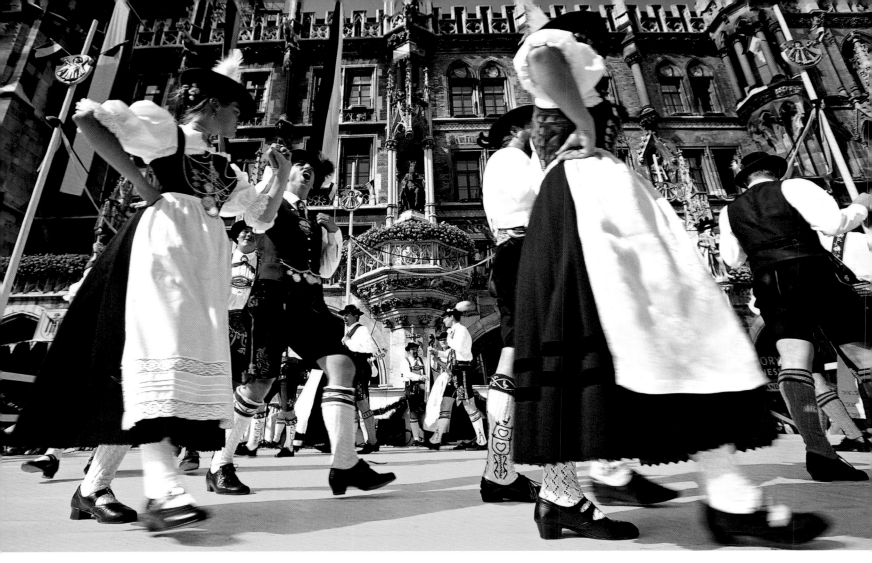

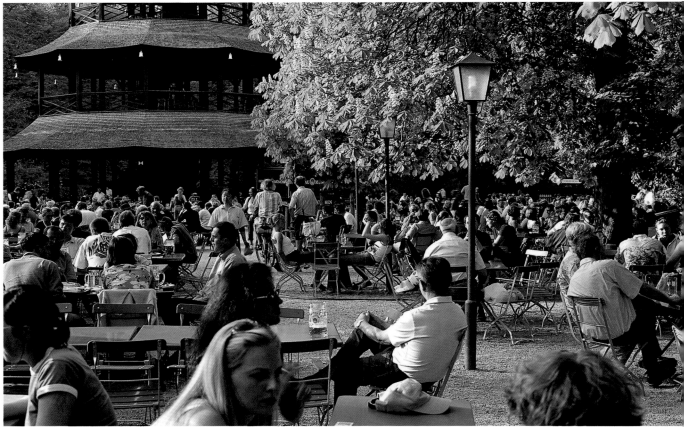

Above:
Marienplatz was where Munich was born, where several important trade routes intersected, where the all-important salt and grain markets were held. This is also where the festival celebrating the foundation of the city is staged each year.

Right:
One of the best known and mostly heavily frequented beer gardens in Munich is the one at the foot of the Chinese Pagoda in the Englischer Garten. The park, laid out between 1789 and 1832, is largely the work of Ludwig von Sckell and sprawls 350 hectares (865 acres) along the River Isar, making it the largest inner city park in Germany.

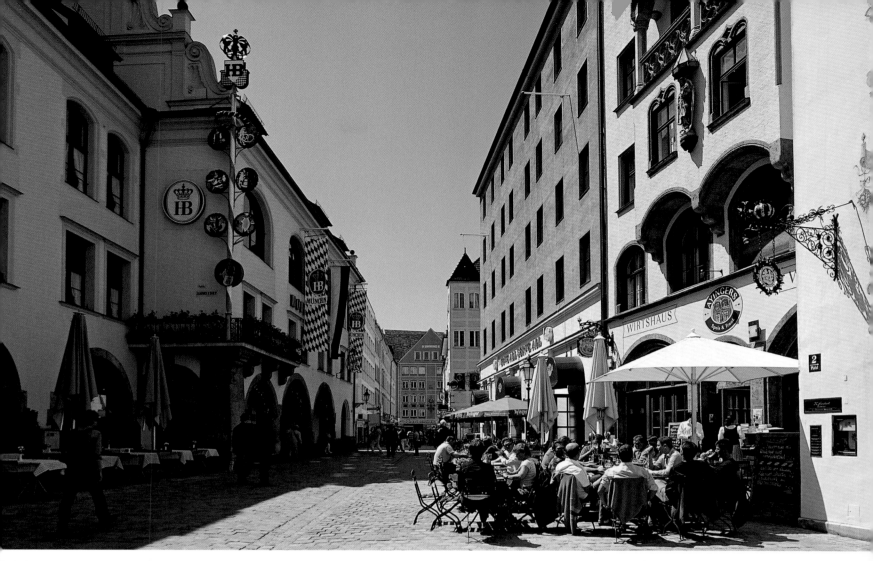

Above:
The famous Hofbräuhaus (left) was, as the name suggests, originally part of the old palace (Alter Hof), moved to its present location on Platzl at a much later date. It has since become the epitome of the Bavarian brewery and a household name the world over.

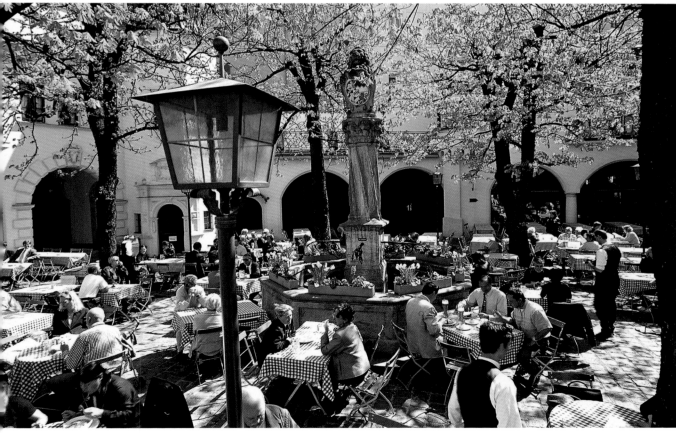

Left:
If the Schwemme ("watering hole") inside the Hofbräuhaus is too loud or too crowded, the shady beer garden with its tinkling fountain is a pleasant alternative. A litre "Maß" tastes just as good out in the fresh air and the raucous tones of "In München steht ein Hofbräuhaus" are less grating out under the trees...

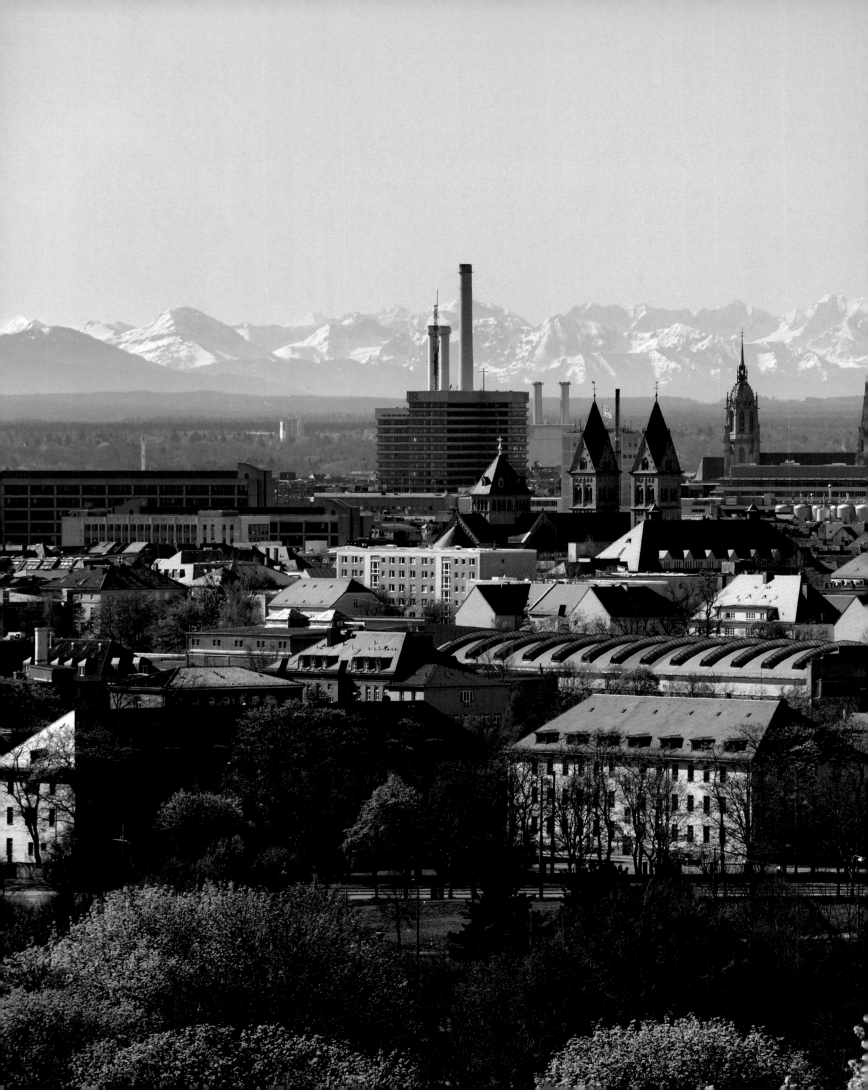

Looking south from Olympiaberg past the church of St Benno in Neuhausen and the Paulskirche, the jagged contours of the Alps seem to lie just beyond the city boundaries, especially on days when there's a föhn wind.

This statue erected in honour of Max Joseph I, the first king of Bavaria, on Max-Joseph-Platz in Munich is something of an eye-catcher. Max Joseph was the man who commissioned the building of Munich's opera house, seen here behind his effigy. The national theatre, erected between 1811 and 1818, was made famous by performances of works by Richard Wagner and Richard Strauß, among others.

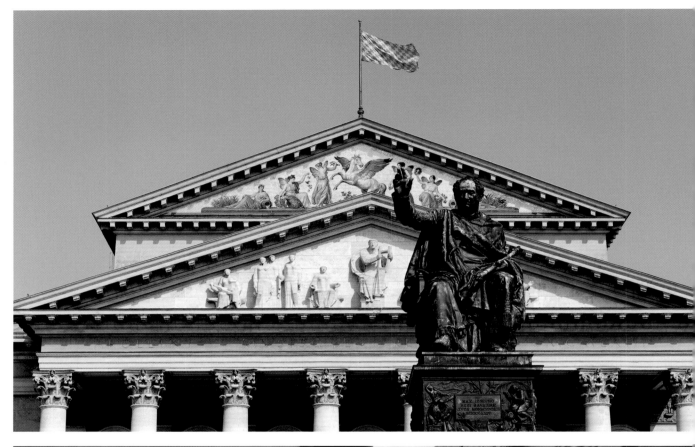

A hidden gem of the Renaissance, the three-storey arcades of Münzhof are on Hofgraben off Maximilianstraße. The royal mint operated here between 1809 and 1983; the palace is now home to Bavaria's offices for the conservation of historic monuments.

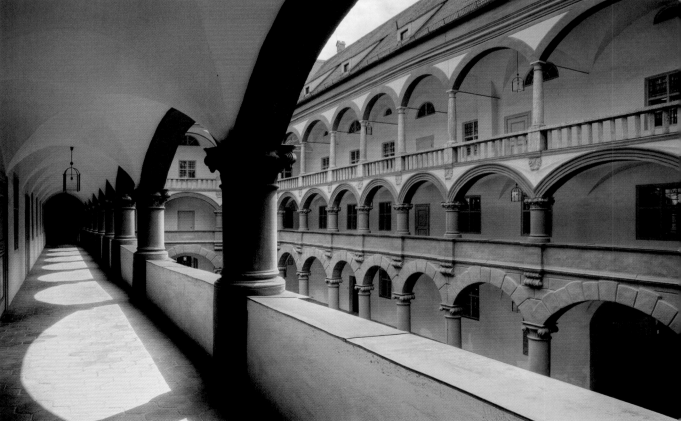

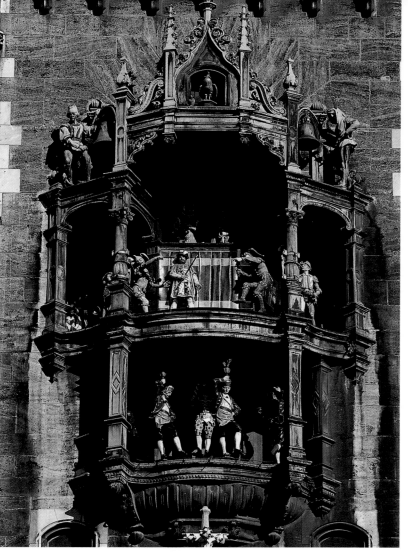

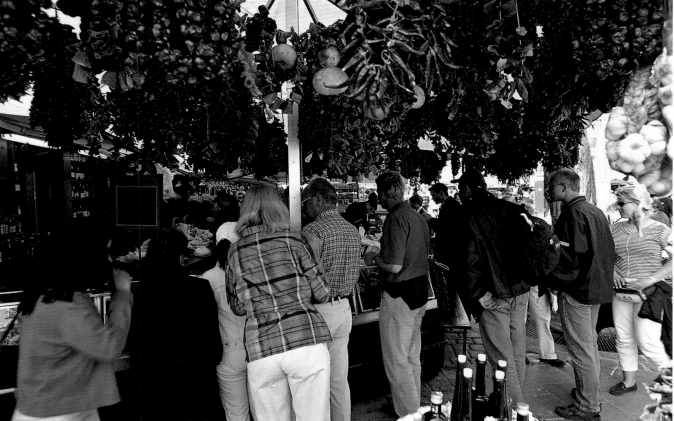

Above left:
The Valentin Fountain on Munich's Viktualienmarkt commemorates the famous actor and cabaret artist Karl Valentin.

Above right:
The carillon in the tower of the neo-Gothic Neues Rathaus on Marienplatz, built between 1867 and 1908, is a major attraction. Hundreds congregate here each day to watch the 32 wooden figures re-enact scenes from Munich's past.

Left:
The Viktualienmarkt is the best place in Munich for fresh fruit and veg and specialities from overseas. If you're lucky you might be served by one of Munich's real characters...

Right:

A grand and spectacular procession marks the overture to the Oktoberfest, in which the festival's landlords are accompanied to the Wiesn by guards of hunters and groups in national Bavarian dress.

Below:

Inside the Hippodrom beer tent at the Oktoberfest in Munich. The biggest folk festival in the world was first staged in celebration of the marriage of Crown Prince and later King Ludwig I to Therese von Sachsen-Hildburghausen.

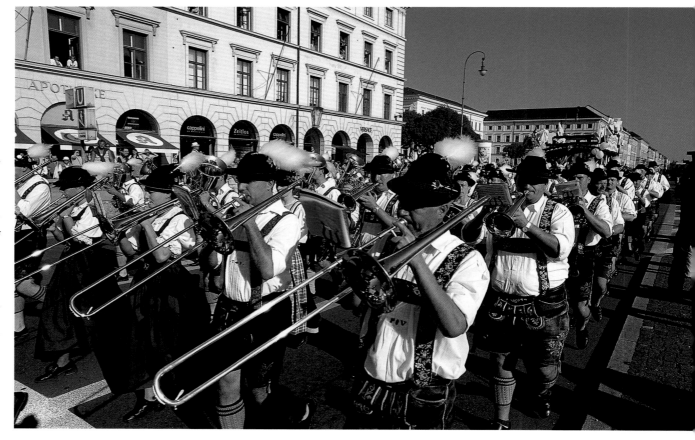

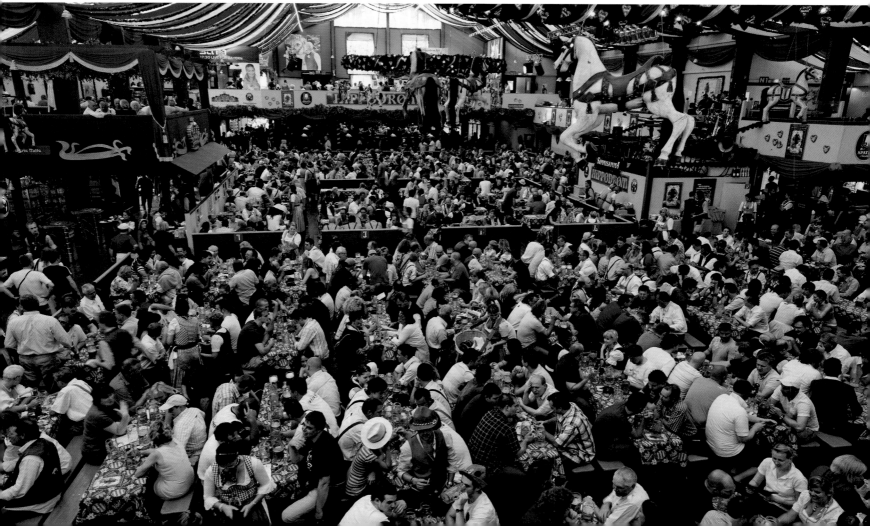

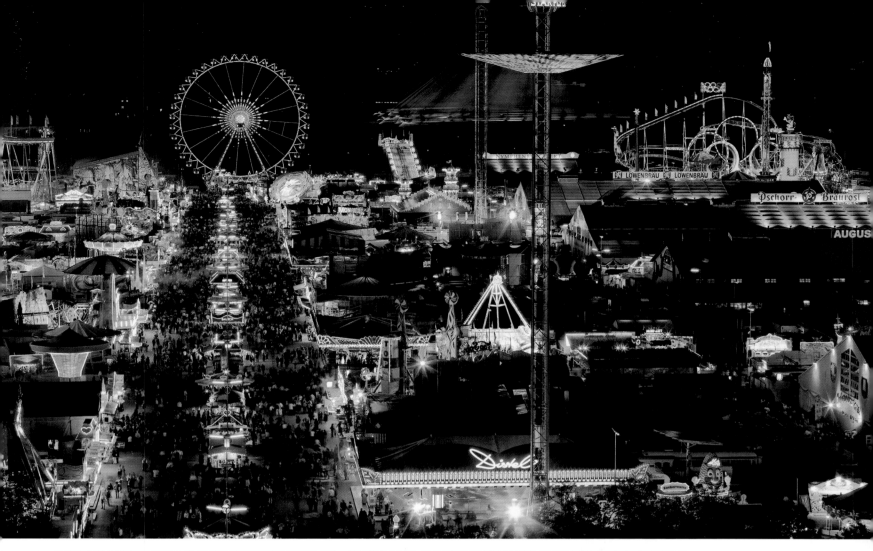

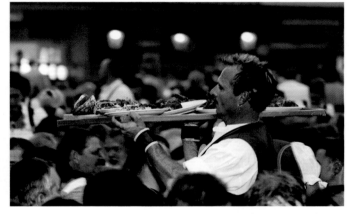

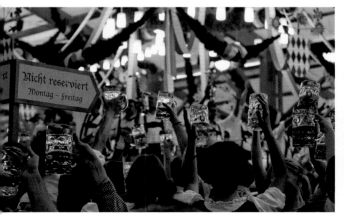

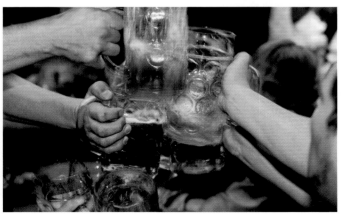

Above:
If you take a trip on the old big wheel, you are rewarded with magnificent views of the Oktoberfest by night, packed with traditional fairground attractions, such as the merry-go-round and helter-skelter, and the latest in loud and dizzy high-tech rides.

Small photos, left:
The waiters and waitresses at the Oktoberfest have a hard job of it, tending to the merry punters both day and night.

"LIQUID LUNCH"
AND OTHER DELICACIES

The claim that almost everything in Bavaria revolves around beer may not be new but it certainly polarises opinions – at least those of the non-Bavarian populace. The locals themselves are unperturbed. Like so many other things, they say nonchalantly, it's merely a question of faith. Karl Ignatz Geiger came to the same conclusion over 200 years ago; in an account of his travels of the Pfalz, Bavaria and Austria, in which he attempted to further the cause of the temperance movement, he remarks: "A Bavarian – not excepting the female sex – drinks a leisurely ten, twelve litres of brown beer a day; those who drink more are not few. The consumption of beer is thus beyond all belief."

Whatever your personal judgement, beer and Bavaria are inextricably linked. The federal state which is home to the Hofbräuhaus, Weihenstephan and many others is thus not only "the number one brewery in the world" but also the father of the two dukes who performed perhaps the greatest service to the beverage ever. In 1516 William IV and his brother Ludwig X passed the memorable German Purity Law which decreed that beer should contain nothing but water, barley malt and hops. Bavaria provided the ideal ingredients – and still does. The Hallertau is the largest hop-growing area in the world and famous for its top-quality produce. It's thus hardly surprising that the legendary god of beer King Gambrinus is said to have many a favourite port of call in Bavaria. In Upper Bavaria these are the renowned brewery of Andechs Monastery and the state capital of Munich. Nowhere else in the world – at one time and in one place – do so many people devote themselves body and soul to the pleasures of beer as at the yearly Oktoberfest.

Radi, Leberkäs and Weisswurst

Yet even in Bavaria you can't live off beer alone. Local menus are as much a homage to farming tradition as they are to the quirks and fancies of the indigenous population. It would be classed as a sin, for example, if the infamous "Radi" or white radish were to be missing from your Bavarian picnic or "Brotzeit". Cut into thin spirals, it's sprinkled with salt "until it weeps". Only then is it considered edible. Despite its generous seasoning it has a residual hot bite which is why it may not have transcended Bavarian boundaries as a national delicacy. "Leberkäs" is an entirely different matter; meat loaf has become an international staple.

The fact that its name is entirely misleading is beside the point. Containing neither liver ("Leber") nor cheese ("Käse"), it's thought that it was originally called "Lebenskäse" or "the cheese of life" – until outsiders misinterpreted the Bavarian to produce the new spoonerism. Perhaps the best example of a typically Bavarian dish is the white sausage or Weißwurst. Its creation was not, however, the result of years of careful culinary experimentation; it owes its existence to a party of impatient guests and the inspired actions of butcher's apprentice Sepp Moser. His clientele wanted sausages. Unfortunately, the master chef had run out of the standard-issue long, thin sausage cases and had to use short fat ones instead. To save time he didn't fry the sausages as ordered but simmered them in a pot of boiling water. Instead of causing an angry uproar, Moser earned himself effusive praise and long-lasting fame as the inventor of a new delicatessen. As the rest of Germany has benefited from Bavarian cuisine, so too has Bavaria profited from foreign influences. Now sold as local specialities, the popular "Leberknödel" (liver dumplings), "Kartoffelknödel" (potato dumplings) and "Grießnockerln" (semolina dumplings) are actually imports from neighbouring regions and countries.

Another type of dumpling consumed with great enthusiasm here is the sweet variety, the "Dampfnudel". An absolute staple of the Bavarian kitchen, this is a large ball of yeast dough which is "finished" in the milky steam given off when it's heated up. Yeast dough is also the main ingredient of an "Auszog'nen", popular with locals and visitors alike, which is baked in clarified butter. One of Bavaria's most bizarre culinary delights is the episode in the life of famous Rococo architect François de Cuvilliés who as the elector's "chamber dwarf" was ordered by Max Emanuel II to be "baked" in an enormous pie.

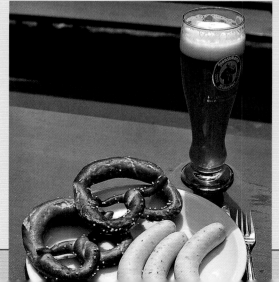

Left:
The legendary Weißwurst was "created" in Munich in 1857. It's delicious with fresh pretzels, mustard and, of course, beer.

Above:
Although the beer tents at the Oktoberfest seem to get bigger and bigger each year, it's still a tight squeeze – which is half the fun!

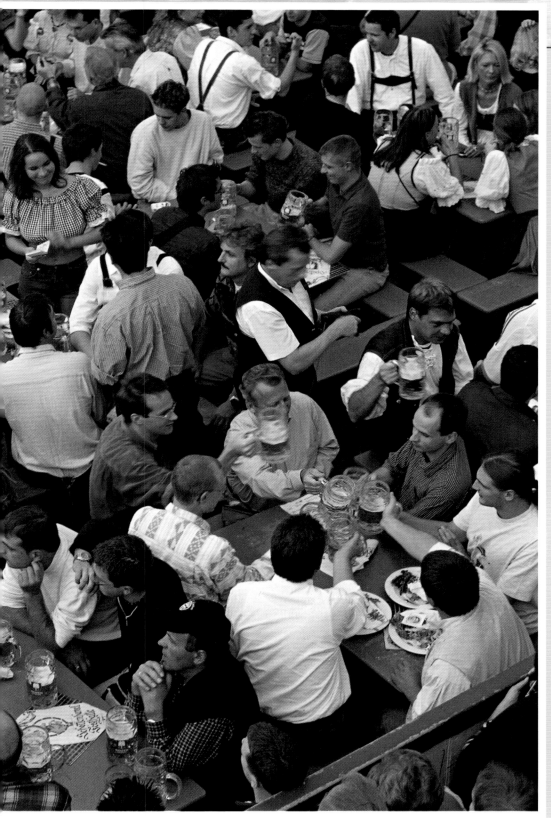

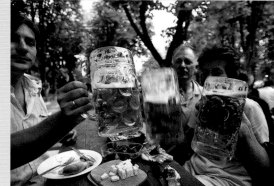

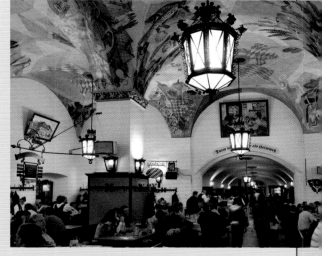

Pictures right, from top to bottom: Whether in Munich or here in Menterschwaige, beer tastes best out in the open air in the company of good friends!

Hops from the Hallertau region of Upper Bavaria are said to be the best in the world and coveted by breweries both close to home and far afield.

The famous Munich Hofbräuhaus has been making beer since 1592 and is never short of customers.

Another Upper Bavarian delicacy is "Steckerlfisch", a freshwater fish skewered on a stick and baked on a charcoal barbecue.

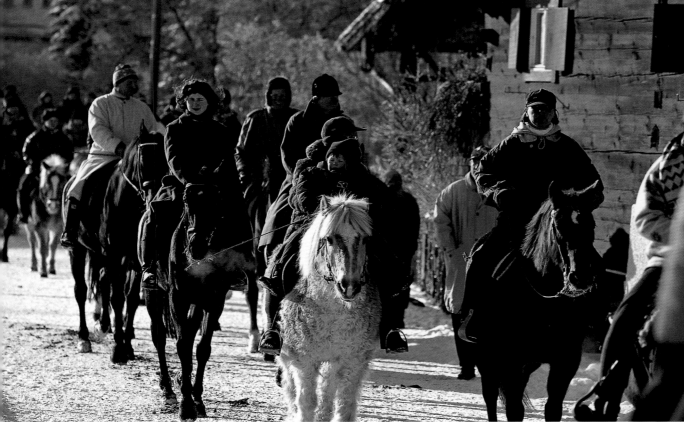

Left page:
The chapel at Andechs Monastery is a Gothic hall church which in the second half of the 18th century was refurbished in decorative Rococo with plenty of stucco and frescos by the famous Johann Baptist Zimmermann. Still a place of pilgrimage, Kloster Andechs is also well known for its strong monastic beer.

The Ammersee is the third-largest lake in Bavaria. Despite its popularity it's plenty big enough for birds and animals to find refuge along its sheltered shores.

April 23 (St George's Day), November 6 (St Leonard's Day) and December 26 (St Stephen's Day) are all special feast days for the farming community of Upper Bavaria. Here St Stephen is being celebrated with a processional ride through the village of Mörlbach on the Starnberger See.

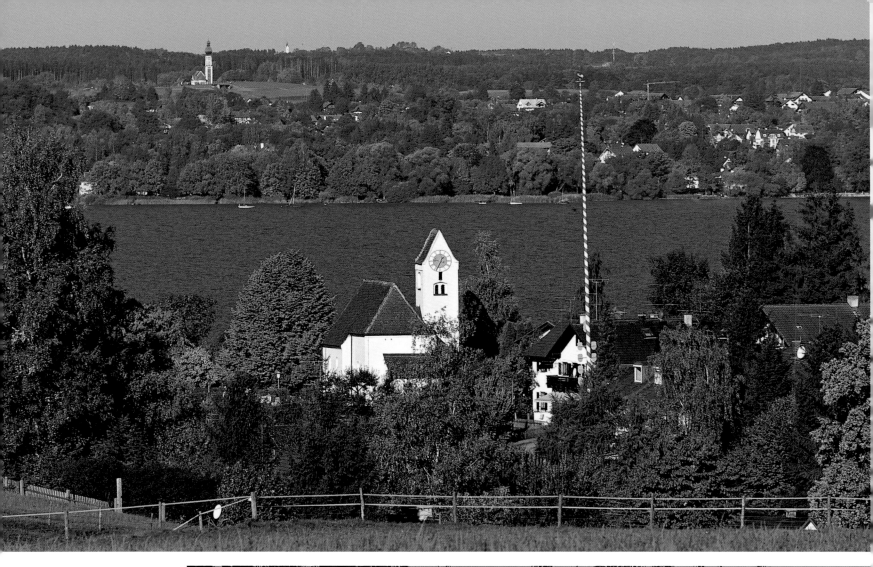

Above:
The shores of the Ammersee are dotted with picturesque resorts, such as Breitbrunn (in the fore-ground) and Hechenwang, where holidaymakers can participate in any number of water sports and also fish, hike and cycle.

Right:
Like the neighbouring Wörthsee, the tiny Pilsensee with its shady shoreline is actually part of the Ammersee, cut off from its parent lake by silt and organic debris. Its modest dimensions make it warmer than the larger lakes and ideal as an outdoor swimming pool.

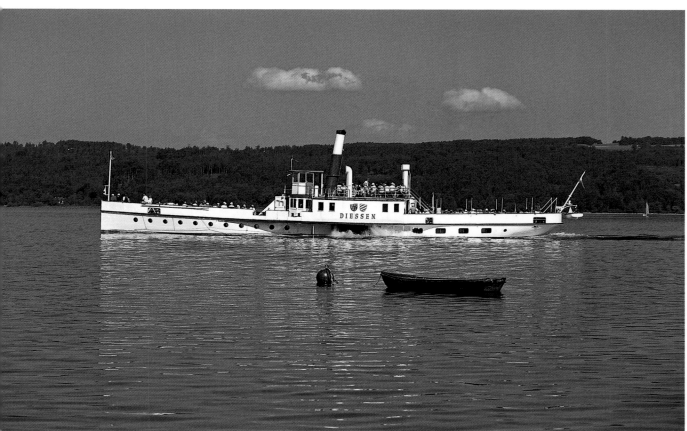

Left:
The Dießen steamer is one of a fleet of pleasure boats which ferry day trippers across the Ammersee from Easter to the end of October. A complete tour of the lake takes three hours.

Below:
The former monastic church of Mariä Himmelfahrt in Dießen (now the parish church) was built between 1732 and 1739 by Johann Michael Fischer. Among its highlights are the high altar by François Cuvilliés and Giovanni Battista Tiepolo's painting for the Sebastian Altar.

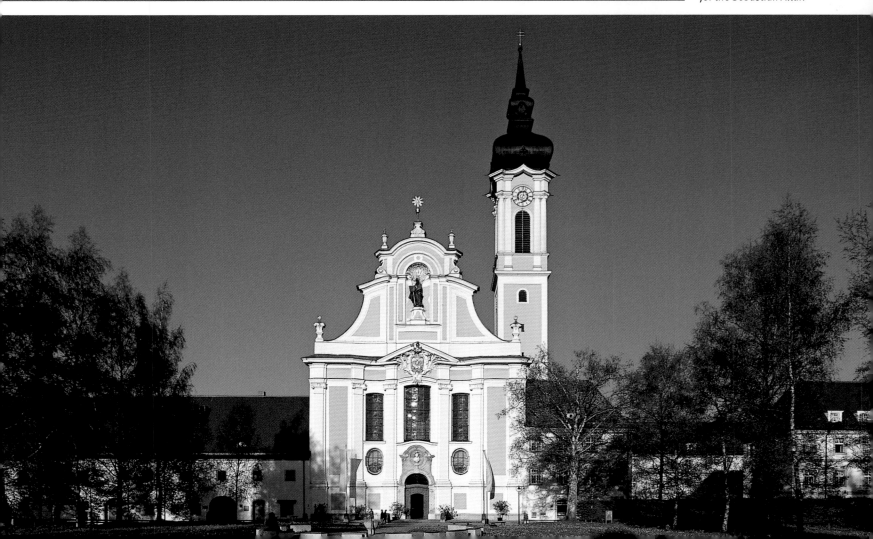

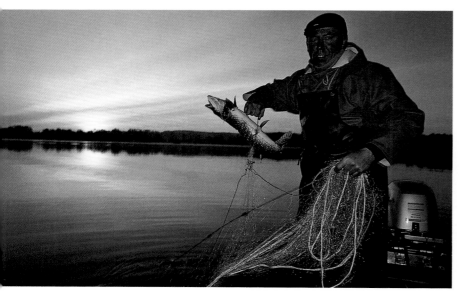

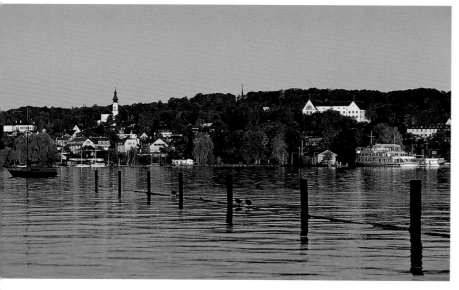

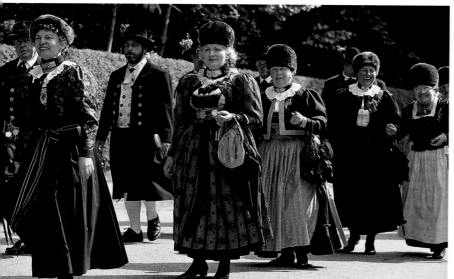

Left:
Besides the spectacular Fischerstechen games which date back to the medieval guilds, in which men try to push each other into the water with long poles, there are still a number of "genuine" fishermen trawling the Starnberger See, among them Siegfried Andrä from Berg.

Centre left:
View from Kempfenhauser across the lake to Starnberg. Once a humble fishing village, during the 19th century the town boomed, with lavish villas

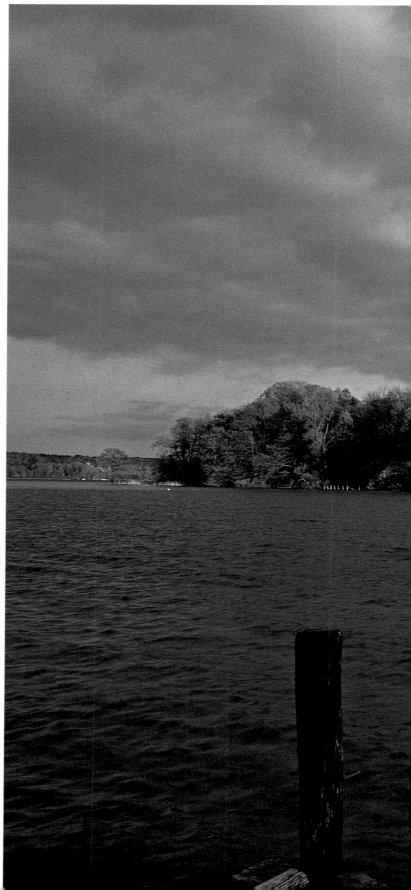

Bottom left:
The Tutzinger Fischer-
hochzeit, the traditional
"fisherman's wedding"
pageant, celebrates the
history of Tutzing which
clings to the western shores
of the Starnberger See.

being erected for the well
endowed. Its local landmark
is the Schloss or palace,
originally an 11th-century
castle erected by the counts
of Andechs-Meranien.

Below:
All ships for the Roseninsel
depart from Feldafing.
The village profited from
its close proximity to the
neighbouring Wittelsbach
castles of Garatshausen
and Pöcking – where

Empress Elisabeth of
Austria spent her
childhood – and soon
went from rags to riches,
with magnificent villas
springing up in place
of lowly farmsteads.

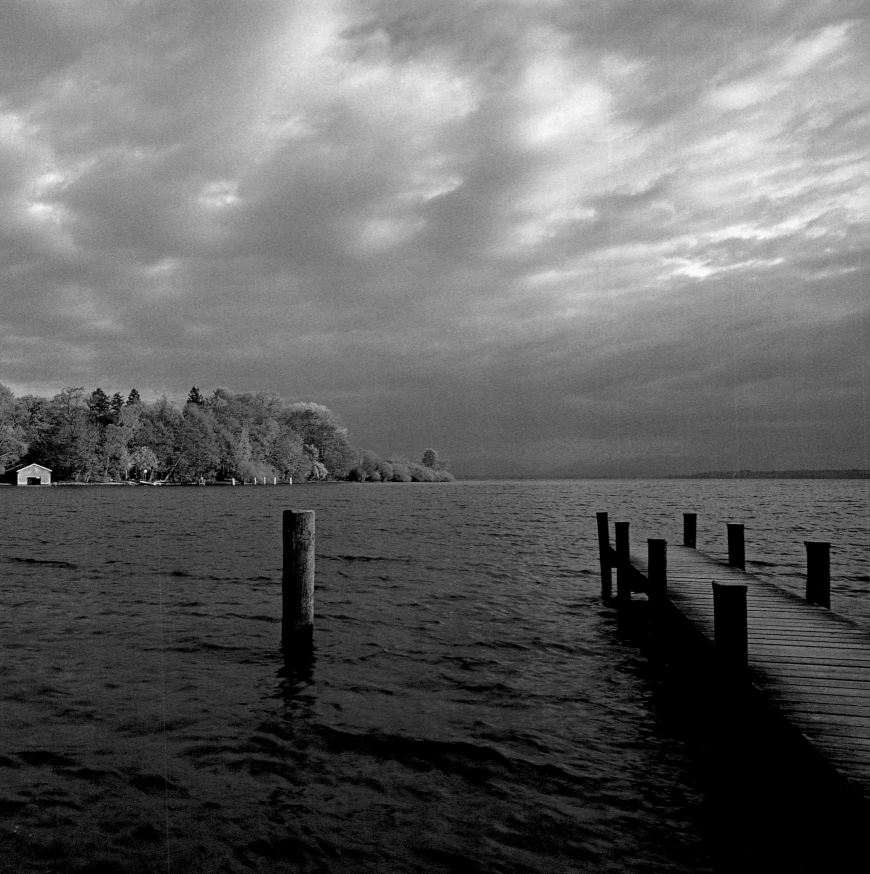

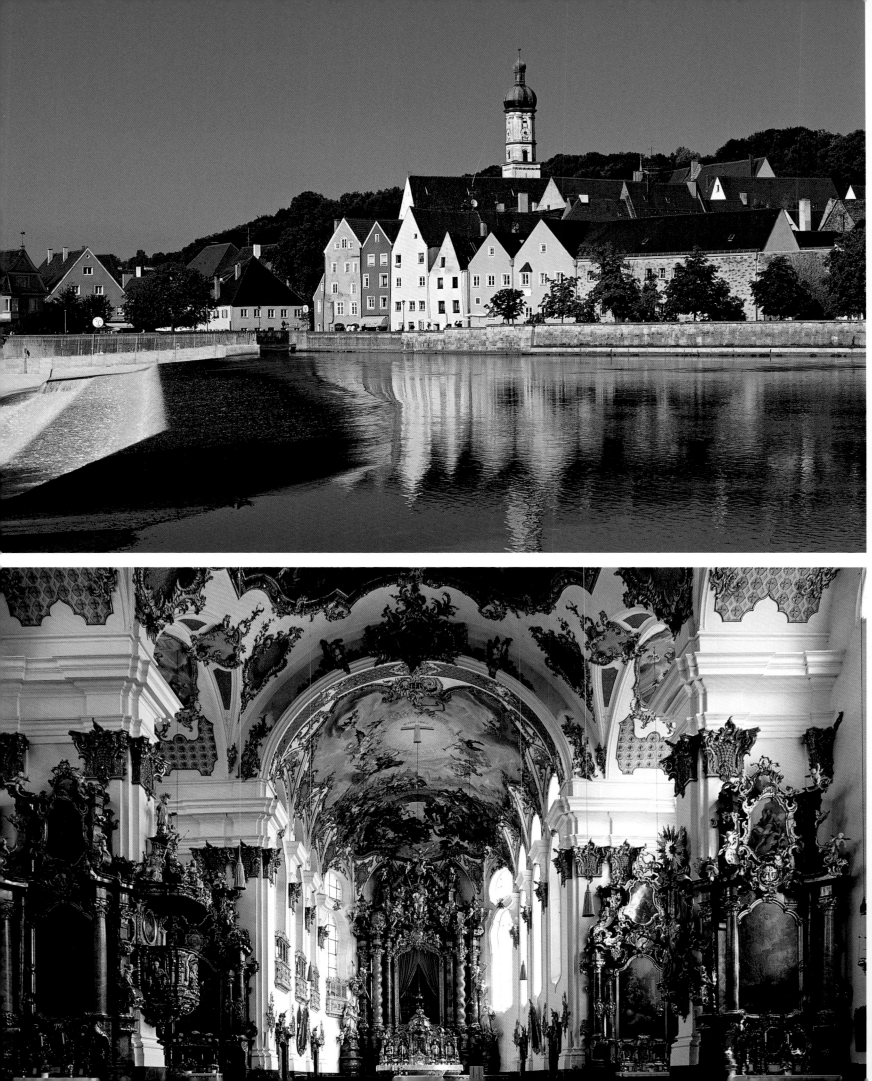

Left:
The town of Landsberg grew up on a bank in the River Lech beneath a castle built by Henry the Lion in the mid-12th century. It boomed during the heyday of the salt trade, its bridge providing an important – and lucrative – crossing over the Lech for traders working the salt route.

Below:
Landsberg's prosperity during the 15th century called for adequate protection from would-be adversaries; defensive walls and towers were hastily erected which are still standing today. The Mutterturm depicted here, however, is a fake, built for artist Hubert von Herkomer in 1884 in the then popular style of the Gothic Revival.

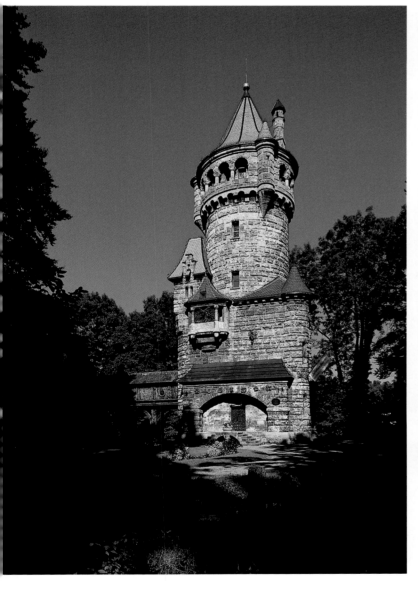

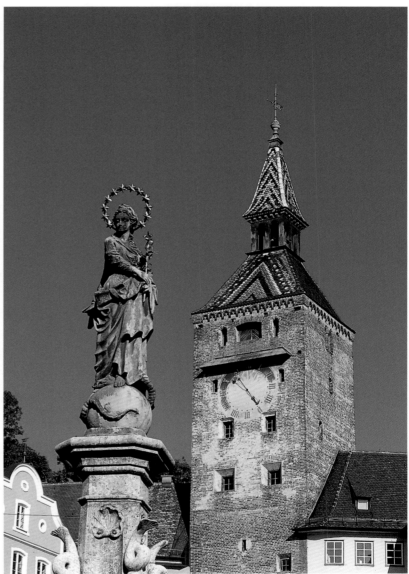

Left:
The former monastic church of the Holy Cross in Landsberg is one of the first in Germany erected by the Jesuits. Among the many features of its lavish late Baroque and Rococo interior are the incredible ceiling frescos by Felix Anton Scheffler.

Above:
The historic heart of Landsberg is undoubtedly its market place, with the 13th-century Schmalzturm, inner city walls and Madonna and fountain from 1738.

47

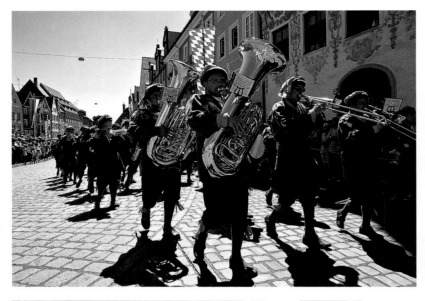

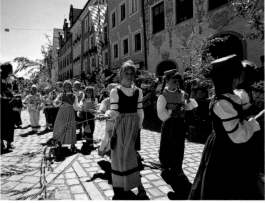

Two photos right:
Every four years at the end of July Landsberg provides the spectacular backdrop for the Ruethenfest, Bavaria's biggest festival for children, where over 1,000 girls and boys re-enact scenes from the town's past.

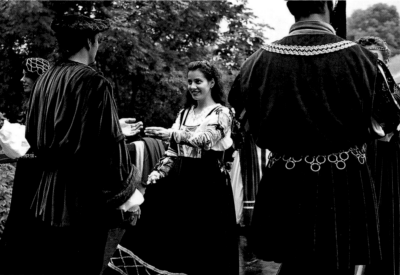

Above and below right and main photo:
At the medieval tournament at Schloss Kaltenberg northeast of Landsberg on the River Lech knights on white chargers and damsels in distress, minstrels and chroniclers, street entertainers and market traders in historic costume bring the late Middle Ages to life. There's jousting, courtly dancing and of course plenty to eat and drink.

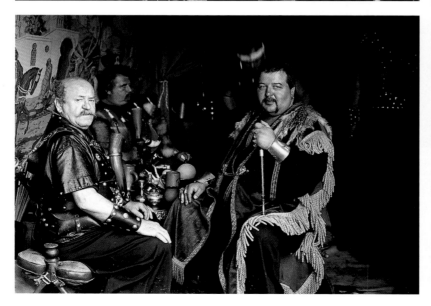

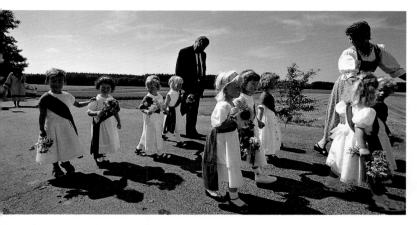

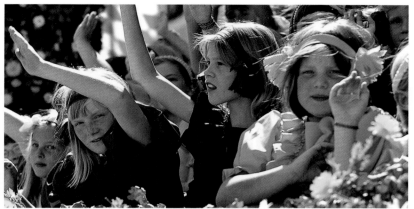

Above left:
The high point in the Vilgertshofen calendar is the "silent procession" scheduled for the first Sunday after the Assumption of the Virgin Mary (August 15).

Above:
The absolute highlight of the children's Ruethenfest in Landsberg is its colourful parade.

49

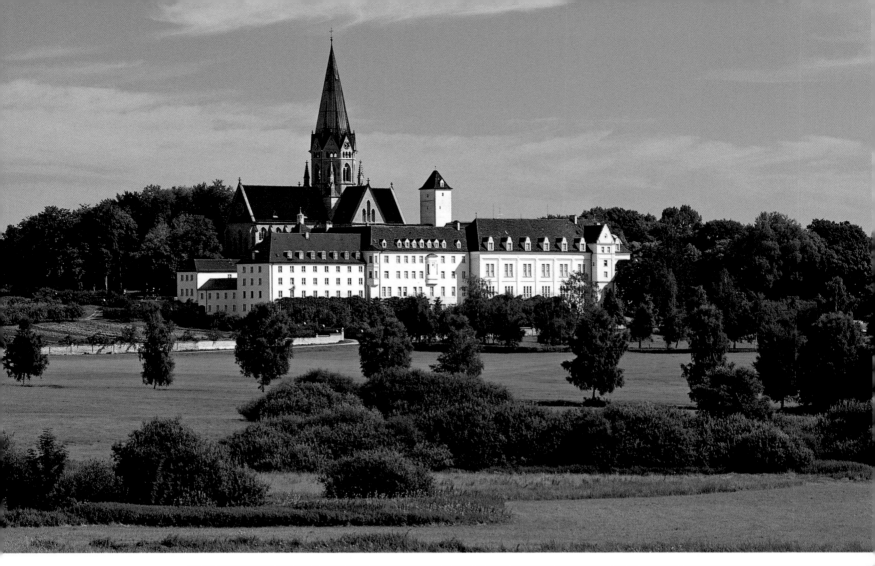

Above:
Surrounded by lush green fields and fertile meadow-land, the gleaming white Benedictine monastery of St Ottilien near Eresing welcomes visitors from far and wide.

Right:
Epfach on the River Lech seen from Reichling. The right-hand tributary of the Danube rises in Vorarlberg in Austria and travels 285 kilometres (177 miles) before joining the larger river. The natural course is controlled by locks before being canalised from Augsburg onwards.

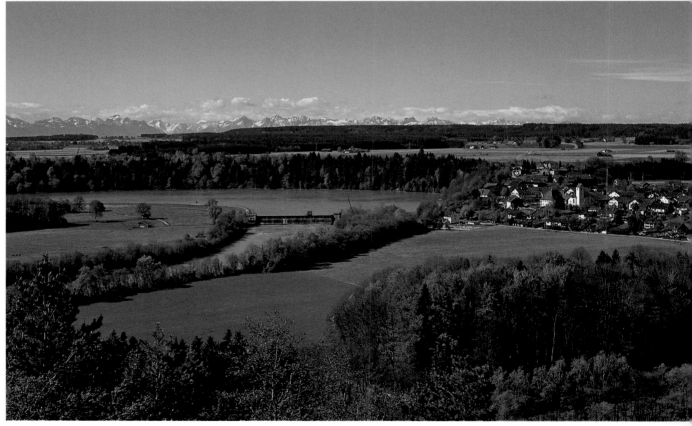

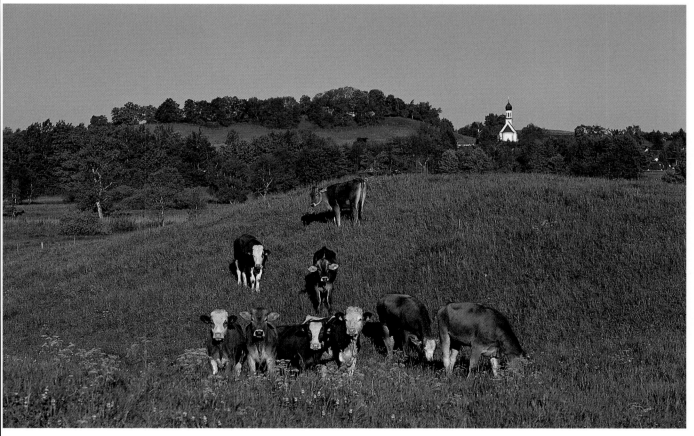

Above:
Prittriching near Landsberg on the Lech. The two spires of the Frauenkirche and Spatzenturm seem to pierce the brilliant blue sky.

Left:
Although more and more of the farming community are finding it impossible to make a living here, the area between Landsberg and Steingaden is still mainly agricultural. The dairy museum in Bernbeuren charts the development of this age-old industry and also demonstrates how butter, cheese, quark and yoghurt are made.

51

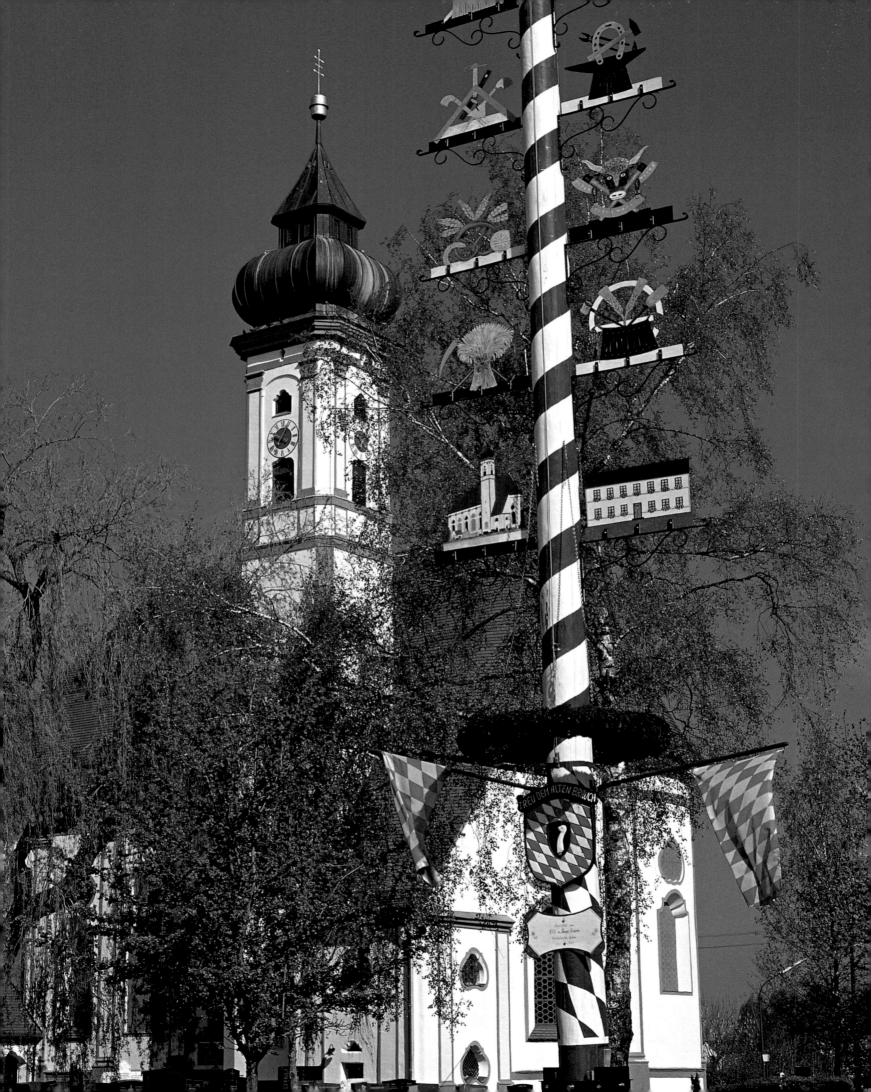

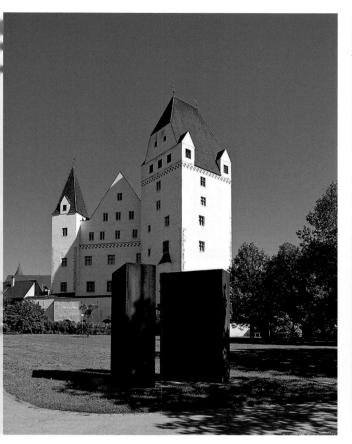

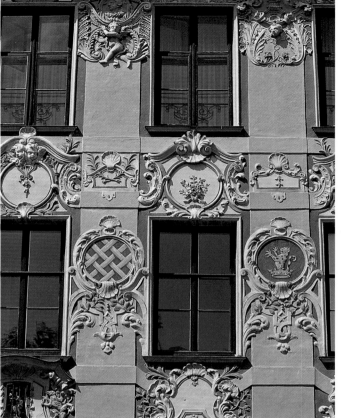

Left page:
Erecting the maypole is an ancient tradition which is diligently observed all over Upper Bavaria (here in Vierkirchen in the Dachauer Land).

Far left:
The Neues Schloss in Ingolstadt once belonged to the dukes of Bavaria and boasts some of the most beautiful state rooms of the German Gothic period.

Left:
Neuburg on the Danube has many a splendid facade, such as this one on Karlsplatz. Erected on the right bank of the river, the town was the royal seat of local princes until 1685 and owes much of its present appearance to the architectural prowess of Count Palatine Ottheinrich who ruled during the 16th century.

Far left:
Ingolstadt's historic centre revolves around its ancient market square or Markt-platz. The Altes Rathaus (old town hall) is in itself relatively modern, built in 1882, yet was once part of the much older Catholic Moritzkirche which dates back to the Carolingian period.

Left:
Neuburg's castle goes back to the reign of Count Palatine Ottheinrich. His successor Philipp Wilhelm later added a fourth wing to the original three. The courtyard is enclosed on three sides by Renaissance arcades and galleries.

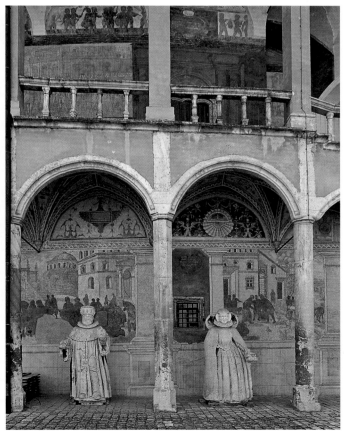

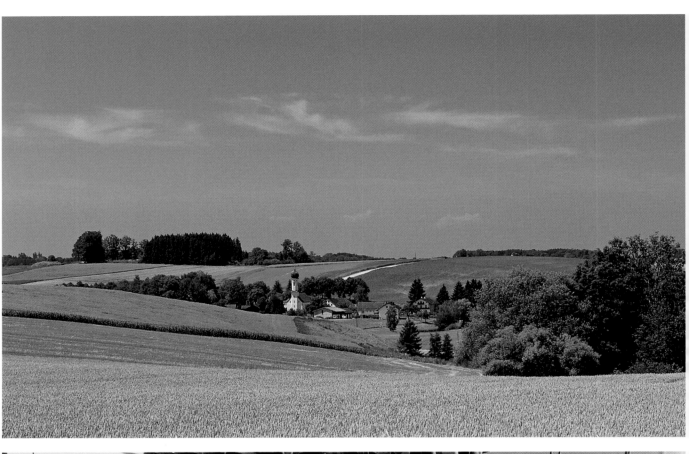

In the summer months the hamlet of Matzbach near Erding is like a picture postcard, its fields of corn and barley rippling in a gentle breeze under a perfect blue-and-white Bavarian sky.

In the Hallertau hops used to be picked by hand by labourers from the poorer regions of Bavaria, such as the Upper Palatinate and the Bavarian Forest. Today the crops are harvested by modern machinery.

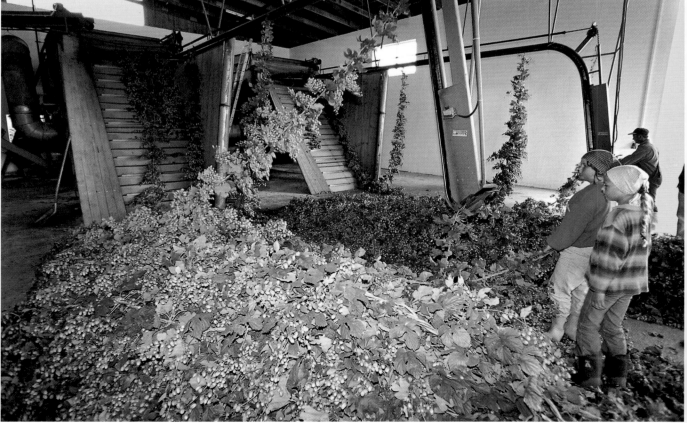

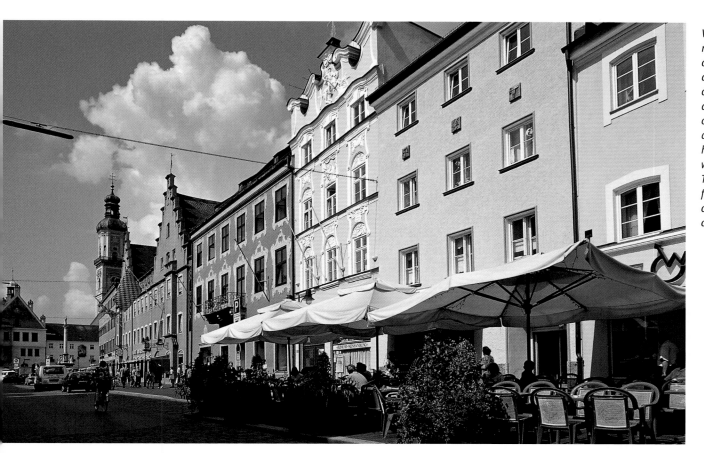

View of the main street running through the centre of Freising. The old diocesan town looks back on a turbulent history dominated by a number of great names. Records claim the first missionary here was Korbinian – who was later made a saint. The bishopric itself was founded in 739 on the order of the pope by none other than St Boniface.

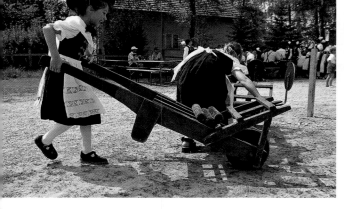

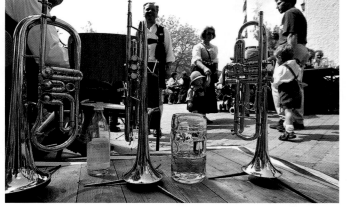

Left and far left:
Celebrating the arrival of May in Eicherloh near Erding. The local band enjoys a well-earned break while the children take part in a barrow race.

Far left:
The beer garden at the Bavarian state brewery of Weihenstephan is as good a place as any to try out some of Upper Bavaria's local specialities, such as knuckle of pork with dumplings and beer.

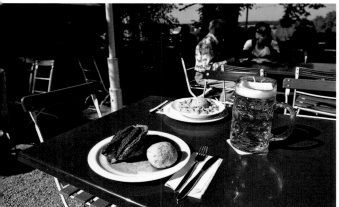

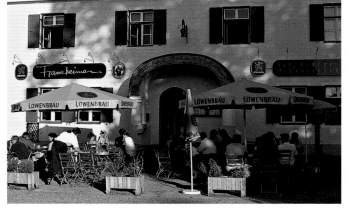

Left:
Hospitality is writ large in Upper Bavaria. Local pubs and restaurants – such as the Zangerwirt in Eichenried shown here – set great store by both their cuisine and a general atmosphere of convivial well-being.

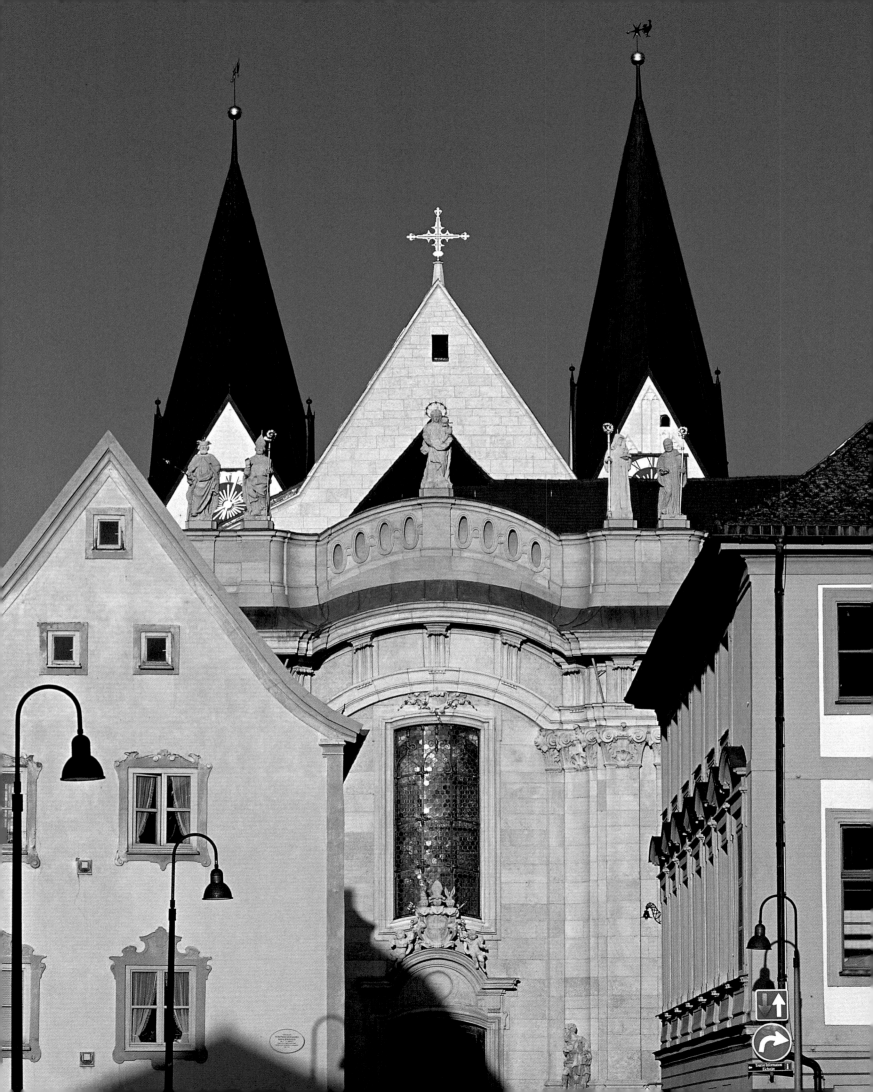

Below:
Even if it has not completely
escaped the machinations
of the modern age, much

of the Altmühl Valley has
remained untouched, with
plenty of idyllic spots for
keen canoeists to explore.

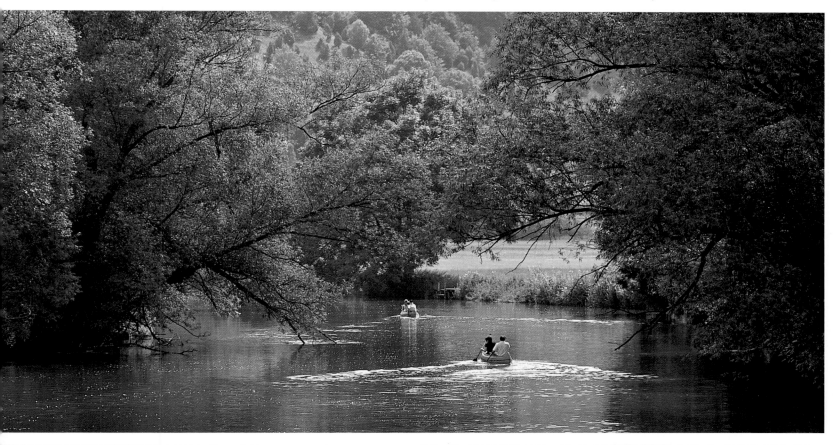

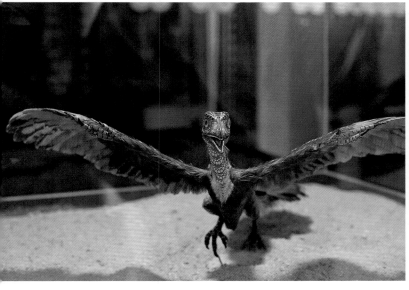

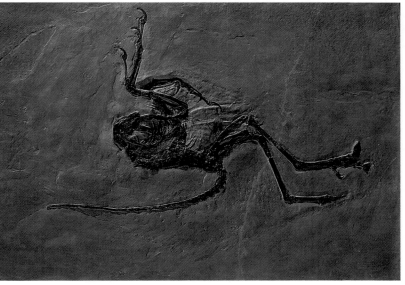

Above left and right:
The Willibaldsburg in
Eichstätt is home to the
Jurassic Museum which

documents the period of
190 to 135 million years BC
in the Swabian and
Franconian Alb region.

Among the fossilised
plants, amphibians, fish,
jellyfish, insects, reptiles
and pterodactyls is a world

rarity: the prehistoric bird
Archaeopteryx, shown here
fossilised in Solnhofen
Limestone and as a model.

From the Pfaffenwinkel to the Tegernsee

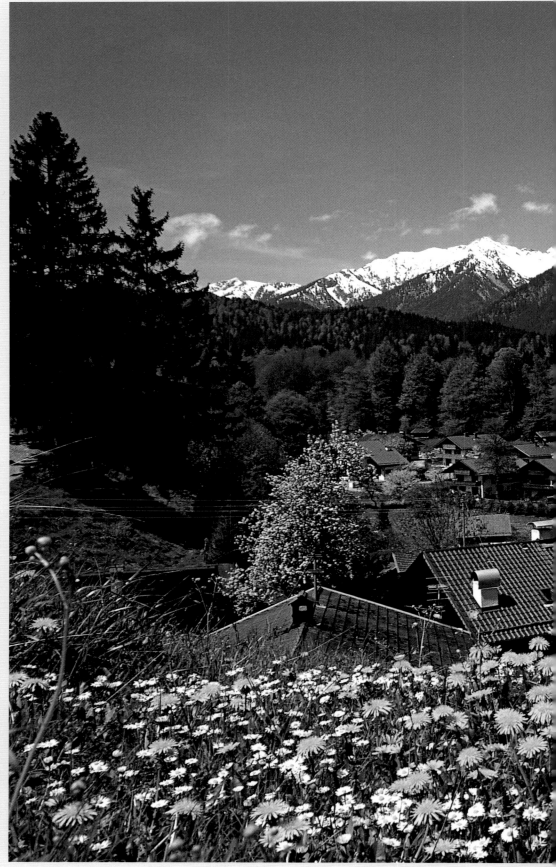

The Werdenfelser Land is at the heart of the Bavarian Alps. Also known as the "golden land" due to its great prosperity, the southernmost region of Upper Bavaria was owned by the monastery of Freising from the beginning of the Middle Ages to the year 1802. Here, flowering meadows surround the little village of Obergrainau with the snow-capped Hoher Ziegspitz in the background.

The Pfaffenwinkel or "parson's place" is aptly named; this tiny pocket of land tucked in between Upper Bavaria and Swabia is absolutely packed with lavishly decorated churches and monasteries embedded in rolling hills and lush green pastures. You'd have to search long and hard to find anywhere else as appealing as this, where just the journey to these magnificent architectural gems alone – whether on foot or by bicycle – is a pleasure in itself.

In the Werdenfelser Land, however, the mood is positively Alpine. Garmisch-Partenkirchen is at its centre, host to the Olympic Games, various world championships and first-class winter sports events of all kinds. The facades of the local houses, decorated with Lüftlmalerei saints and scenes from village life, compete with the grand panoramas which surround them. The best examples of this highly original folk art are to be found in Oberammergau and around Bad Tölz.

From here it's not far to the Tegernsee where the Bavarian holiday first came into fashion. The beautiful land of the Benedictines and Wittelsbachs which exerted such a magnetism on the first tourists back then has lost absolutely none of its simple country charm over the years.

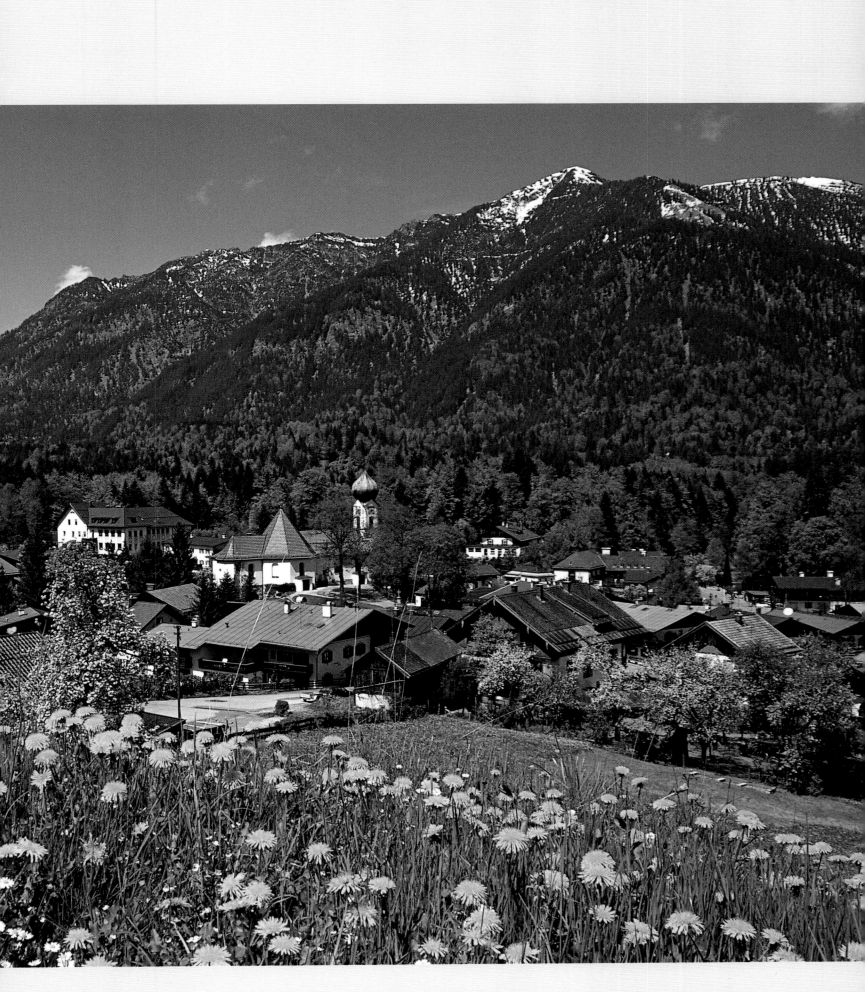

Below:
In Upper Bavaria even the cows wear national costume! Dependent on their livestock for centuries, the local populace celebrate their animals in autumn, adorning them with bright garlands of flowers when they are driven down from their Alpine pastures for the winter.

Right:
In the south of Upper Bavaria, where the grazing is particularly good, dairy farming is all-important. In the Alpine Foreland and mountain valleys, however, livestock is primarily bred for the table.

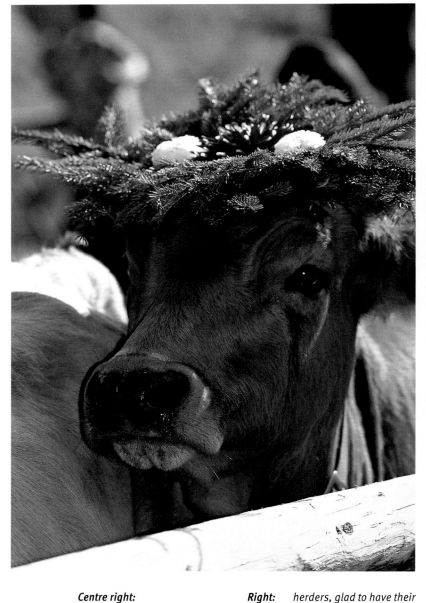

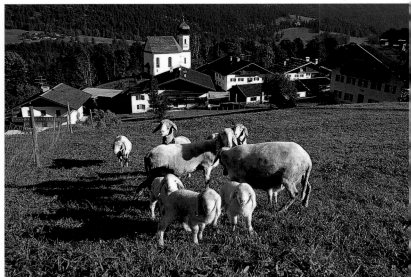

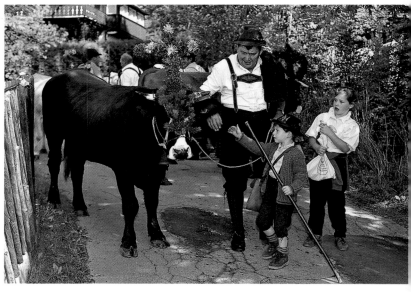

Centre right:
View of Wamberg in the Werdenfelser Land. Less particular in their grazing habits than cows, sheep are a good means of clearing land no longer used for pasture.

Right:
Driving cows down from their summer pastures in Garmisch-Partenkirchen. Both the animals and their herders, glad to have their livestock safely stabled for the winter, celebrate their safe return by dressing up for the occasion.

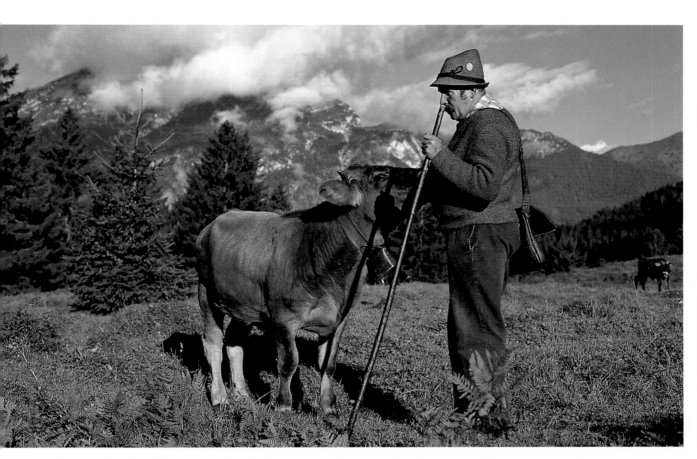

Seite 62/63:
View of the Alpspitze and Zugspitze with Parten-kirchen in the foreground. Partenkirchen merged with Garmisch to form the market town of Garmisch-Partenkirchen in 1935. The former dates back to the Roman settlement of Parthanum; first mention of Garmisch was made in 802.

The life of the Alpine cow-herd may often be treated as the stuff of romantic fancy; working out in the open in all weathers with few creature comforts is usually anything but idyllic. Even though mobile phones now provide an essential means of communication, only the toughest stick it out.

Alpine meadows are not just ideal for summer grazing; they're harvested for hay in the autumn which is brought down to the valleys on sledges. The photo shows traditional Alpine haystacks with the Zugspitze Massif behind them.

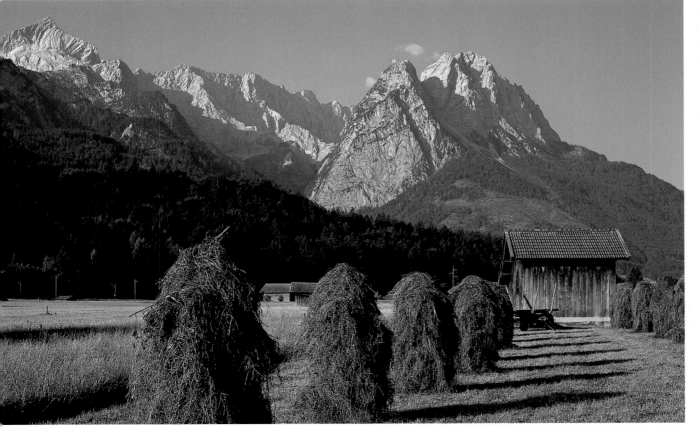

Page 64/65:
The famous holiday resort of Grainau is scenically situated at the foot of the Zugspitze in the Wetter-stein Range. Not only the Zugspitze is easy to reach from Grainau; from here you can also embark on hikes through the Höllental Gorge and the valley of the Höllental that stretches out beyond it.

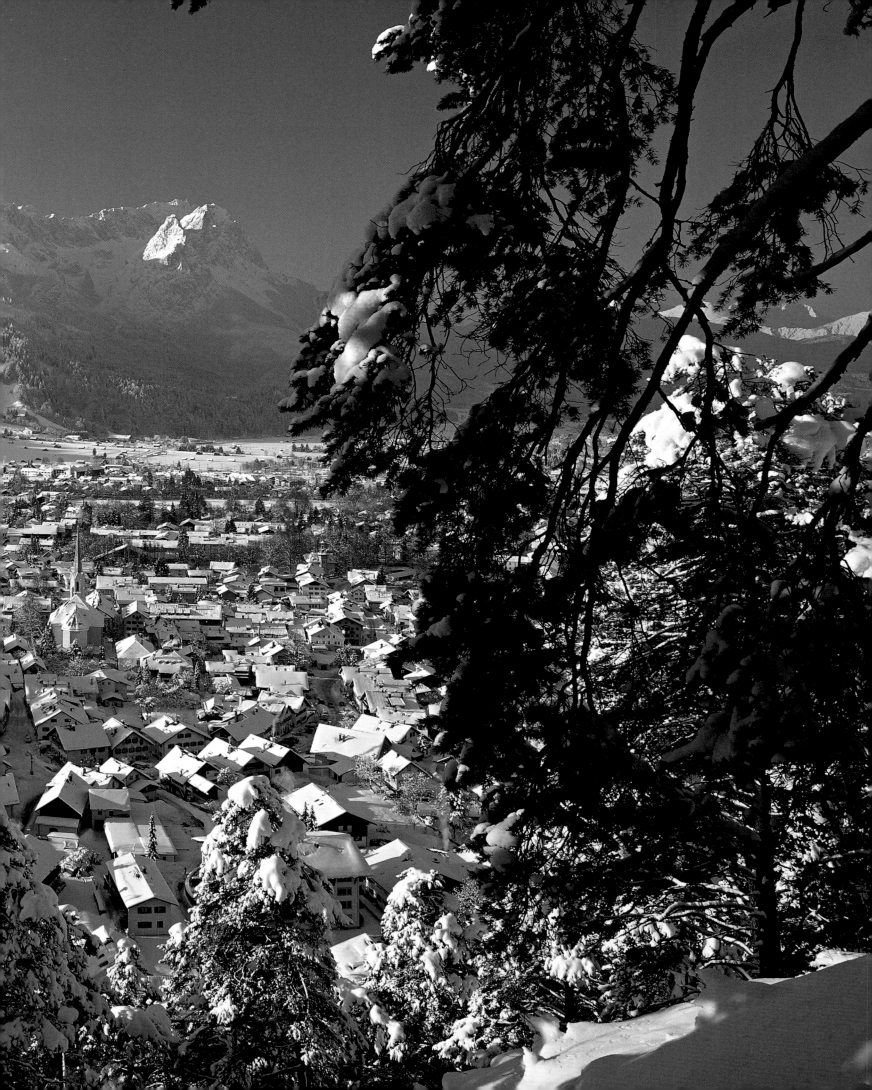

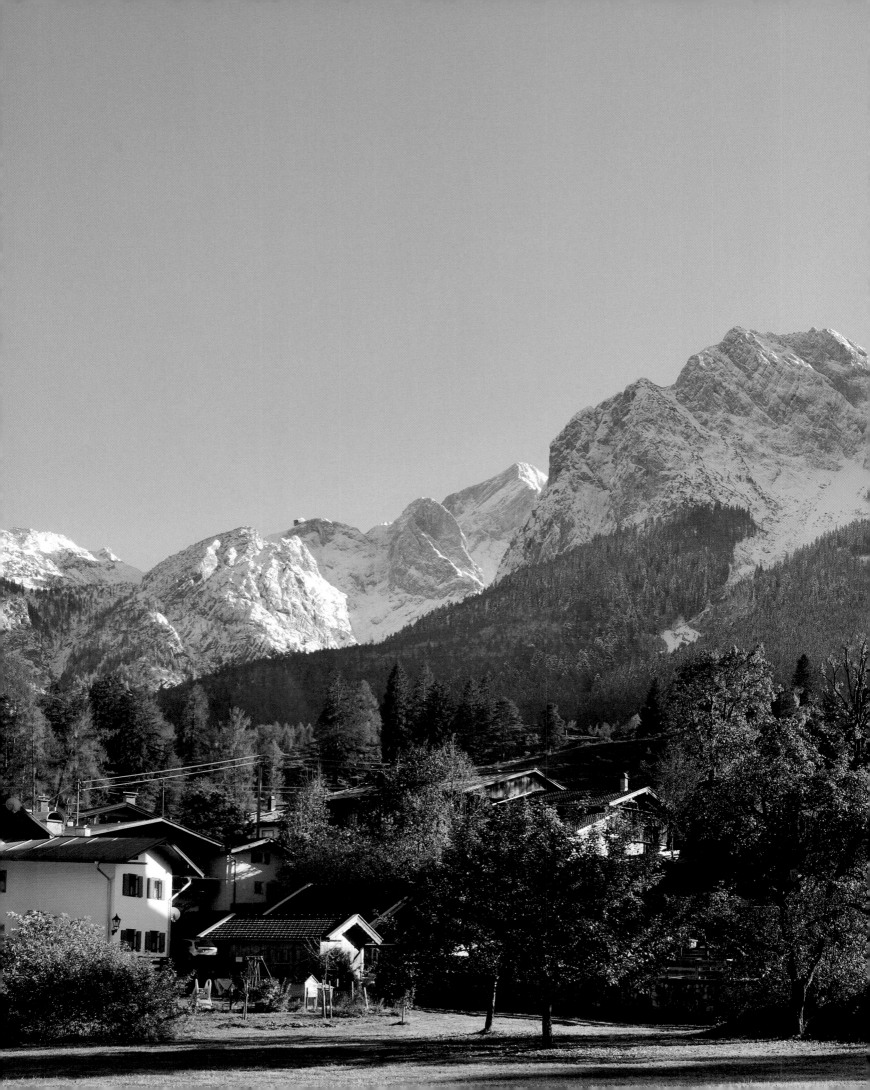

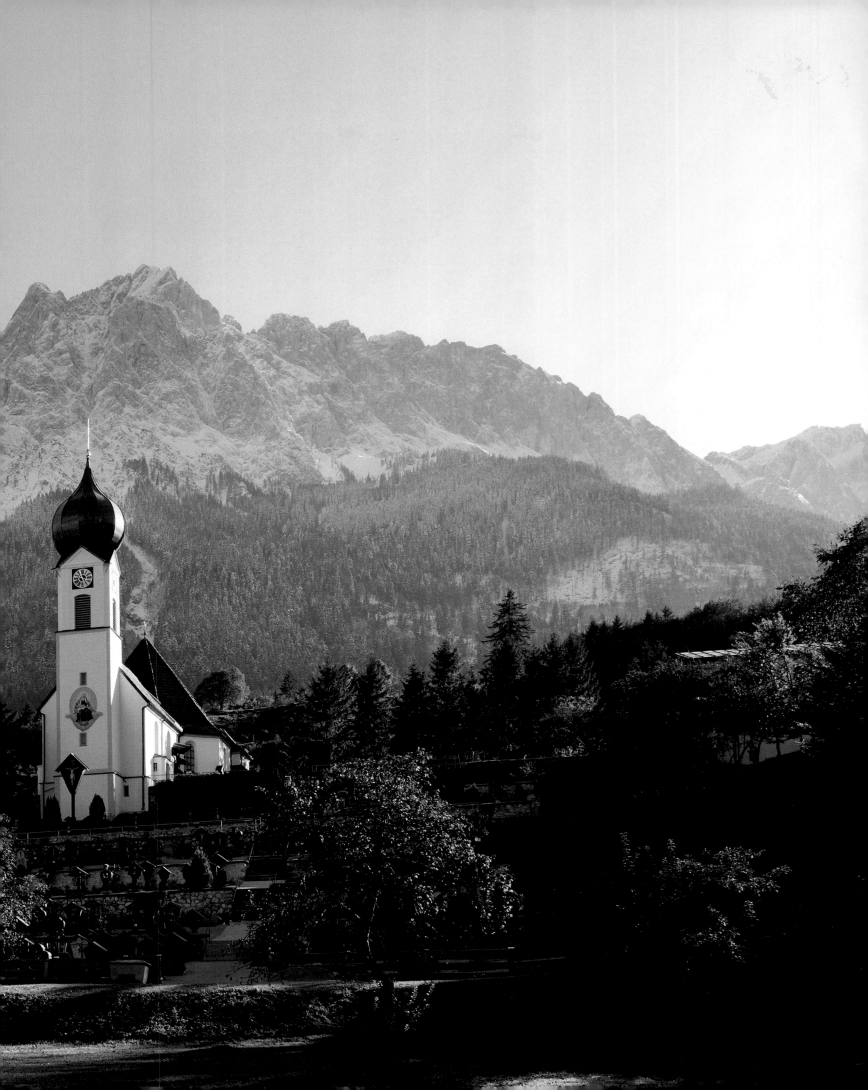

Right:
Originally Gothic, the parish church dedicated to St Peter and St Paul in Mittenwald was baroqueified in the 18th century by Wesso-brunn artist Joseph Schmuzer. The church steeple is decorated with elaborate frescos.

Far right:
Mittenwald is famous for violinmaking and a statue to the south of the local church com-memorates the man who made the first instruments here in c. 1689. Matthias Klotz studied under Nicola Amati in Italy; more about his life and trade can be learned at his former home, now a museum.

Mittenwald, first documented in 1080, was an important centre of trade for medieval merchants travelling between Augs-burg, Nuremberg and Venice. Its much-admired frescoed facades (here the Hotel Post on Obermarkt) came into fashion in the 18th century.

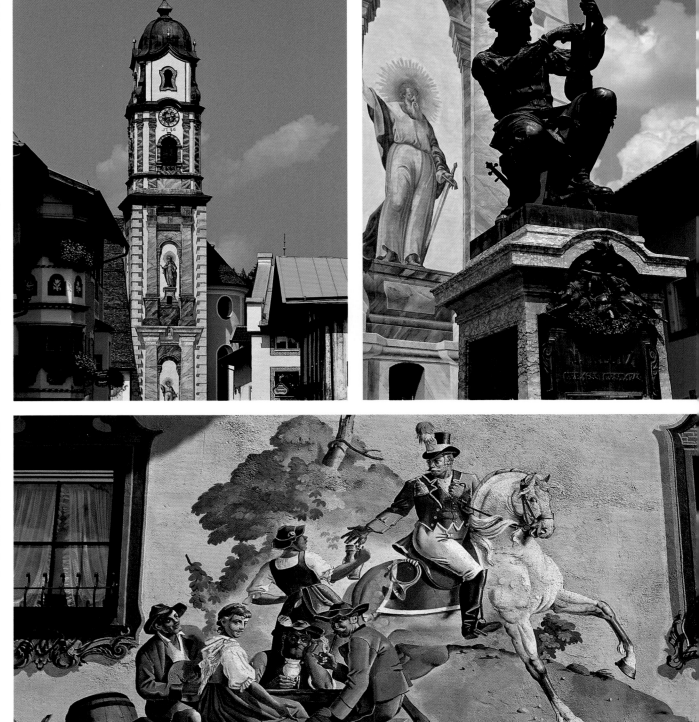

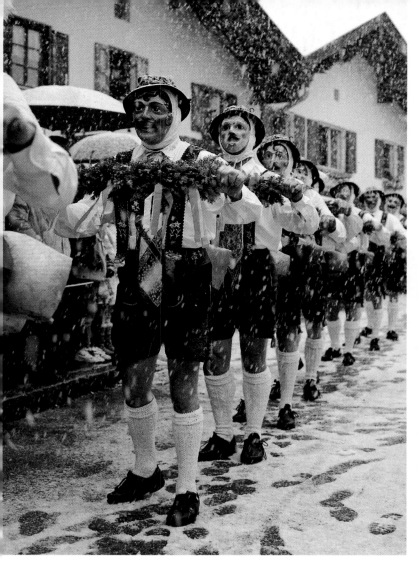

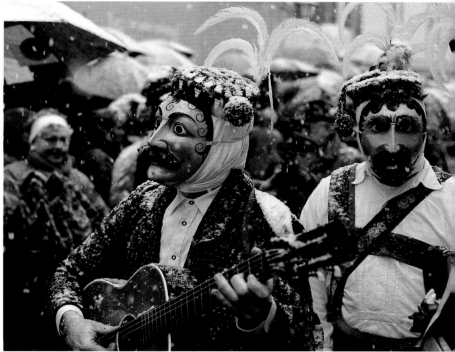

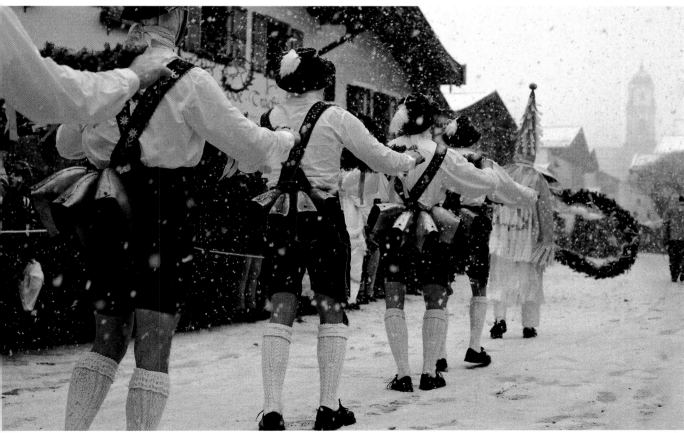

On "silly Thursday", the Thursday before Shrove Tuesday, Mittenwald suddenly springs into action when the clocks strike midday. This is the hour of the "Schellenrührer", men wearing the traditional dress of the Werdenfelser Land and hidden beneath gruesome masks, who leap through the streets to the mad clanging of cow bells to drive away the evil spirits of winter.

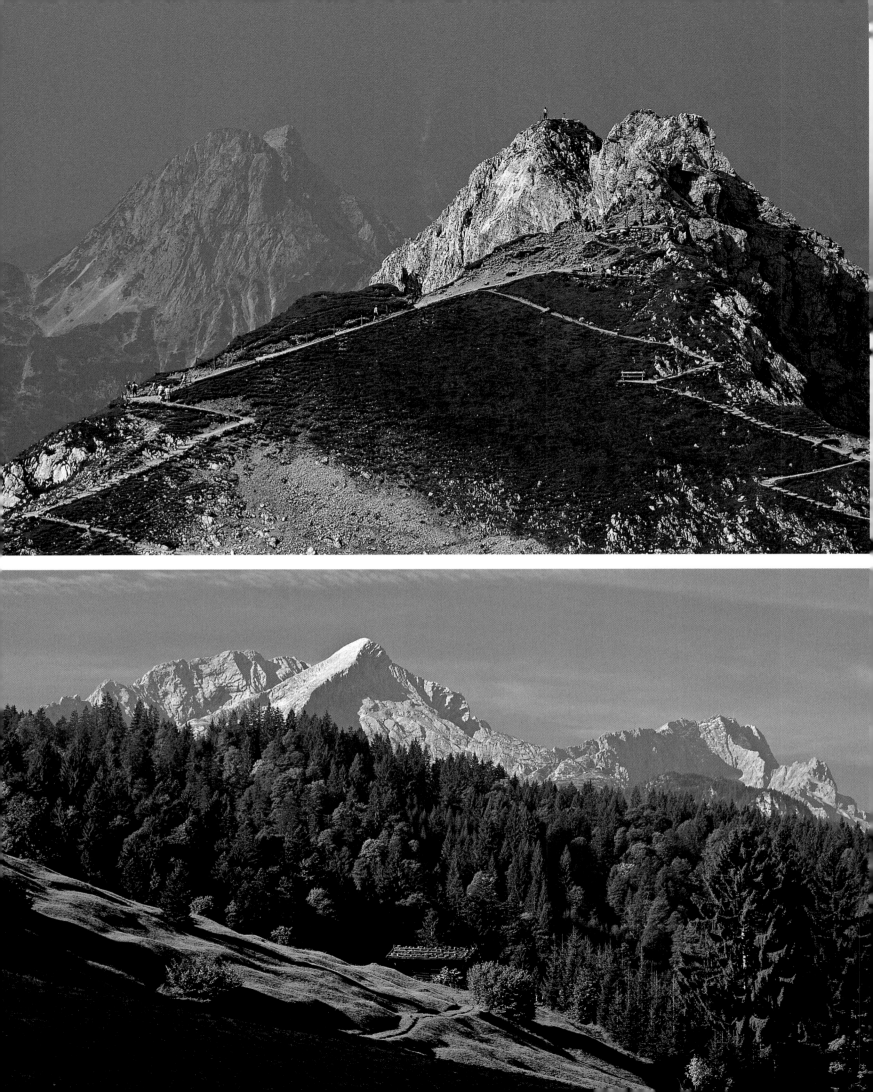

Left:
View of the Nördliche Linderspitze in the Karwendel Mountains which straddle Bavaria and Tyrol in Austria. The four main ridges run west and are of the grey limestone typical for this part of the Alps.

Below:
Not even the hardest stone can withstand erosion by water, as the many romantic gorges in the Bavarian Alps prove, carved out of the rock by wild streams and rivers over millions of years. The photo shows the Seinsbachklamm in the Karwendel Mountains.

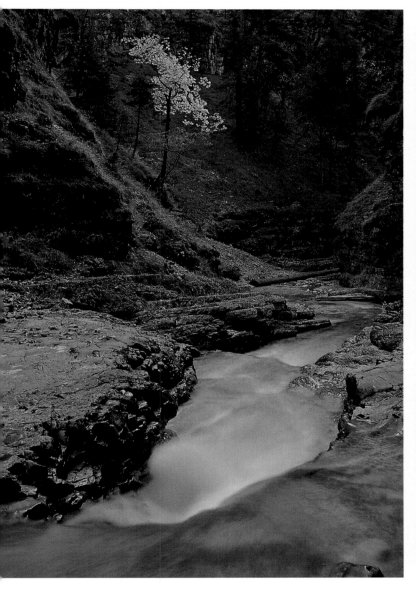

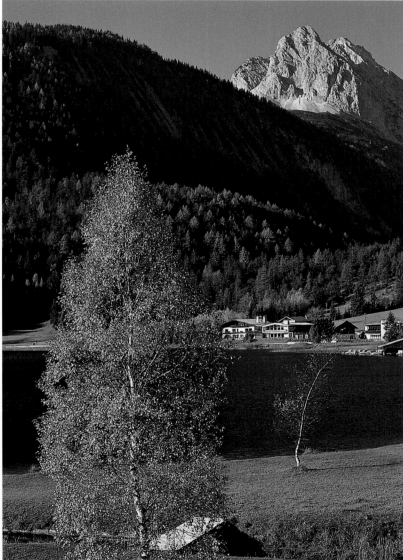

Left:
Looking out from a mountain chalet at Wamberg onto the Zugspitze Massif, Germany's highest mountain, with its twin peaks. In 1851 29 mountaineers dragged a gilt cross up to the top of the western summit; this has since been moved to the neighbouring eastern summit.

Above:
The trail from Mittenwald through the Laintal Gorge, passing through beautiful forest, is particularly scenic. At the end of the hike the Lautersee awaits, a mountain lake over 1,010 metres (3,300 feet) above sea level.

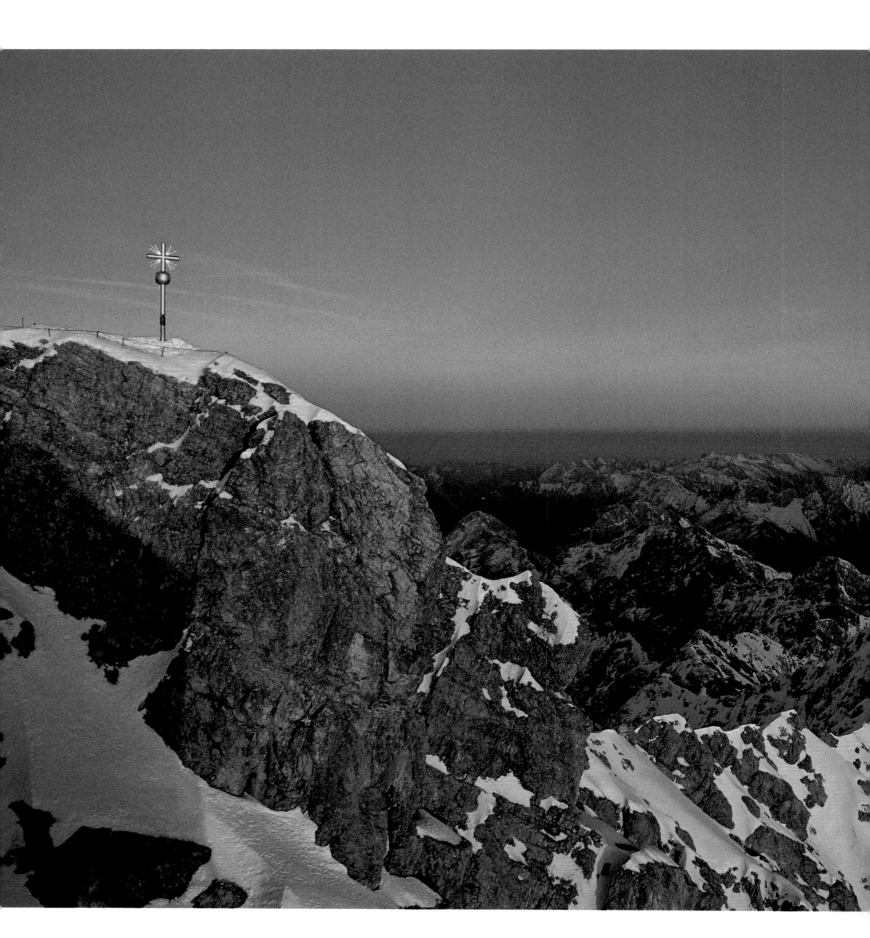

Left:
Looking east from the Zugspitze. If you come up here hoping for some solitude, think again; even in pouring rain, heavy snow and thick cloud the Zugspitze is teeming with tourists. Whatever the weather, there's plenty to do here; the mountain even boasts Germany's highest-lying art gallery.

Below:
The circular walk around the Eibsee affords magnificent views of the Waxensteine. A more unusual perspective is the one from the top of the Zugspitze, with the mountains almost close enough to touch.

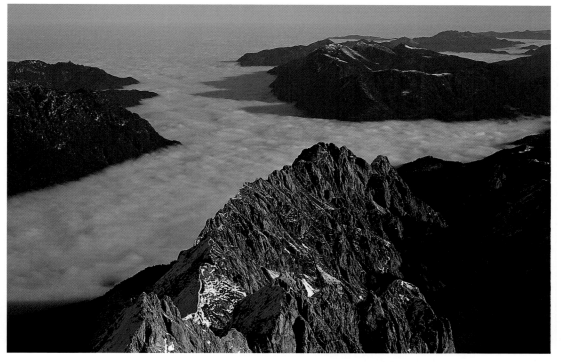

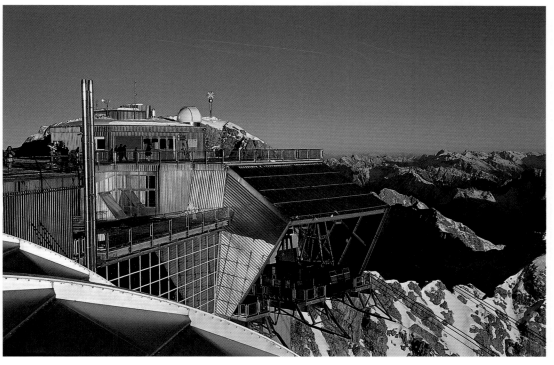

Above:
For over ten years now Zugspitzplatt Station has been linked to the summit of the Zugspitze by a cable car which zooms to the top in just under four minutes. The mountain is otherwise serviced by no less than three railways – heaven for mountain railway buffs...

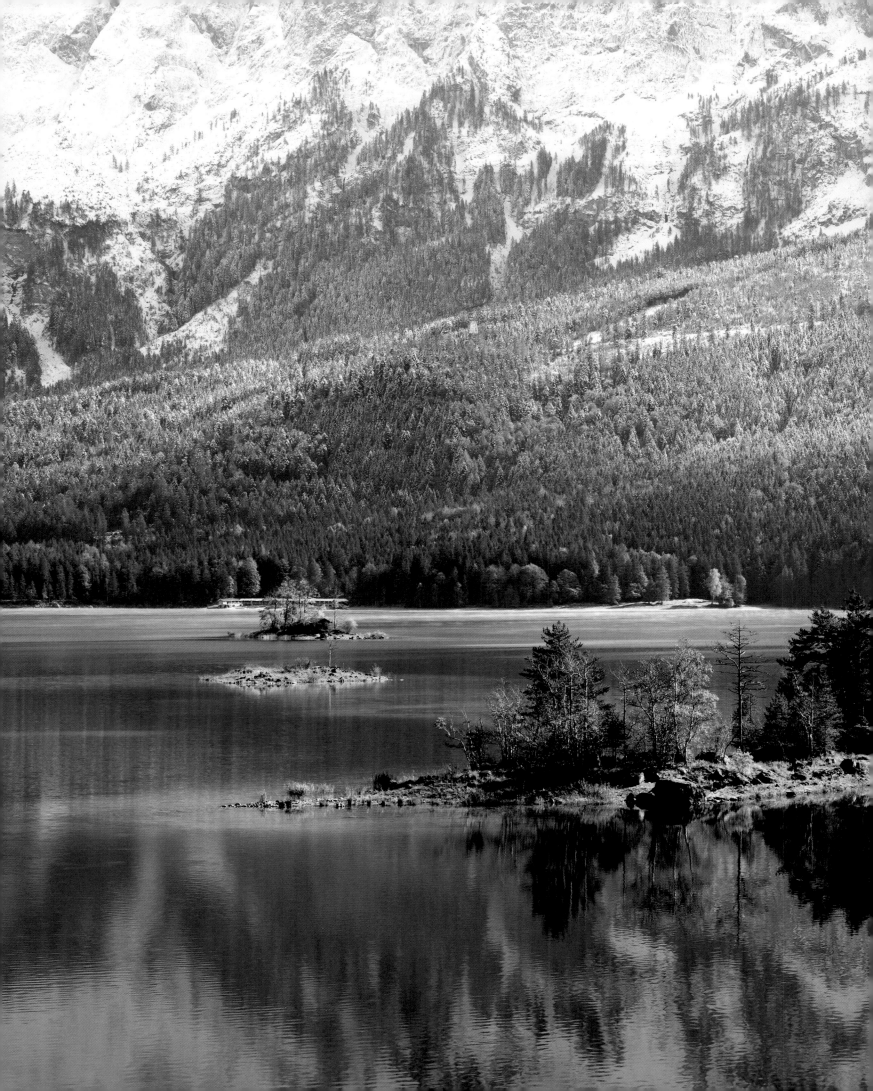

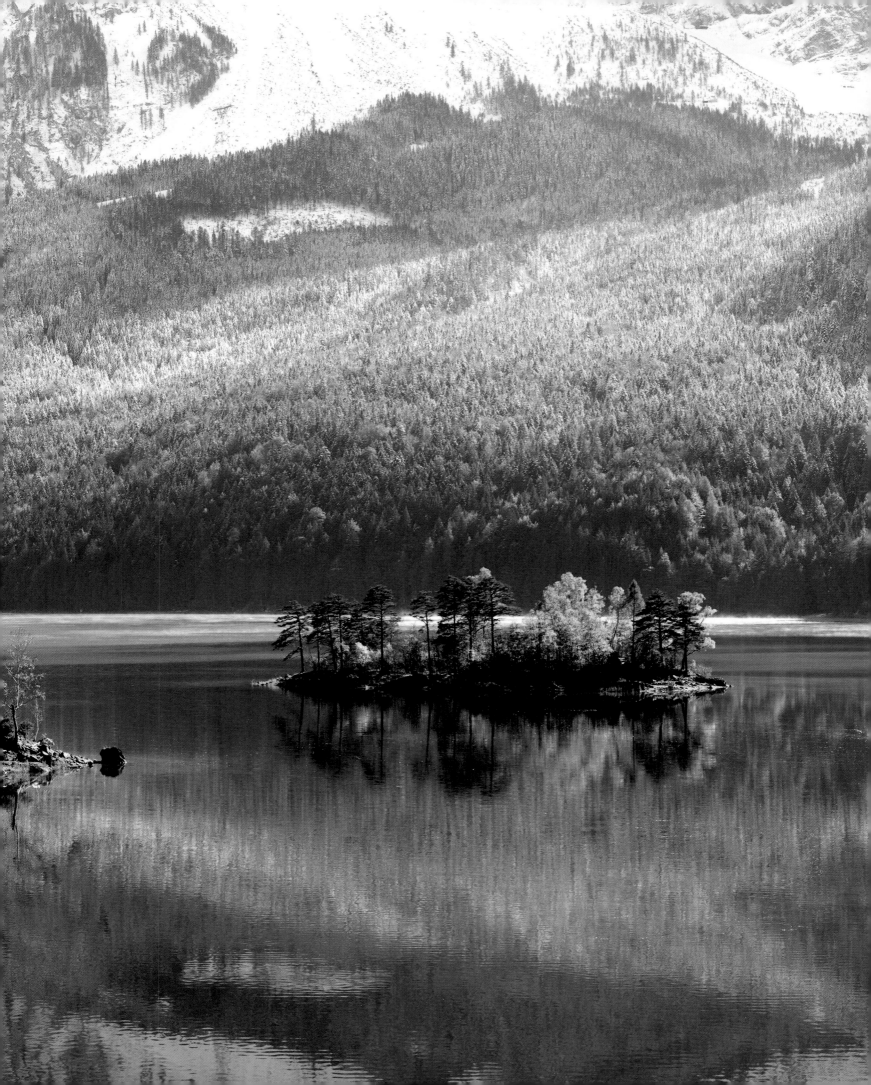

Page 72/73:
View of the Eibsee with its tiny islands. Its scenic setting beneath the Zugspitze and its crystal-clear, green waters make it one of the most beautiful lakes in the Bavarian Alps.

Kuhflucht Waterfalls near Farchant in the Werden-felser Land. The little village is just a few kilometres' walk from Garmisch-Partenkirchen along a beautiful Alpine trail.

It takes just under an hour to walk from Mittenwald through the picturesque Leutaschklamm, the largest Ice Age glacial gorge in the northern Limestone Alps. At the end of the hike the Gletscher-schliff pub provides a welcome respite for thirsty wanderers.

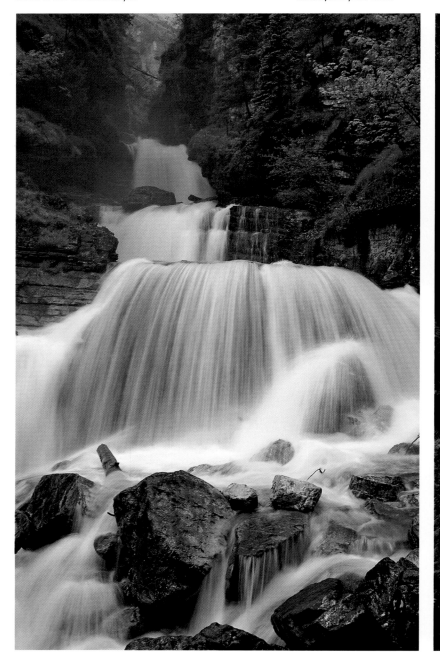

Access to the Höllental Gorge in the Werdenfelser Land is from the village of Hammersbach. The trail up to the mountain chalet at the top zigzags across bridges and through tunnels, passing this spectacular waterfall along the way.

The Partnachklamm is just a kilometre or two from the Olympic stadium at Garmisch-Partenkirchen. A trip to the magnificent gorge is not without its dangers, however; in 1991 part of the rockface came down, blocking passage through the ravine for over a year.

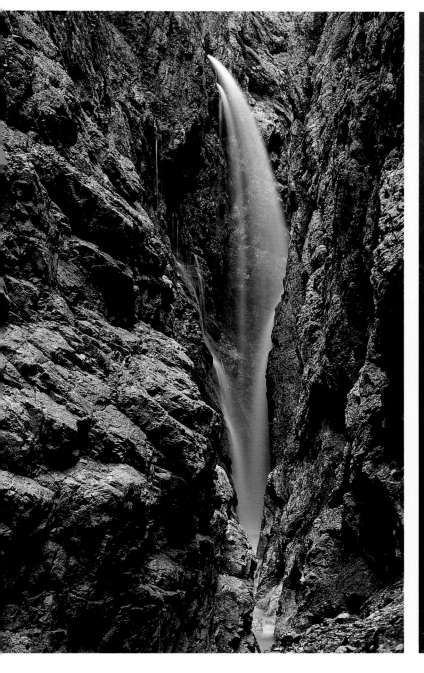

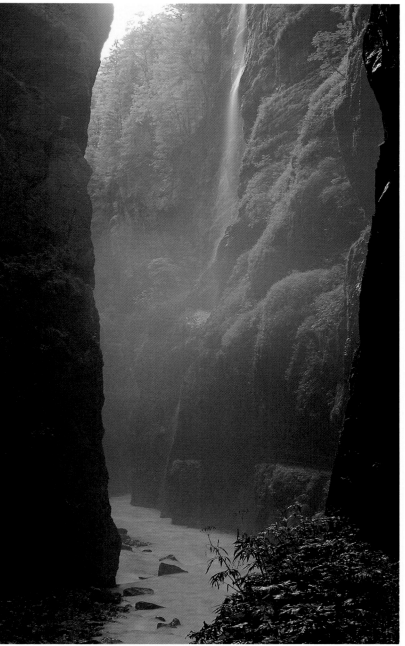

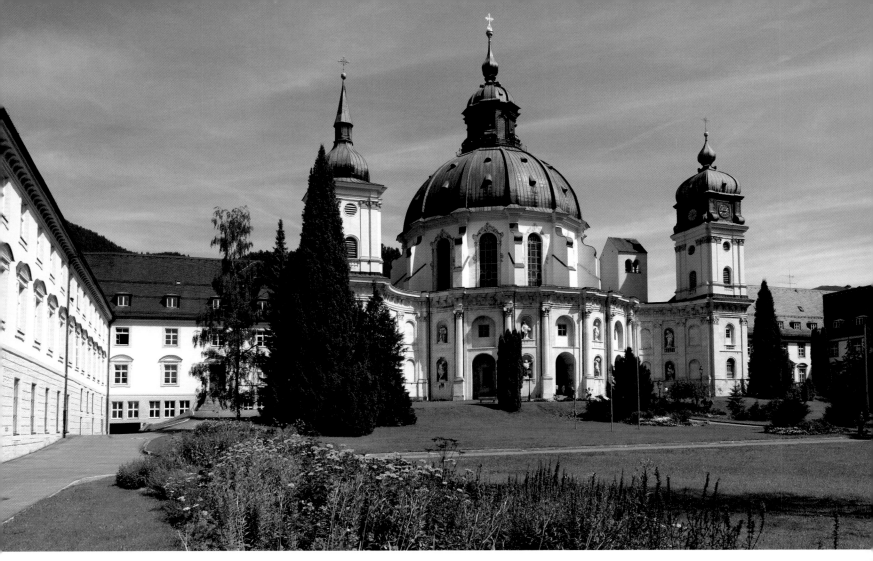

Above:
Ettal Monastery was founded in 1330 as the result of a vow taken by Emperor Ludwig the Bavarian. Refurbished during the baroque period, the abbey was closed in the wake of secularisation in 1803 and some of its buildings destroyed. The Benedictines only returned 100 years later.

Right:
Between 1710 and 1726 Enrico Zuccalli transformed Ettal's Gothic monastic church into a celebration of the baroque with an elegant domed cupola. Following a fire Wessobrunn artist Joseph Schmuzer later gave it its present Rococo guise. The enormous fresco adorning the cupola was painted by Johann Jakob Zeiller in 1746.

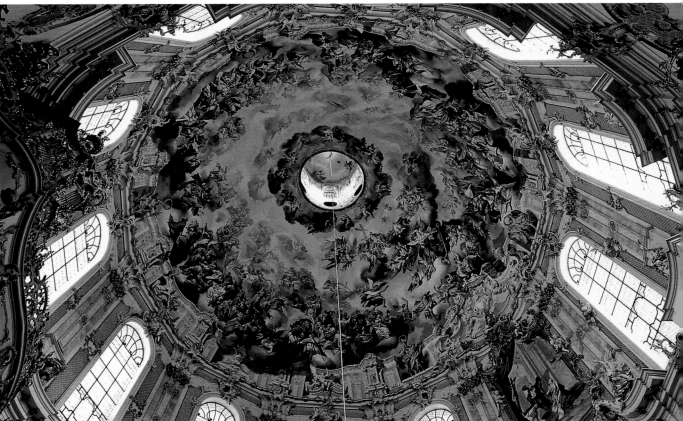

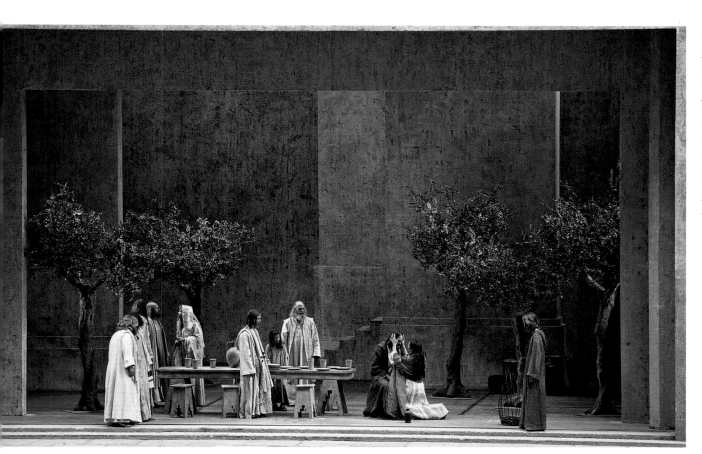

The famous Oberammergau passion plays go back to a vow sworn by the local populace during the plague in 1633. Since 1634 they have been performed every ten years. In 1900 a theatre holding 5,000 was erected for the event on the northern edge of town. This scene from the plays shows Mary Magdalene anointing Jesus Christ.

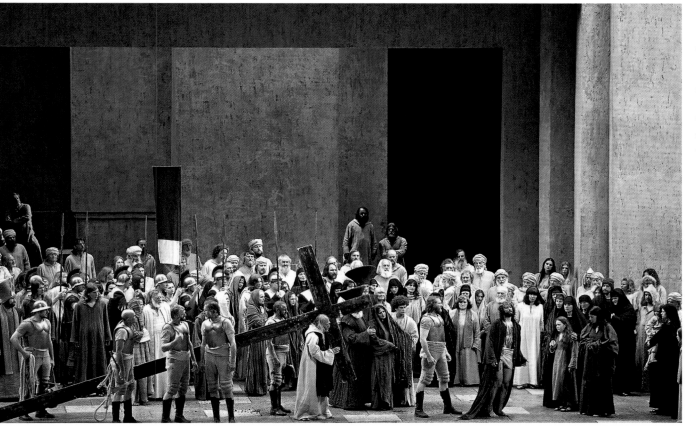

The Way of the Cross. The passion plays are performed by over 1,600 local amateurs, among them 250 children. The season starts in the middle of May and ends in September. A performance lasts around five hours, with one break for lunch.

Page 78/79:
The only building project King Ludwig II saw completed, Linderhof seems more private and subdued than his other fairytale castles. The surrounding park, too, with its Venus Grotto and Oriental Pavilion, is a testimony to the king's personal preoccupation with foreign myths and cultures rather than a public show of royal prestige.

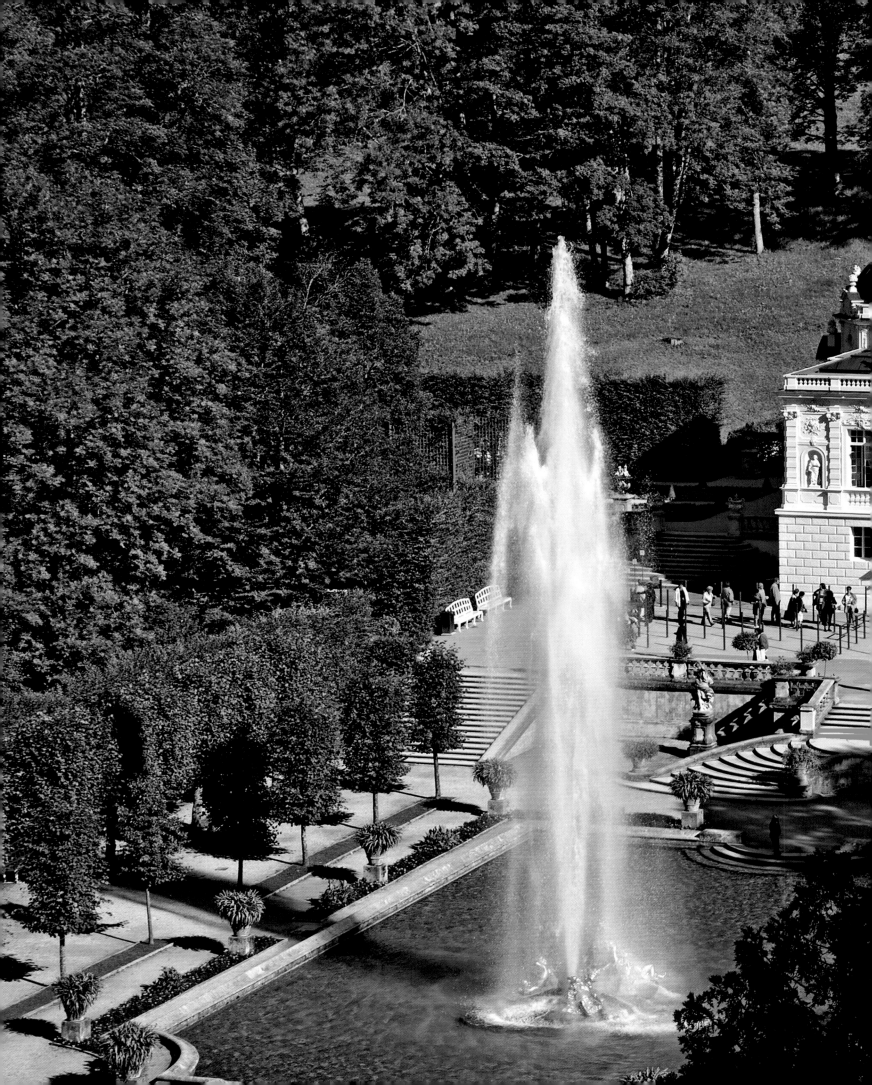

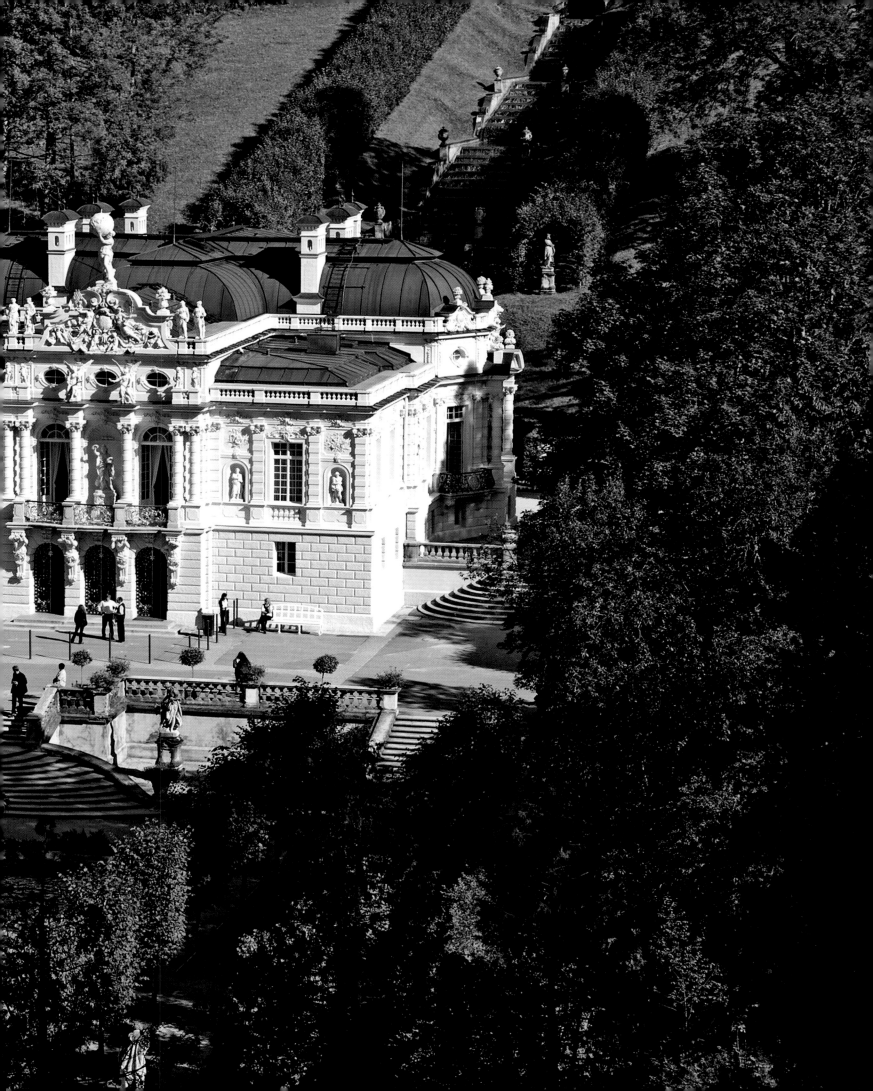

From fairy tale to detective story – the life of Ludwig II

June 11, 1886

The first attempt to arrest the king on the pretext of madness fails. The monarch, however, now appreciates the seriousness of his dilemma, realising the situation is completely hopeless. Going into exile in the Tyrol is as impossible as grabbing the bull by the horns and trying to mobilise his subjects – who still totally adore him – to orchestrate his salvation as Bismarck, ever the tactician, has advised him to do in a telegram. Even now Ludwig remains true to his beliefs, abhorring power games of any kind. "No blood shall be spilled on my account", he decides. He gives up. For, as he writes, "I could cope with them taking my crown but being declared insane will be the end of me". The fairy tale that was his life now becomes a detective story surrounding his death.

June 12, 1886

Declared unfit for government, Ludwig cannot and does not resist the second arrest. He is taken from Schloss Neuschwanstein and imprisoned at Schloss Berg on the Starnberger See. The temple of the muses of his youth, where he once met Richard Wagner on a daily basis, had long been a place of refuge for the king. This is where he spent the war of 1866 which Bavaria was drawn into against his will. This is where in 1870 he had to sign an order to mobilise the troops, sending his loyal subjects marching into France – whose Bourbon heritage so greatly appealed to him – at the side of Prussia who came home victorious. Despite his vivid imagination Ludwig didn't completely lose his grip on reality. One year later Bismarck made him the main player in his battle for supremacy; Ludwig, as chief representative of Germany's princes, was to crown the Prussian king emperor. He refused to be party to the final act of Bismarck's drama and made a point of not attending the coronation ceremony at Versailles, clearly demonstrating what he thought of the entire charade and how sick he was of the role forced upon him by the new supreme power. In 1874 he confessed in a letter to the Russian tsarina Maria Alexandrova that he did "absolutely not agree with the forced design of things in Germany". He then went on to shock his privy council by ordering that they "no longer spoke of politics until His Majesty request they do so". Perhaps now, in his internment at Schloss Berg, these and other past events go through his mind. He is, however, as unable to escape them as he is his prison. His captors have removed the door handles and placed bars on the windows.

June 13, 1886

The weather on Whit Monday is grey and wet. The former ruler's morning walk with his psychiatrist Dr Gudden is followed by a second at ca. 6.30 pm – from which neither ever return. Four hours later they are allegedly found washed up on the shores of the lake. The water at the edge proves, however, to be as shallow as the official stories told about the death of Ludwig II and his doctor. What really happened will forever remain a mystery.

Perhaps this is why the legacy of "Mad King Ludwig of Bavaria" has fascinated us for several generations. His imaginative and prolific architectural opus is certainly still a source of great admiration. After having commissioned the rebuilding of Schloss Hohenschwangau at the beginning of his reign he then had his rooms at the residential palace in Munich refurbished. In 1869, a year after this was finished, he laid the foundations for the magical Schloss Neuschwanstein. At this point Ludwig was already planning his next project – a Bavarian Versailles. Originally this was to be Schloss Linderhof but the king changed his mind; the palatial residence in the Graswangtal was relegated to mere "royal villa". That was in 1879, when work had been in progress at the new Schloss Herrenchiemsee – which was to trump its French model – for over a year. Fate finally put an end to Ludwig's dreams; his untimely demise predated the completion of his various projects. With the exception of Linderhof, Ludwig was never to see his fairytale castles in their finished state.

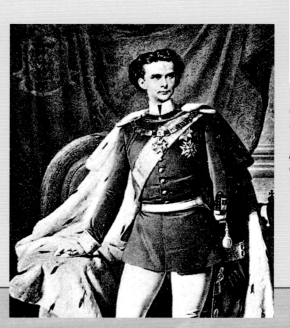

Left:
King Ludwig II, the "inventor" of the Bavarian fairytale castle, on his ascension to the throne in 1864.

Above:
A "new Versailles" was what Ludwig II wanted to create on his lake island of Herrenchiemsee. The foundations of the ambitious project were laid in 1878.

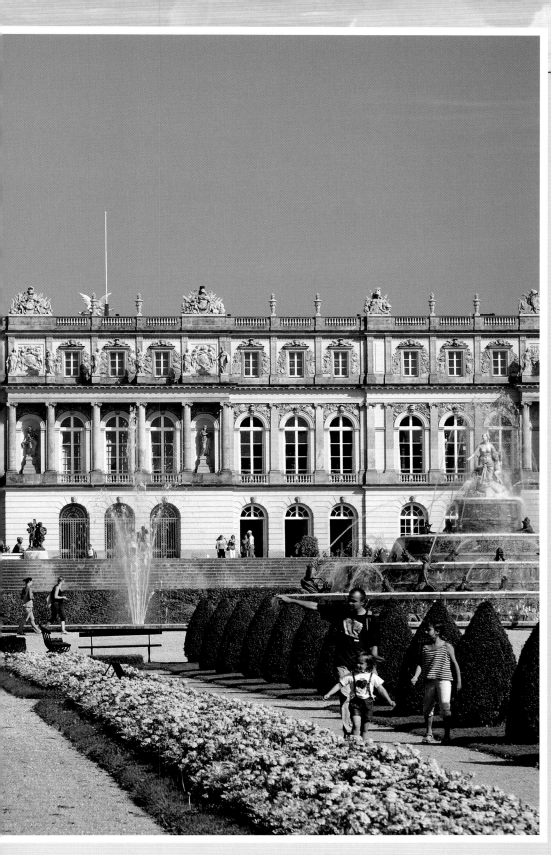

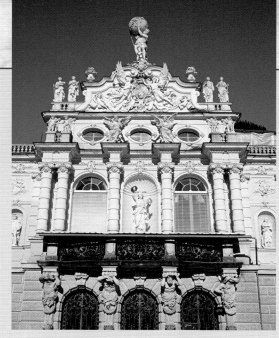

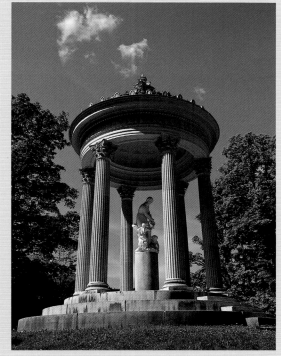

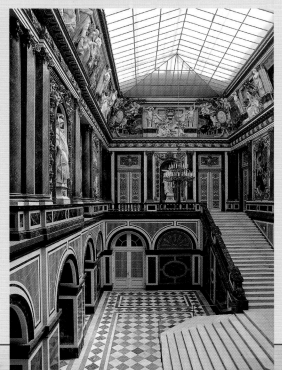

Top right:
Georg Dollmann's brilliant white facade at Schloss Linderhof is a truly impressive sight.

Centre right:
Georg Dollmann, the king's architect, was responsible for the building of Schloss Linderhof, leaving the layout of the park to Karl Effner who designs a number of follies, such as the Venus Temple depicted here.

Right:
The splendid main staircase – together with the Hall of Mirrors and the King's Bedchamber – are among the most popular rooms at Schloss Herrenchiemsee.

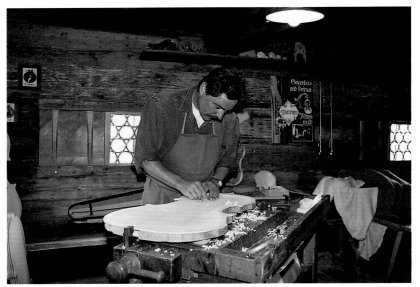

Left:
At one of the historic workshops in Glentleiten violinmaker RW Leonhardt demonstrates just how much time, skill and patience go into making a musical instrument.

Below left:
Not so long ago almost all roofs in Upper Bavaria were decked with traditional wooden shingles. Now too expensive for most to afford, the ancient art of shingle making is gradually dying out. Erwin Porer is one man who continues to practise the craft, here at the Glentleiten Museum.

Below:
Upper Bavaria's open-air museum of Glentleiten high up above the Kochelsee was opened in 1976. New buildings and facilities are constantly being added. One of the museum's biggest assets is its regular presentation of traditional, often long-forgotten crafts.

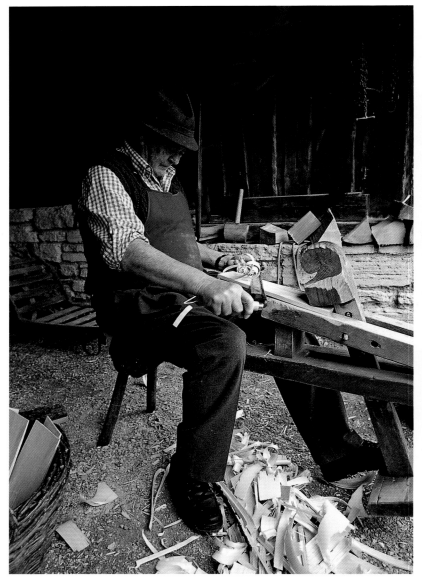

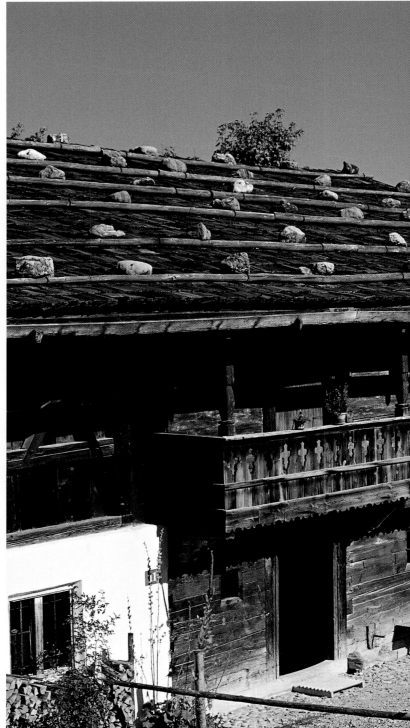

Top right:
The surname Wagner (Carter) is to Germany what Smith is to England; the great number of people with this names illustrates how commonplace these occupations once were. The advent of iron in wagon building has since made the "carter" redundant; at Glentleiten Dominikus Miller is one of the few who continues to ply this ancient trade.

Centre right:
The Upper Bavarian joy of music is legendary. The zither in particular is very popular and still plays an important role in the folk music of the Alps.

Bottom right:
Pottery and stoneware don't just make good ornaments; they have also proved their worth over centuries of use, as a visit to the Glentleiten Museum illustrates.

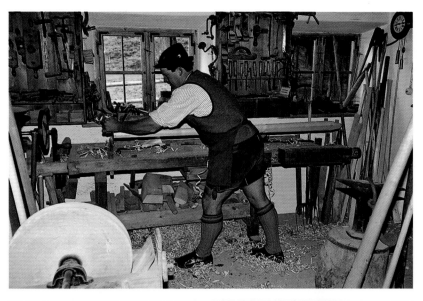

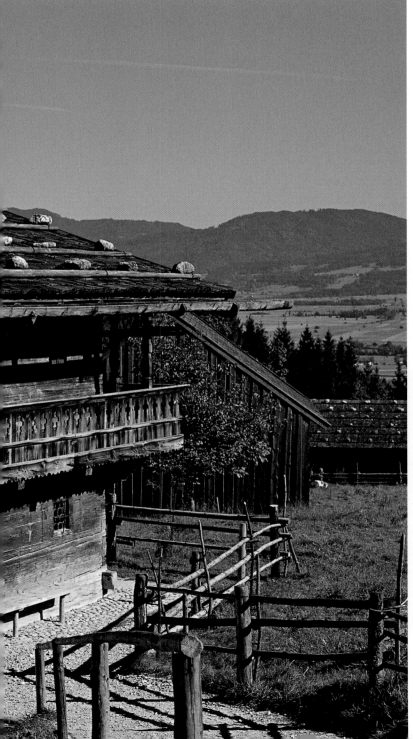

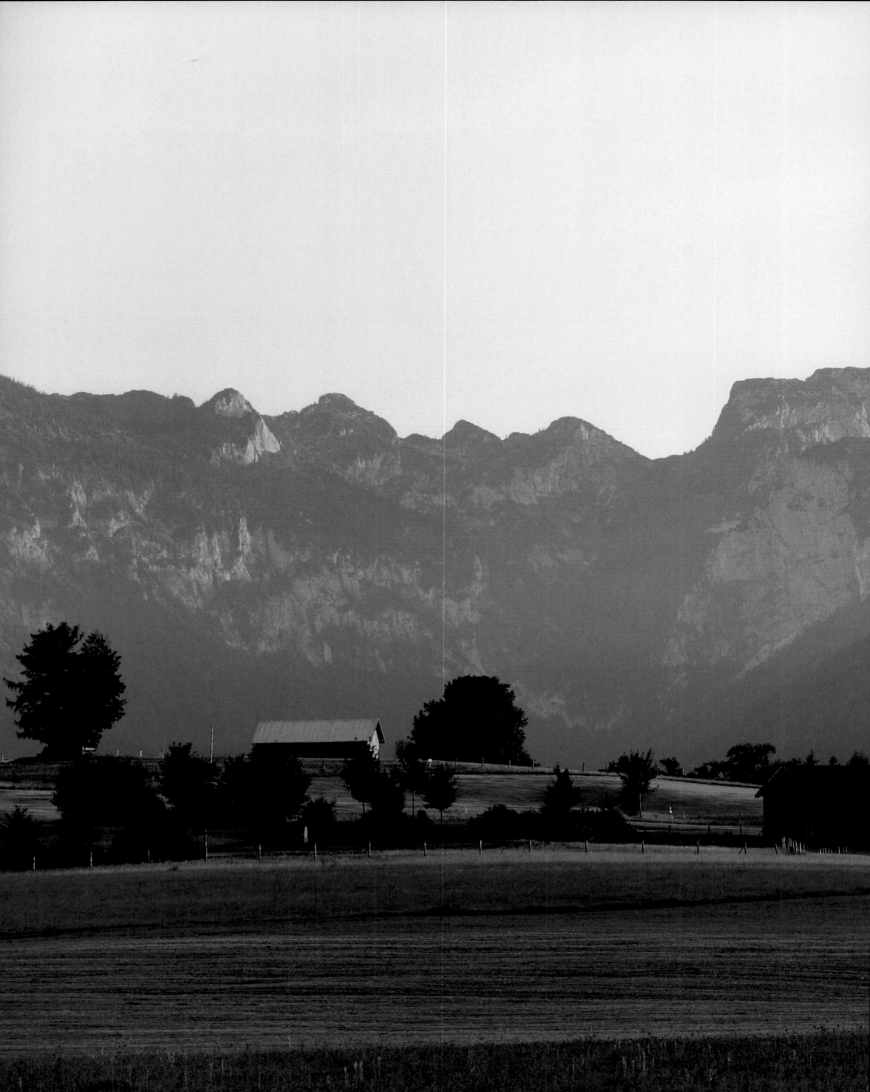

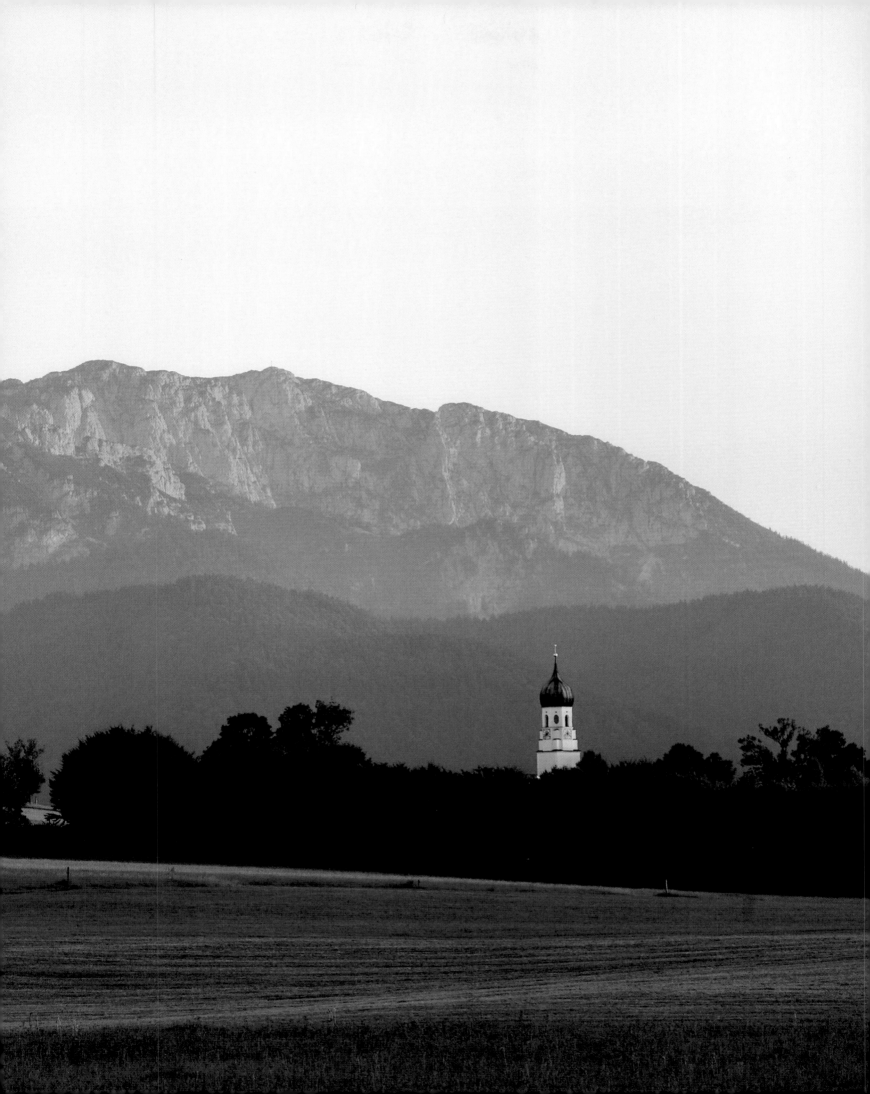

Page 84/85:
The marvellous country-
side of Upper Bavaria is
epitomised here in lush
Alpine pastures, the onion
dome of Gaißach and the
mighty Benediktenwand
beyond, tinged by the
setting sun.

Below:
The serene waters of
the Schwaigsee near
Bad Bayersoien northwest
of Oberammergau.
Ca. 800 metres (2,600 feet)
above sea level, part of
the moorland has been
designated a local
conservation area.

Top right:
Legend has it that Duke
Tassilo III is the founder
of the monastery at
Wessobrunn (753). Only
the clock tower remains of
the original Romanesque
church. The last monastic
and present parish church
of St John's was erected by
the Schmuzer family in 1758.

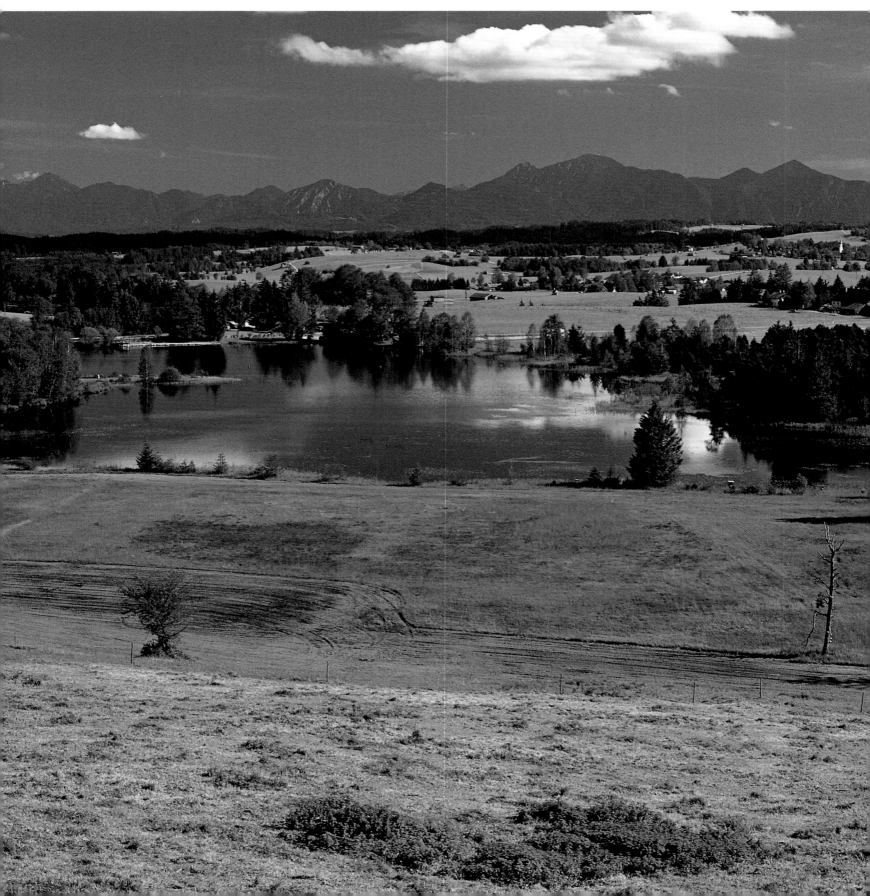

Centre right:
This traditional St Leonard's Day procession, in which about 200 horses take part on November 6 each year, is headed for the church in Murnau-Froschhausen.

Bottom right:
Weilheim at the heart of the Pfaffenwinkel was first mentioned as an "oppidum" (town) in 1238.

The square of Marienplatz is dominated by the parish church of Mariä Himmelfahrt, parts of which date back to the Gothic period.

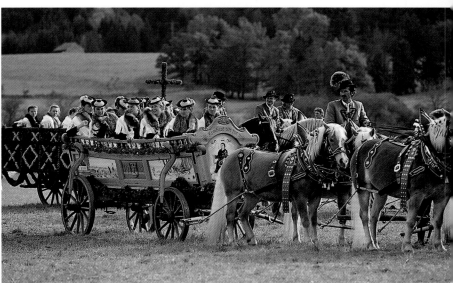

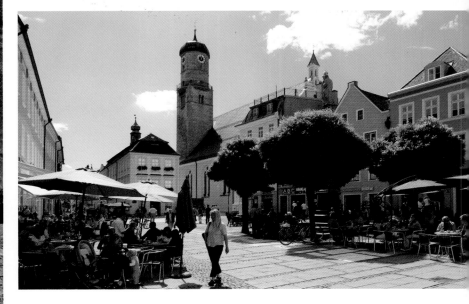

DER BLAUE REITER –
AVANT-GARDE IN THE ALPS

Never before had I seen anyone paint as seriously and tenderly as him. "Zitronenochsen" [Lemon Oxen] and "Feuerbüffel" [Fire Buffalo] are what he named his animals. (...) He transformed tigresses into anemones, leopards were adorned with necklaces of stock. (...) Yet this was all before the war." This sensitive tribute was written by the Jewish poet Else Lasker-Schüler in honour of her friend who died on the battle fields of Verdun in 1916. He was Franz Marc, one of the great pioneers of modern art. Born in Munich in 1880, Marc studied at the city's art academy, travelling to France, Paris and Mount Athos while still a student. In 1910 he changed his artistic direction, starting to paint in colours which no longer echoed the hues of nature but instead corresponded to an imaginative code of his own. He began using shapes and patterns which challenged the eye of the observer, painting in new cubist forms. And he shifted the focus of his output, placing "the fate of the animal" and the "living creature" at the centre of his work. This new, revolutionary way of observing and depicting the world had been preceded by courses in painting and drawing and the intense study of local folk art in the Alpine foothills. Marc completely absorbed the images and colours of his new environment, reaching the conclusion that "art (...) in its essence is at all times most wildly distant from nature".

He was not alone in his convictions. Heinrich Campendonck, Alexey von Jawlensky, Paul Klee, Alfred Kubin, August Macke, Marianne von Werefkin and Gabriele Münter all shared his views. After leaving the Neue Künstlervereinigung (New Artists' Association) in Munich, at the end of 1911/beginning of 1912 the group staged their first joint exhibition. They strove for an art revival which went back to its roots and called themselves Der blaue Reiter (The Blue Rider) after a woodcut by Wassily Kandinsky decorating the cover of a 1912 journal of the same name.

Artists' colony in Murnau

Two of these "wild things from Germany", as Marc called himself and his colleagues, were not only close to him in mind and spirit but – following Marc's move from Ried near Benediktbeuern to Kochel – also in body. Gabriele Münter and Wassily Kandinsky had lived, loved, worked and warred with each other in nearby Murnau on the Staffelsee since 1908. After first setting up home at an Alpine tavern, a year after their arrival painter Münter bought her own house. Soon afterwards Kandinsky's fellow Russians Marianne von Werefkin and Alexey von Jawlensky came to join them, prompting the locals to dub number 6 Kottmüllerallee "the Russian house".

Gabriele Münter lived here more or less permanently until 1962, bequeathing her home to the town in her later years. The Gabriele-Münter-Haus was opened to the public as a museum in the 1980s. The interior, paintings and documents all recapture the spirit of the modern age at one of its very places of origin. Another shrine to the dawn of the 20th century is the neighbouring Franz-Marc-Museum on the southern outskirts of Kochel on the Kochelsee. The villa at number 43 Herzogstandweg houses paintings, graphics and sculptures by Marc and his artistic companions, among them the famous "Die roten Rehe" (Red Deer) and "Die drei Pferde" (Three Horses). Marc lies buried at the local cemetery which both Gabriele Münter and Kandinsky painted several times.

The wheels of fortune – which here go by the name of Lothar-Günther Buchheim – have brought another top collection of art works

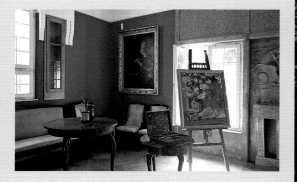

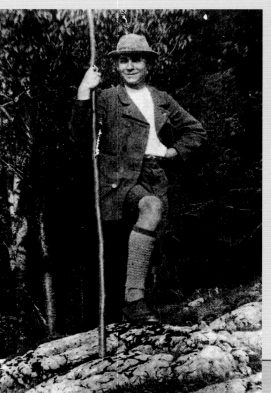

Left:
Franz Marc was a keen hiker, often abandoning his palette and easel for an improvised walking pole.

Far left:
One of the cultural highlights of Itting on the western shores of the Ammersee is the house of artists Anna and Matthias Gasteiger, now used as a museum.

to Upper Bavaria, these by Germany's second major avant-garde group of the 20th century. The artist Buchheim, perhaps most famous for his filmed novel "Das Boot" (The Boat) seen by millions across the world, has set up his easel in the small town of Bernried on the shores of the Starnberger See. The absolute show stoppers of the Buchheim Museum, erected by architect Günther Behnisch of Munich Olympic Stadium fame and opened in 2001, are the inspired artistic messages passed on to us by Die Brücke (The Bridge) from Dresden – creative documents which are well ahead of their time.

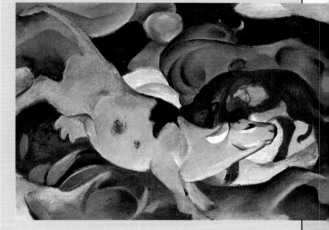

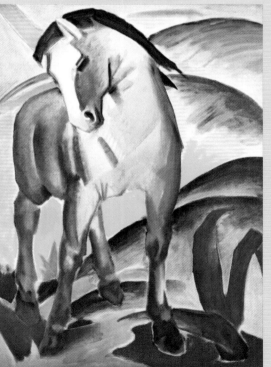

Above:
The Gabriele-Münter-Haus in Murnau, in the artist's possession for almost half a century, has retained much of its original interior and houses a collection of her work.

Above right:
"Kühe – rot, grün, gelb" (Cows – Red, Green, Yellow) was painted in 1912 by Franz Marc, a major pioneer of the German Expressionist movement.

Right:
Animals were artist Franz Marc's favourite motif. The illustration shows the famous "Blaues Pferd" (Blue Horse) painting from 1911.

89

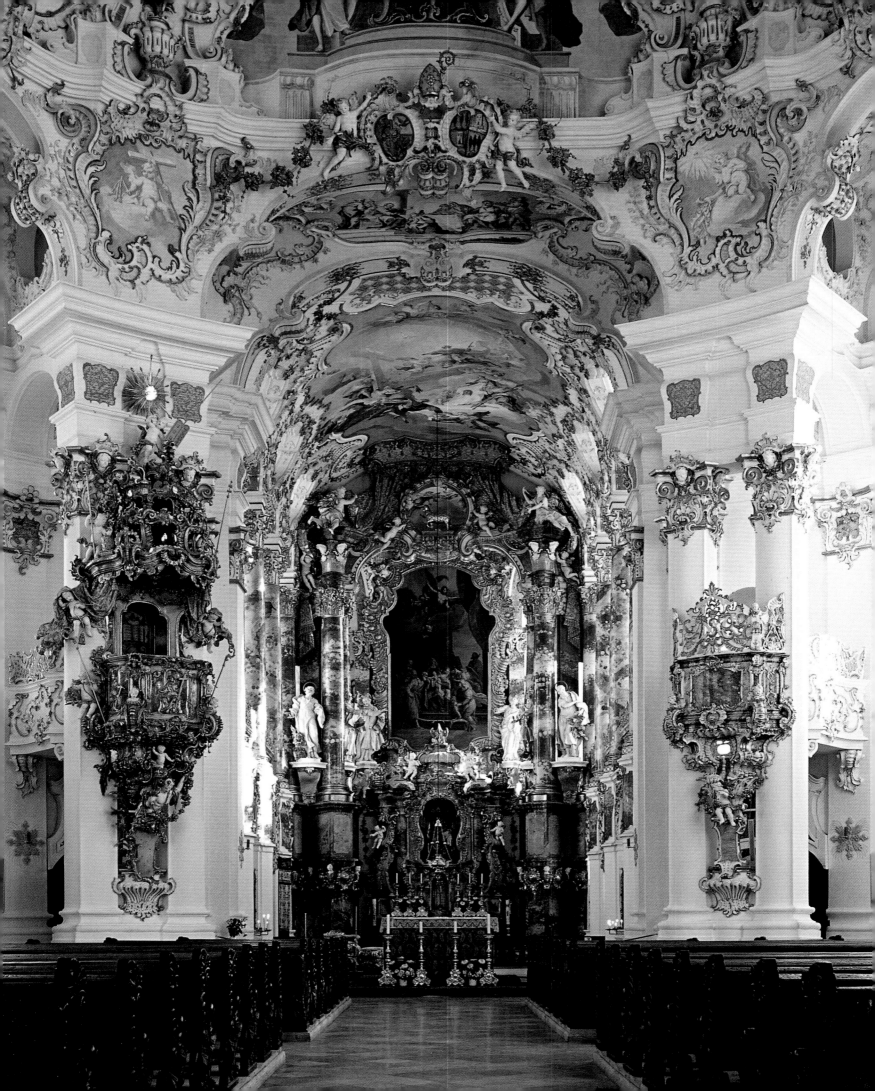

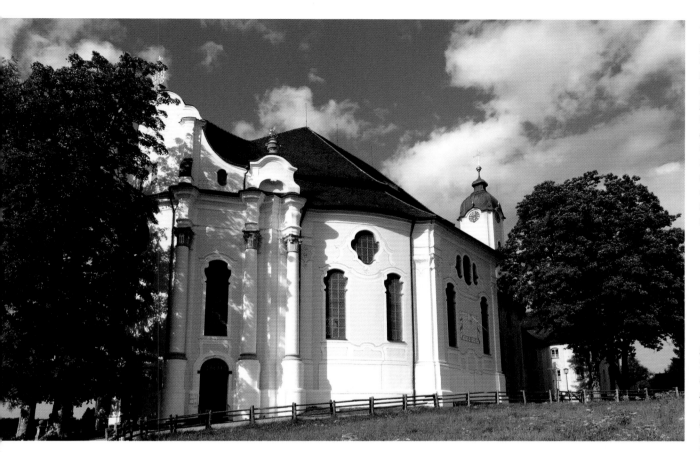

The foundations for the pilgrimage "church in the meadow", as the Wieskirche translates, were laid in 1746. Eight years then passed before brilliant architect Dominikus Zimmermann, his no less adept brother Johann Baptist and various other artists of great skill completed the building commissioned by the abbot of Steingaden Monastery.

Left page:
The Wieskirche is an architectural orgy of stucco, gold leaf, cherubs and frescos, a celebration of the Rococo on an unprecedented scale. The oval interior has an elaborate two-storey loggia, an excessively ornate pulpit and a magnificent painting heralding the miraculous powers of this sacred place.

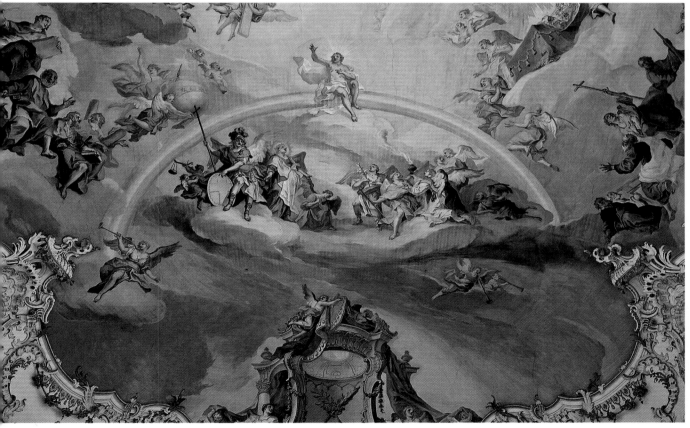

The centre piece of the Wieskirche's ceiling frescos, created by Johann Baptist Zimmermann, is a depiction of the Resurrection of Christ with Jesus astride a rainbow, here interpreted as a symbol of reconciliation.

Right:
Without music a party
just isn't a party in Upper
Bavaria. This band is
playing at the Lechgau
festival in Rottenbuch. In
its scenic setting high up
above the Ammer Valley,
the village is famous for its
carthorse foal market – the
largest in Germany – held
here each autumn.

Below:
The church of St Andrä
in Etting near Polling is
just one of the many
marvellous places of
worship which give the
Pfaffenwinkel or "parson's
place" its name.

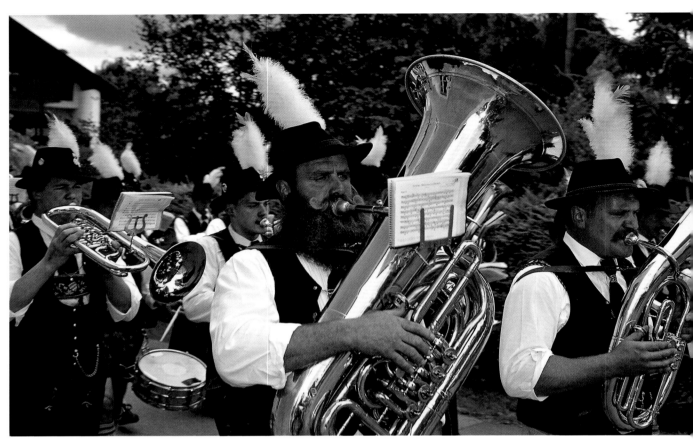

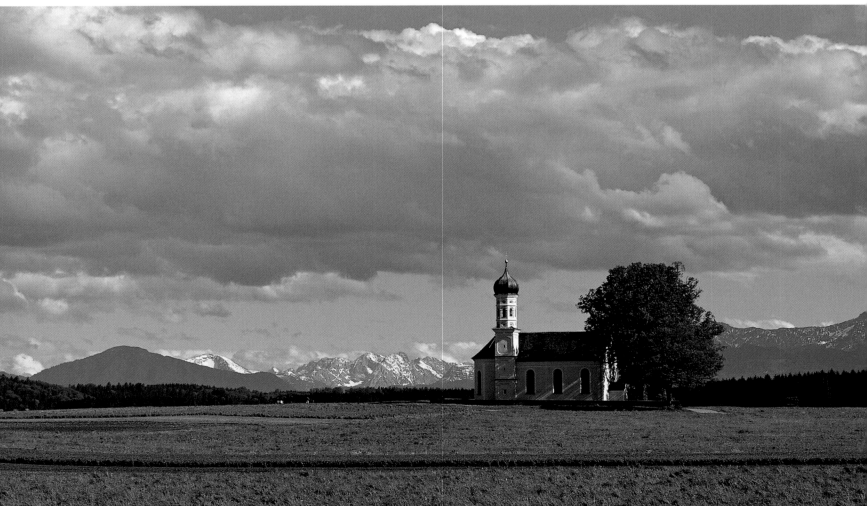

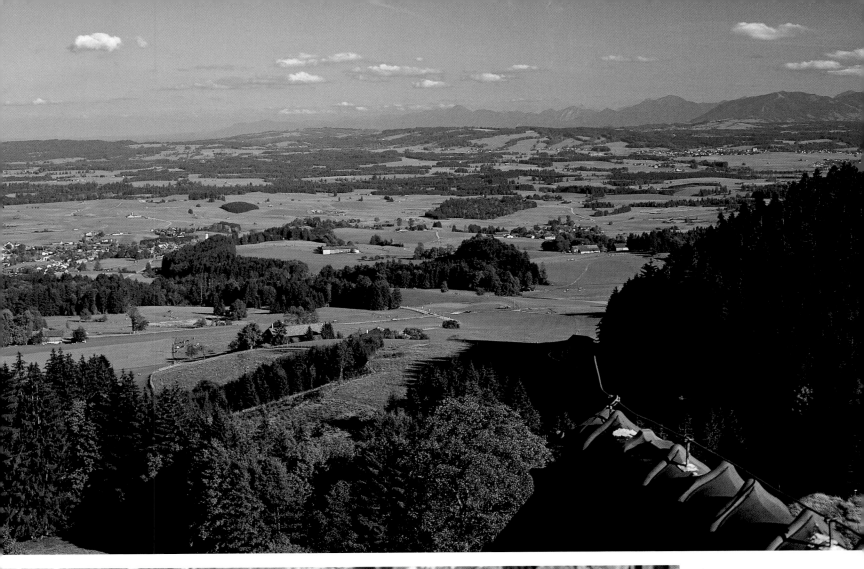

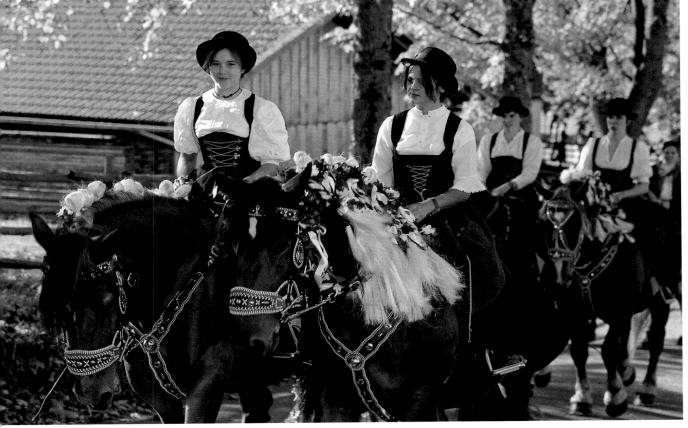

Above:
Looking east from the Auerberg out over the idyllic countryside of Upper Bavaria.

Left:
A procession on horseback in honour of St Leonard, the patron saint of livestock, in Wildsteig in the Pfaffenwinkel.

Below:
Iffeldorf's parish church of St Vitus sports the onion dome typical of Upper Bavaria. Its interior is a riot of colour, a homage to the

Rococo and the stuccoers of the Wessobrunn School, with impressive ceiling frescos painted by Johann Jakob Zeiller in c. 1750.

Top right:
Another typical featur of Upper Bavaria are th crucifixes dotted abou the wayside, such as th

Centre right:
On the Staffelsee
near Murnau, the dark
shadows of the forest
on the water are
disturbed by the wake
of a solitary canoe.

Bottom right:
Time seems to have
stood still at this old farm-
house in Schlitten near
Wessobrunn, its picket
fence softened by a riot of
summer blossom escaping
from the traditional
cottage garden.

one in Burggen in the
Pfaffenwinkel. They are a
testimony to the strong
faith of the people in this
part of Germany.

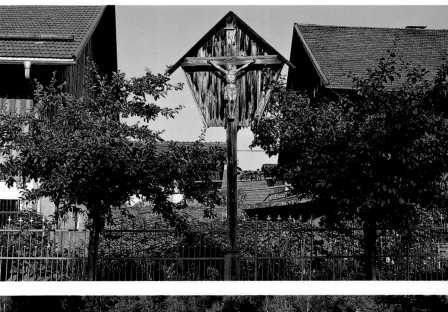

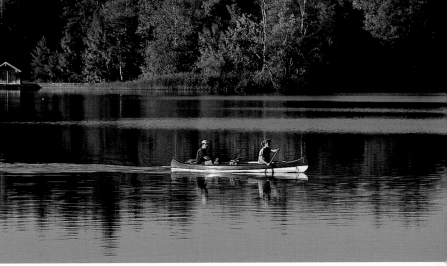

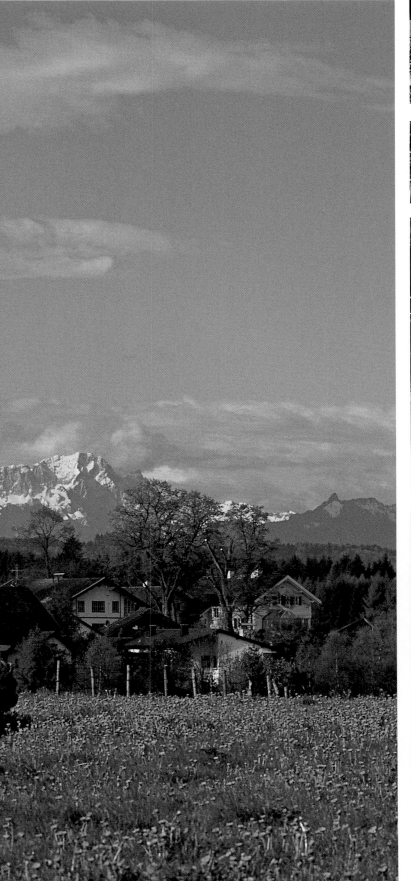

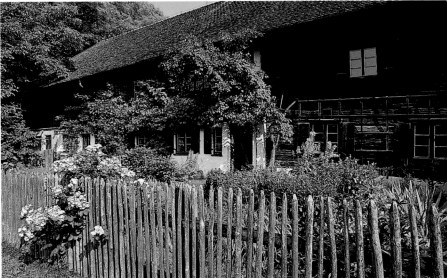

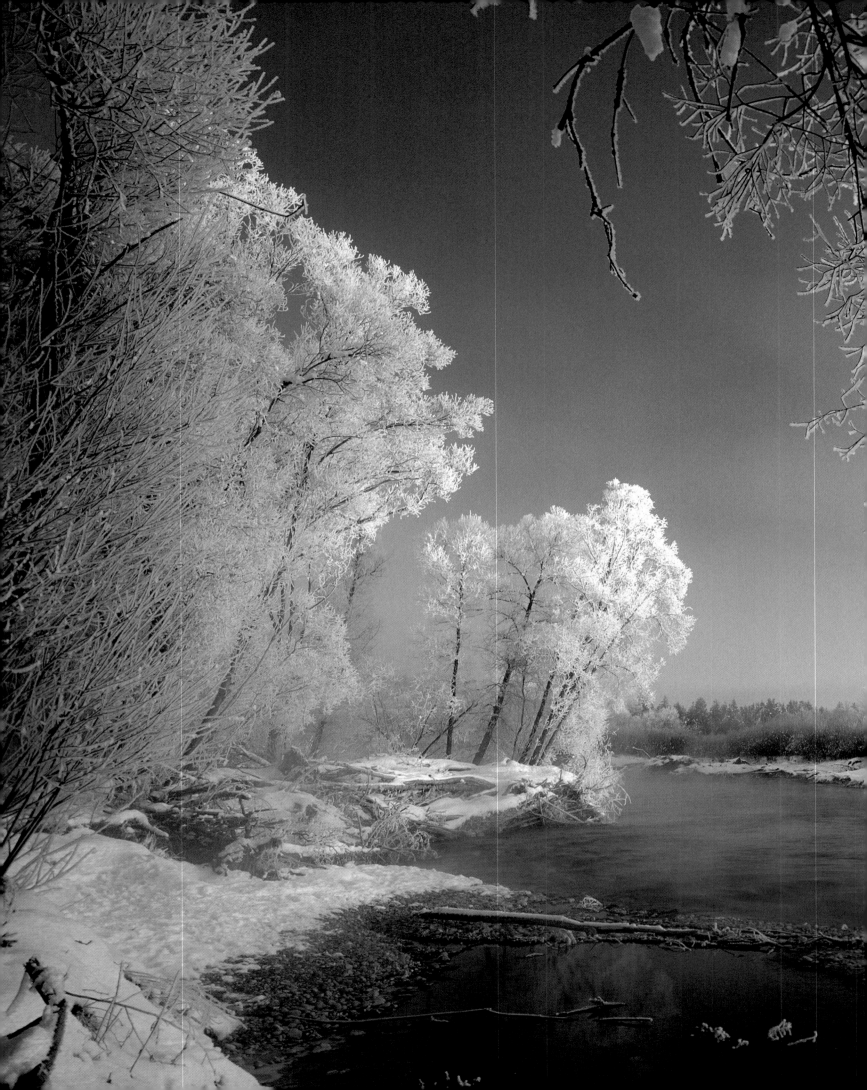

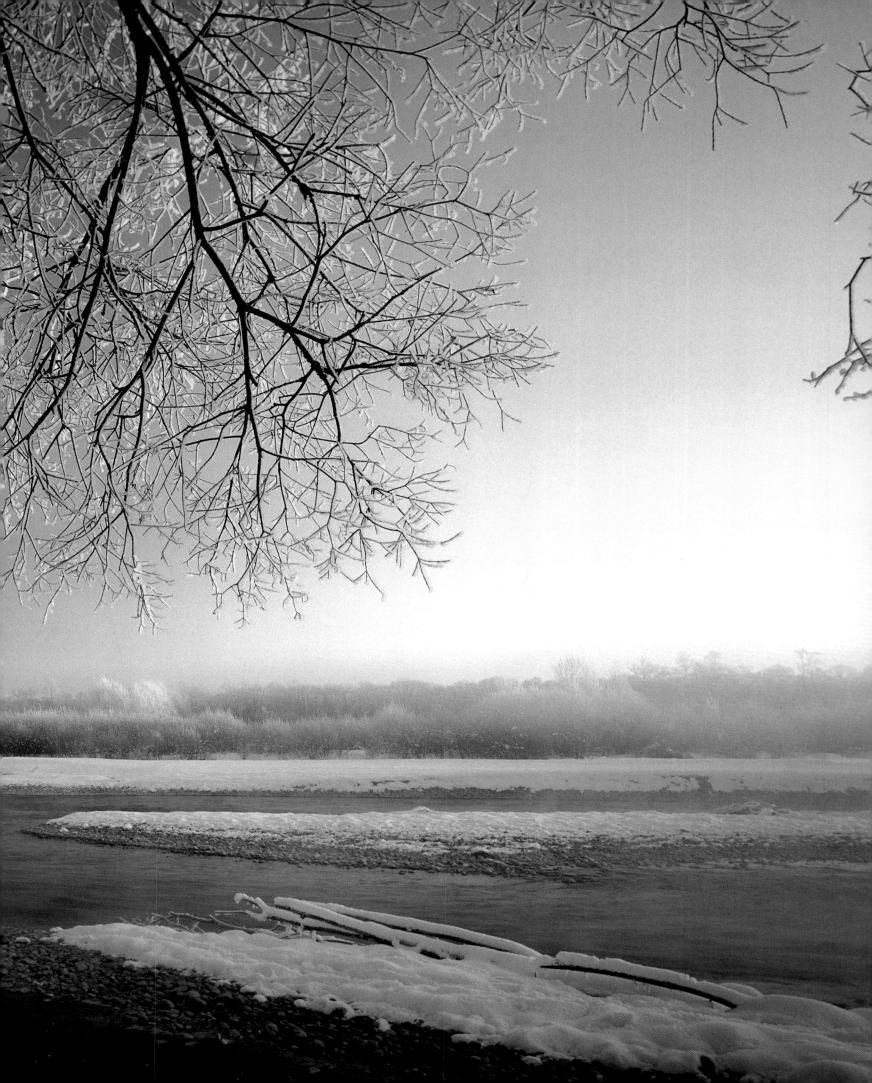

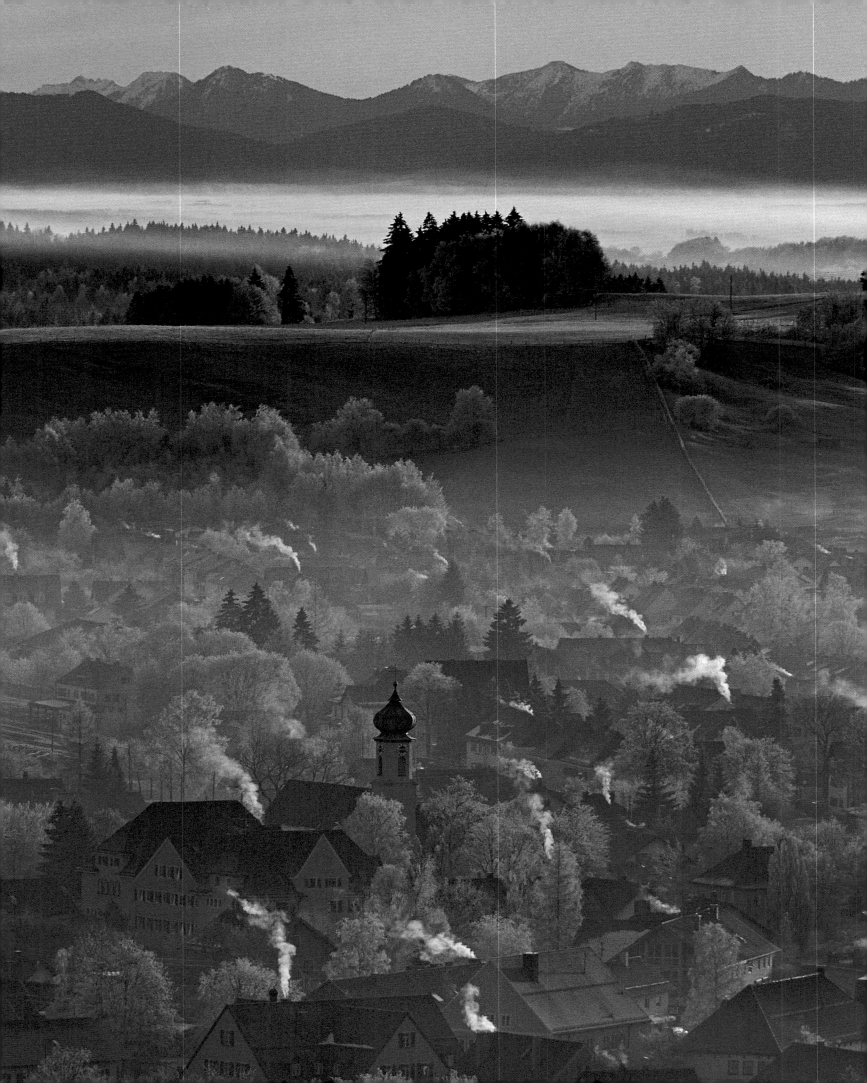

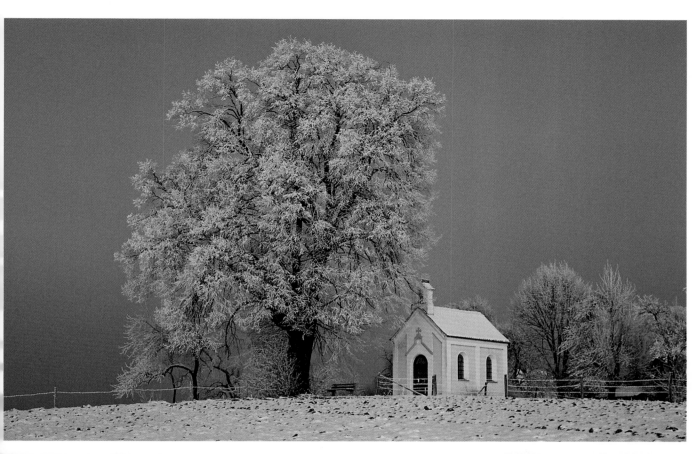

Page 96/97:
The Isar near Geretsried on an icy winter's morning. In summer the river is busy with rafts, canoes and other small river craft.

The first thin covering of snow and a crisp hoarfrost mark the arrival of winter to this tiny chapel outside Aidenried near Pähl.

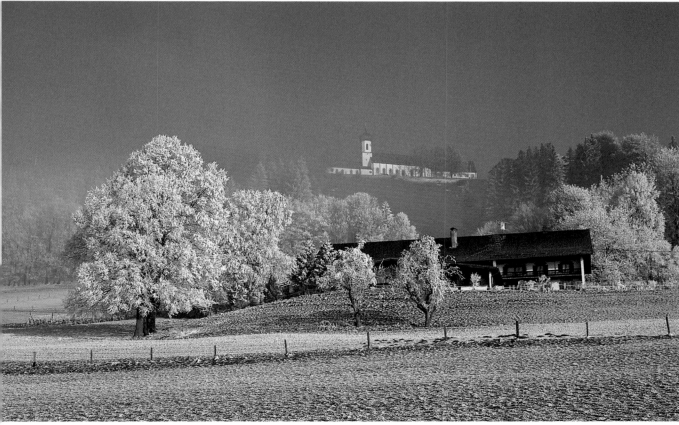

Hoher Peißenberg Mountain in the Pfaffenwinkel is known locally as the Rigi of Bavaria. It has such fantastic panoramic views that despite being much lower than the Wendelstein, Herzogstand and Wallberg it's still one of the most popular viewpoints in the whole of Bavaria.

Left page:
Inverted weather conditions near the health resort of Peiting in the Pfaffenwinkel, a couple of kilometres west of Peißenberg. The pilgrimage church of Maria Egg peaks out from between the trees.

Wendelstein, Chiemgau and Berchtesgadener Land

Although just 1,838 metres (6,030 feet) high, the Wendelstein puts all neighbouring peaks to shame. The classic viewpoint in the Bavarian Alps – even Germany's astronomers and meteorologists have set up shop here – was made accessible to a mixed clientele early on in Upper Bavaria's tourist career. In 1912 a rack railway was installed – Germany's first Alpine railway – which still steadily climbs the mountainside along an impressive structure of galleries, bridges and tunnels.

The Chiemgau to the east forms the south facade of this Alpine edifice. At its heart is the enormous Chiemsee lake whose 82 square kilometres (32 square miles) of water have earned it the title of "Bavarian sea". The two larger of the three islands look back on a long monastic tradition. Herrenchiemsee also enjoyed a brief period of rule by King Ludwig II whose Bavarian Versailles attempted to trump the original.

For many visitors the epitome of Alpine romanticism is the Berchtesgadener Land, with each new corner you turn more breathtakingly sensational than the one before. The church in Ramsau, set against a marvellous mountain backdrop, is undoubtedly one of the highlights of this national park. The absolute pinnacle of Alpine beauty is, however, the Königssee, where the sky, mountains and brilliant waters have created a natural spectacle which is unrivalled anywhere else in Germany.

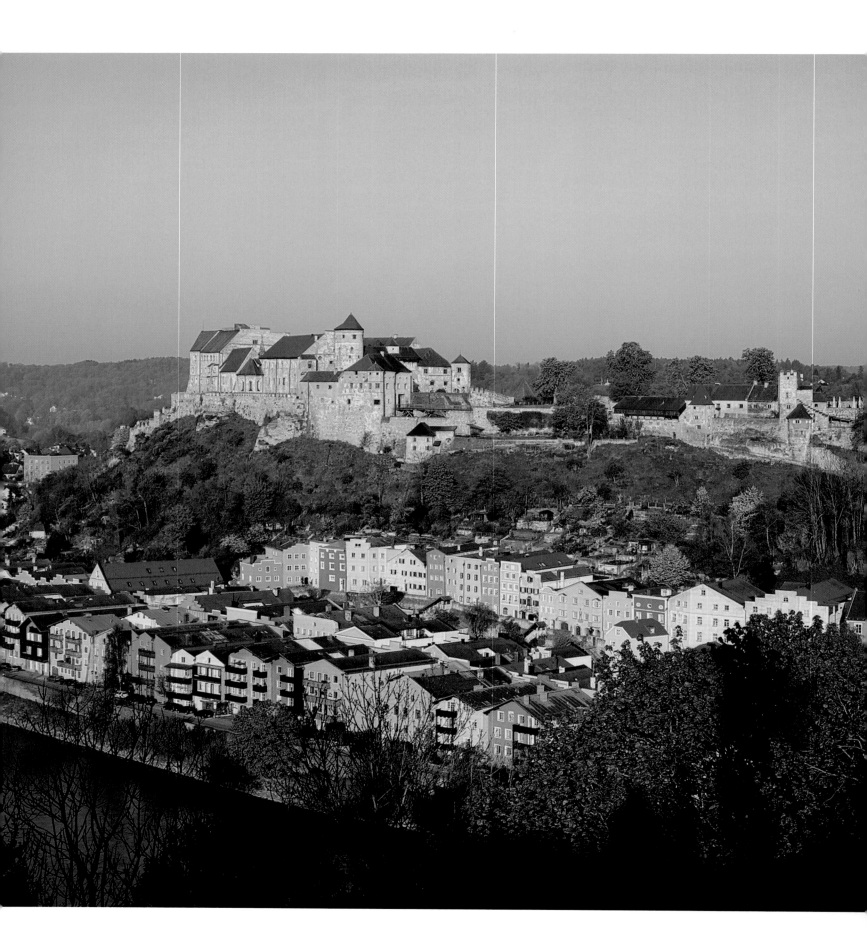

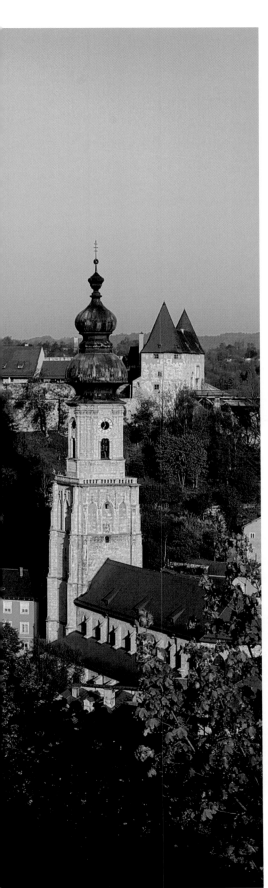

Left:
View out across the River Salzach of Burghausen with the castle up above it, the largest of its kind in Germany. The town, which greatly prospered from the salt trade, was first mentioned in 1025. The seat of the dukes of Bavaria-Landshut from 1255 onwards, between 1505 and 1802 Burghausen was one of Bavaria's four centres of government.

Below:
Mühldorf on the River Inn with Stadtplatz and the Nagelschmiedturm. In 1190 King Henry IV granted the town permission to open a "salt depot" and it soon became an important centre of trade for the salt industry. For centuries the town belonged to Salzburg, only falling to Bavaria in 1802.

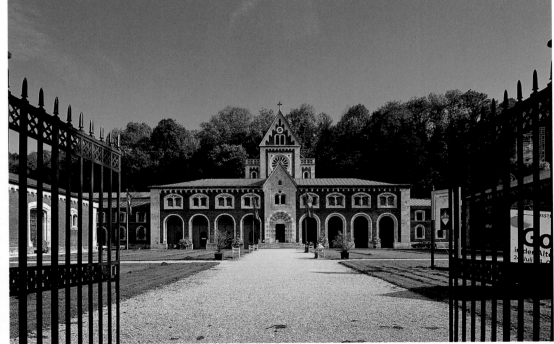

Above:
The graduation works in Bad Reichenhall bear witness to the long tradition the spa has had of salt extraction. The pump rooms are an architectural addition from the 19th century.

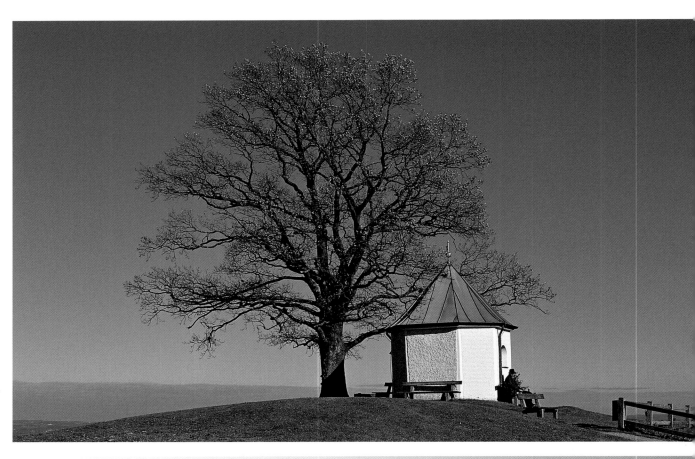

The Luitpold Oak and Aussichtskapelle on Samerberg Mountain near Törwang. As the name suggests, there are marvellous panoramas of the Chiemgau Alps from the minute "viewpoint chapel".

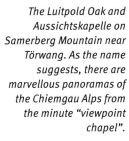

The gentle slopes of the lea of the Inn have been shaped by the course of the river over millions of years, providing an idyllic pastoral setting for the round church of St Peter's in Berg.

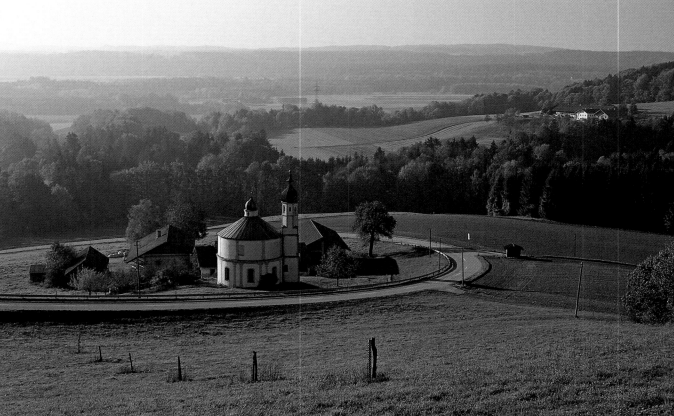

Kapellplatz in Altötting.
The parish church of
St Philip's and St Jacob's
in Altötting is a late
Gothic hall church with a
Romanesque west front.
One of the chapels leading
off from the cloisters
(shown in the foreground)
is named after Commander
Tilly whose descendants
lie buried here.

Pilgrims travelling to
Altötting head straight for
the chapel in the centre of
town with its sacred statue
of the Virgin Mary, said to
have miraculous powers.
The votive tablets hanging
in the nave and the arcade
of the chantry chapel give
thanks for the spiritual
assistance provided by the
Madonna in hours of need.

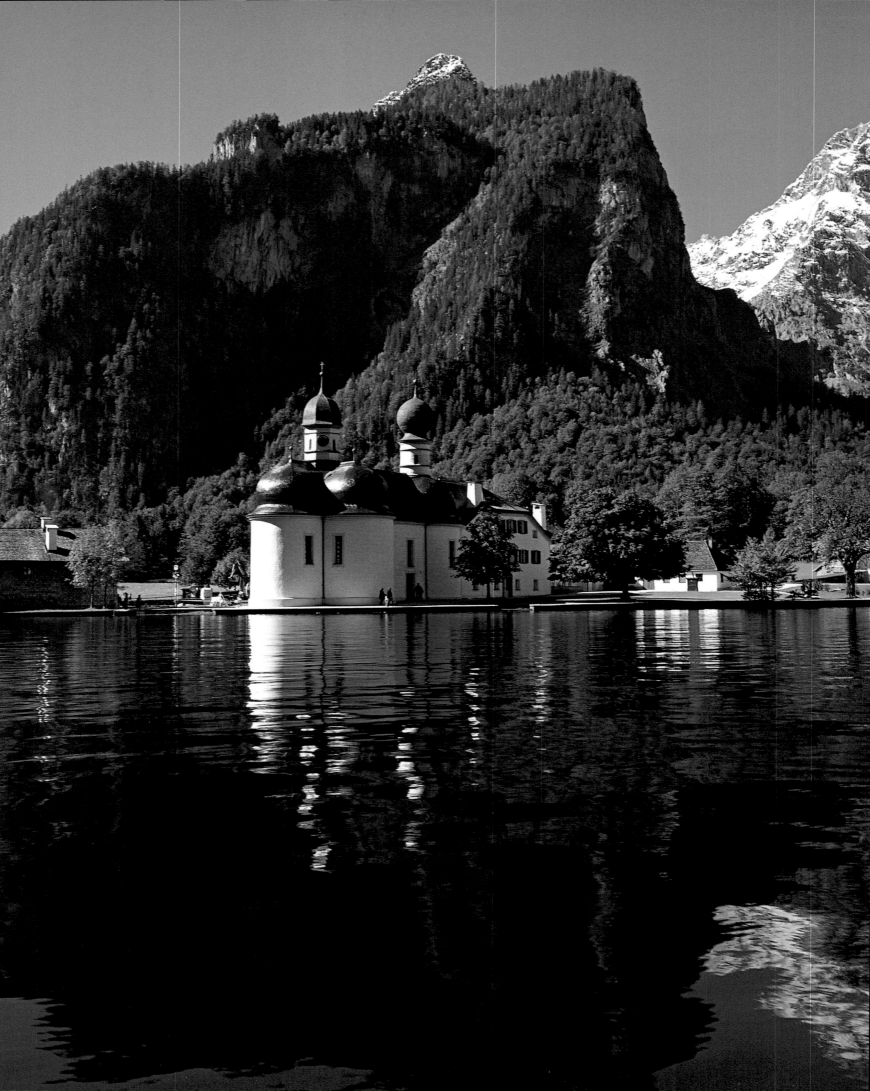

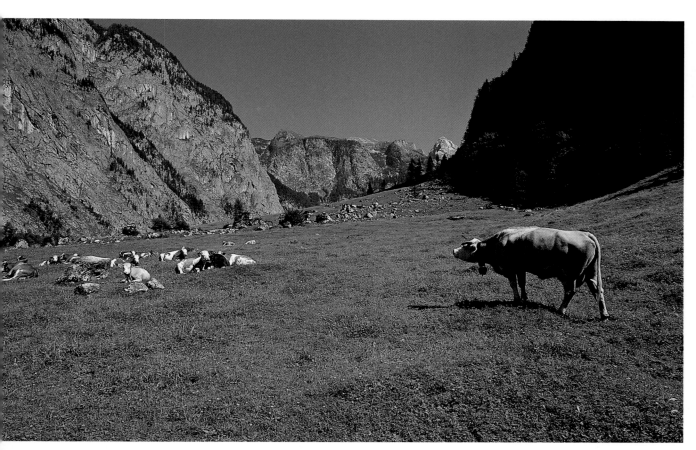

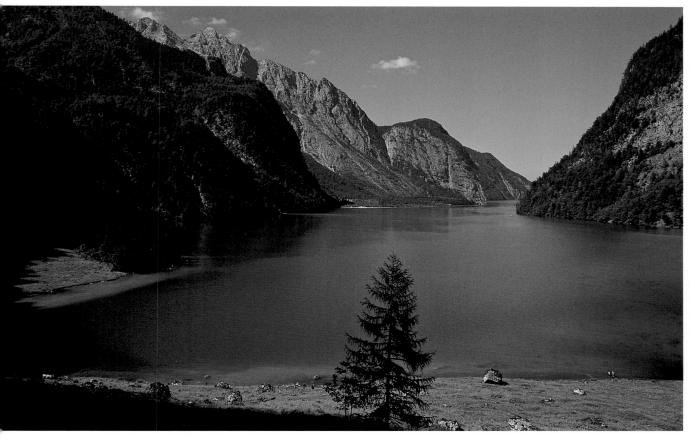

Left page:
One of Upper Bavaria's most famous motifs is the Königssee with the St Bartholomä peninsula and pilgrimage chapel. The nave of the church dates back to the first half of the 12th century; the exterior is baroque.

Sallet-Alm in Berchtesgaden National Park. The original nature conservation area centred on the Königssee alone; the park now covers the entire southernmost tip of the Berchtesgadener Land. Tourists are welcome – as long as they observe the country code and treat these magnificent surroundings with due care and respect.

View of the Königssee and Sallet-Alm. The Alpine meadows look absolutely fantastic in late April and May when they're in flower, smothered in gentians, saxifrage, buttercups, forget-me-nots, geum and poppies.

Page 108/109:
Paragliders at the Predigt-stuhl. Bad Reichenhall's local mountain is about 1,600 metres (5,250 feet) above sea level and is serviced by cable car. From the top you can see the Staufen Mountains, Salzberg and the Untersberg and the Berchtesgaden Alps.

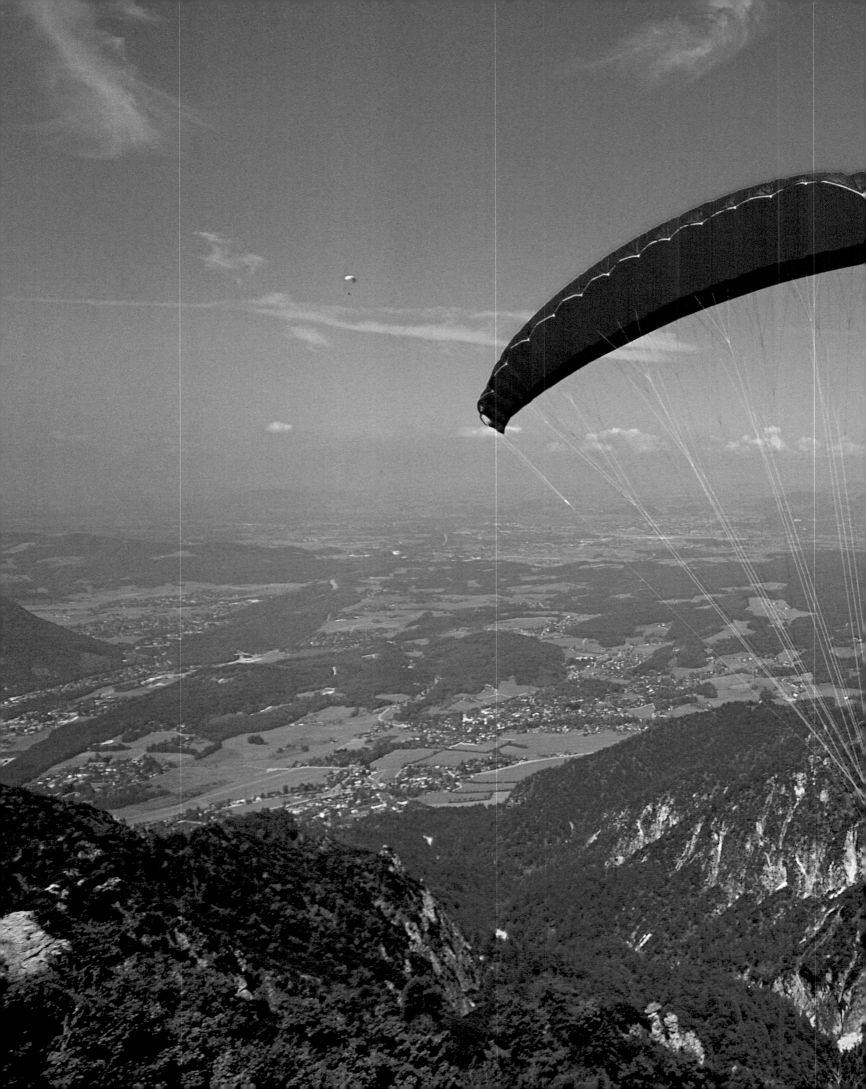

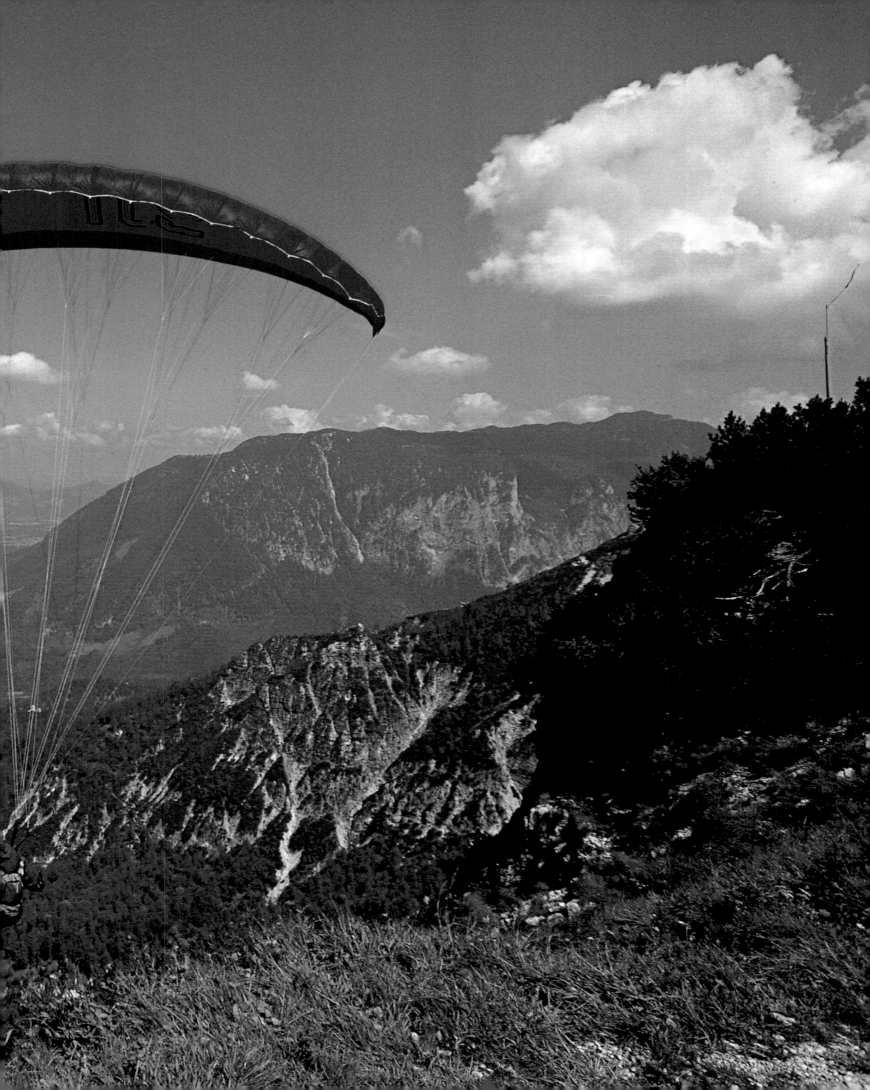

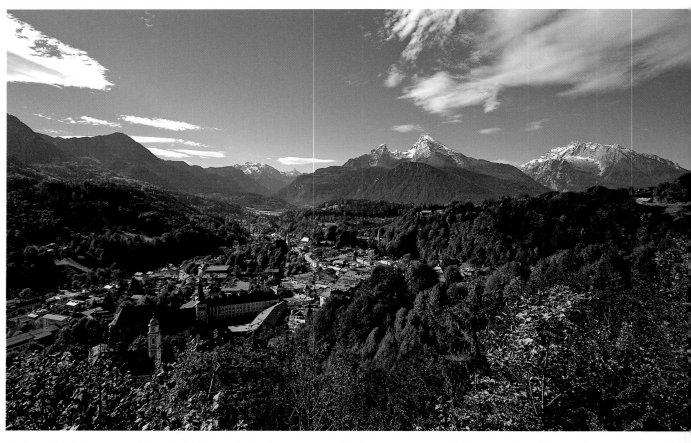

The tiny hamlet of Ettenberg seen from the summit of the Kneifelspitze. The quickest route up to the top of this famous peak – with wonderful views out across Berchtesgaden and the Watzmann – starts at the pilgrimage chapel of Maria Gern.

View from the Lockstein of Berchtesgaden and the Watzmann. The east face of the latter – and much of the rest of it – is a challenge only the most experienced mountaineer should take. Wild and extremely dangerous, there have been plans to "civilise" the Watzmann by installing a cable car up to the summit; luckily these have never been put into practice.

Right page:
The Berchtesgaden National Park information centre is in an old farmhouse in the Klausbachtal. The picturesque lake of Hintersee is a fine place to begin exploring this valley which has panoramic views of the Hochkalter Mountains.

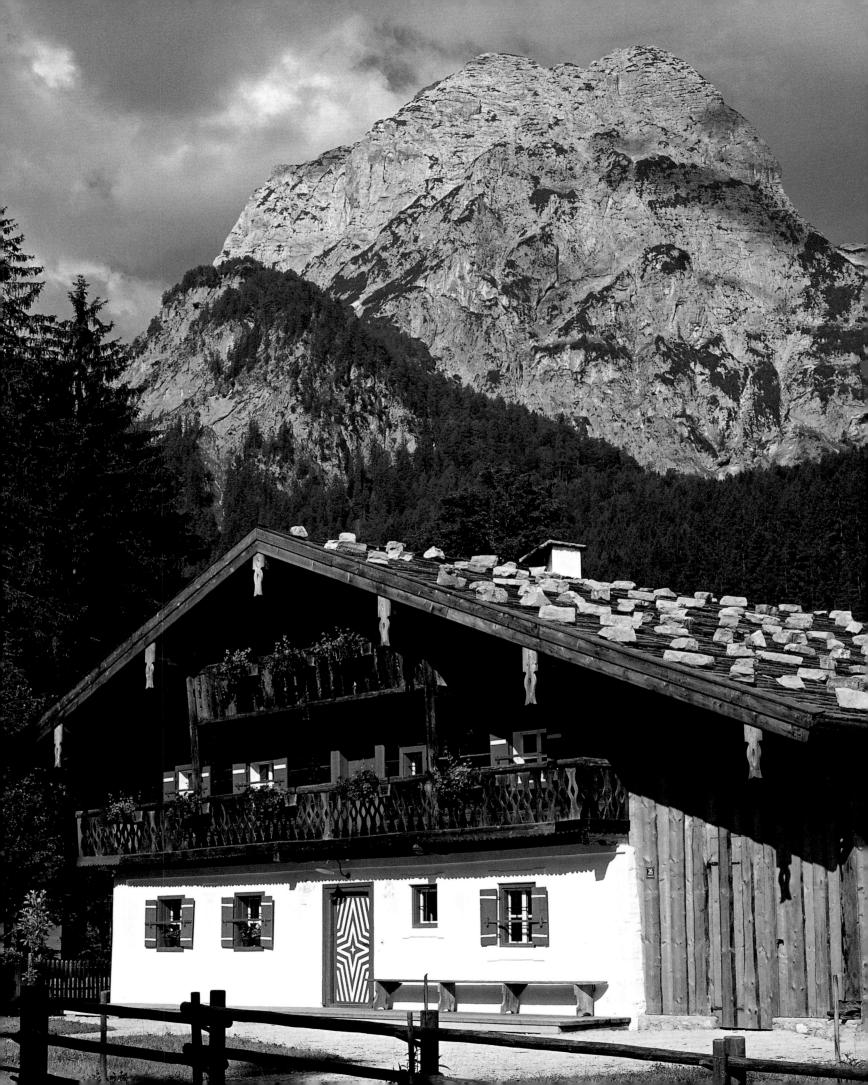

CALENDAR OF EVENTS

Tradition is writ large in Upper Bavaria and local customs are observed with a greater fervour here than anywhere else nationwide. Church festivals play a major part. Rogation processions and pilgrimages – Altötting is the most heavily frequented and Andechs one of the most popular places of pilgrimage in Germany – pay homage to the devout faith of the indigenous population past and present.

The most magnificent of these religious feasts is Corpus Christi. The highlight of the celebration of the Eucharist are the traditional and extremely colourful parades, some of which are staged on water. Now that the legendary Chiemsee lake pilgrimage is no longer held the major crowd-pullers are the Altschliersee fair in August and the grand procession across the Staffelsee. From the shore the many boats decorated with garlands of brilliantly coloured flowers look like floating gardens.

In honour of the extreme importance livestock held – and in part still holds – for the people of this region the patron saints thought to be responsible for the protection of animals are celebrated with particular diligence. On April 23 – or on other days around this date – St George takes to his horse for a ride through the villages, accompanied by a merry throng of followers. The most famous of these gala processions, the *Georgiritt* in Traunstein on Easter Monday, culminates in a wild sword dance. The auxiliary St Leonard is of a much milder temperament than the military St George. Initially elected as the patron saint of the imprisoned and the mentally ill, a few hundred years ago he changed his calling. His main attribute – a chain – was now seen to offer guidance not to humans but to animals. There are parades in his honour (known as Leonhardiritte) in Murnau, Benediktbeuern and Kirchweidach in the Rupertiwinkel, among other places. The main venue is, however, Bad Tölz, where on November 6 proud riders and horses in their festival attire trot through the streets alongside an impressive entourage of traditionally painted carts and wagons. Other events in a similar vein are the St Ulrich's procession in Steingaden on the first Sunday after July 4 and the Stephani-Ritt in Tutzing on December 26 in the middle of the winter.

Of beaters and Buttmandln

Winter sees a number of other Upper Bavarian traditions. On the first three Thursdays in Advent "beaters" roamed the streets (and in some villages still do), driving away the evils of darkness in return for some small reward. The Feast of St Nicholas in the Berchtesgadener Land is commemorated by demonic "Buttmandeln" in their frighteningly grotesque masks. Winter weather – in other words: snow – is also what the fools of Fasching hope for when they congregate on the Sunday before Shrove Tuesday on the slopes above the Spitzingsee for their annual mad ski race. The more imagination put into the design of the costume and mode of transport, the better; the smoothness of the ride is secondary, much to the enjoyment of the spectators. In true "It's a Knockout" style, the sillier and more accident-prone the descent, the greater the fun.

Although Munich's Mardi Gras revelries are also a spectacle not to be ashamed of, one of its major highlights sadly only takes place every seven years. The famous Schäfflertanz dates back to the end of the bubonic plague 500 years ago when local shepherds were the first of the guildsmen to again frequent the streets of Munich, heralding their return with a now famous dance. The Oberammergau passion plays which are performed every 10 years from mid-May to the end of September are based on a similar event, going back to a vow sworn during the plague in 1633.

More medieval fiction than historical fact, the costume dramas enacted each year at Kiefersfelden have been immensely popular for generations. The oldest pageant in Germany has its origins in the year 1618. Ancient the tradition may be; its themes of joy and sorrow, love and death, presented with typical Alpine candour and great sentiment, prove as popular now as they were then and go a long way to explaining the huge success of amateur folk theatre in the mountains and lakes of Upper Bavaria.

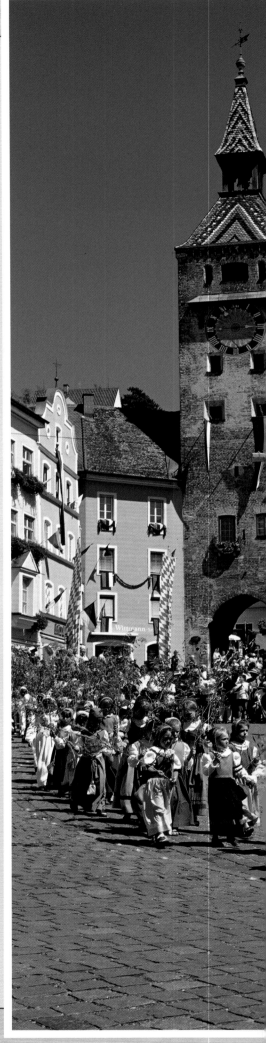

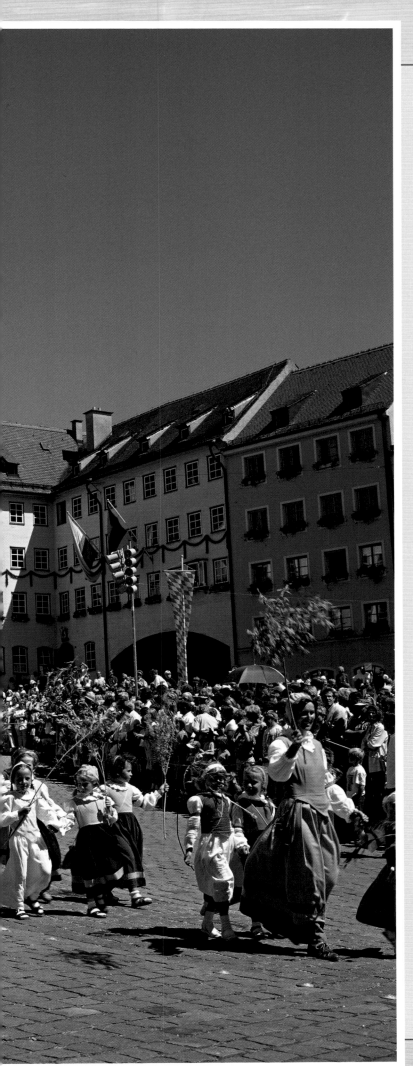

Left:
With its splendid town houses and medieval gateway, the main square in Landsberg on the River Lech provides the perfect backdrop for the children's Ruethenfest.

Pictures right, from top to bottom:
September 29 is the festival of St Michael who is celebrated with processions in local costume, such as this one in Gaißach in the Isarwinkel.

The area around Miesbach is heralded as being the cradle and bastion of traditional customs and costume, here on joyful display at the St Leonard's Day procession in Fischhausen.

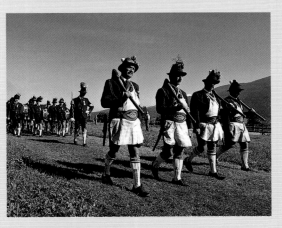

Armed with scythes and shaving-brush hats, these men celebrate the feast day of St Michael in Gaißach.

The festival of St George, April 23, was the day when people once again donned their "green shoes"; in other words, it was the first day in the year when it was warm enough to go barefoot.

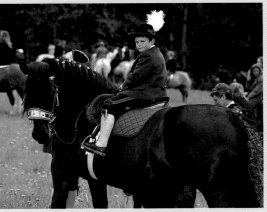

Far left:
The St George's Day parade in Penzberg near Weilheim-Schongau wouldn't be complete without the dulcet tones of the local wind band.

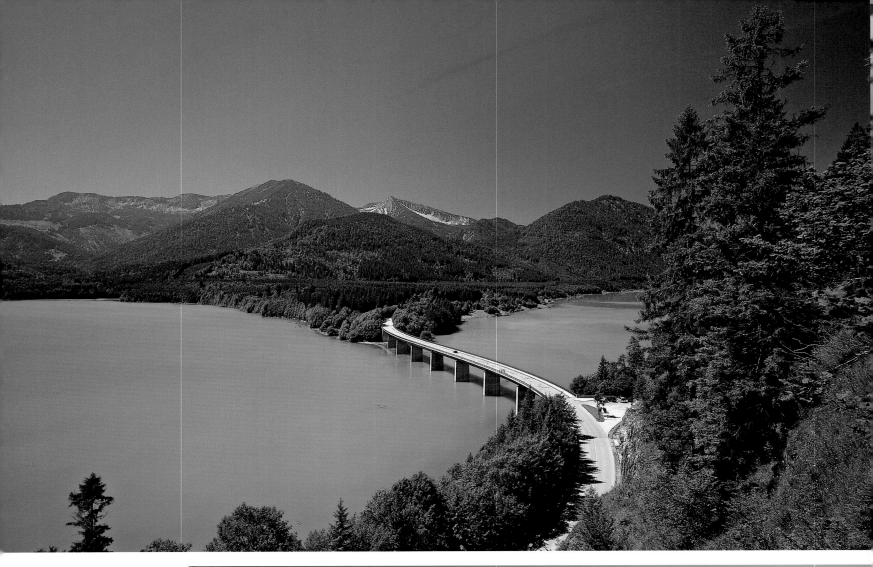

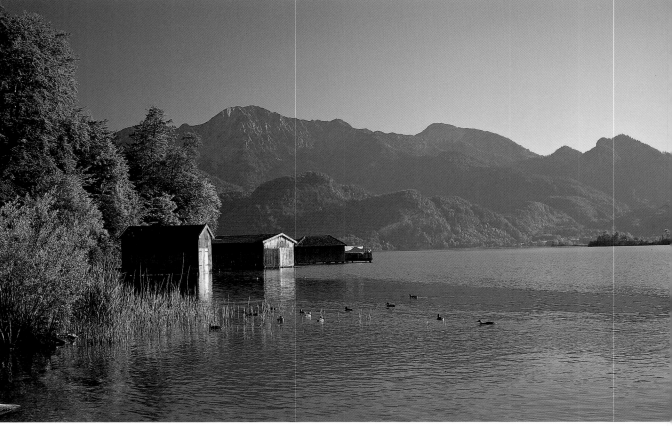

Above:
The Sylvenstein Reservoir south of Lenggries regulates the flow of the Isar and acts as a source of hydroelectric power. When full after heavy rain or a thaw the lake measures 20 kilometres (12 miles) in length. The bridge across the sparkling green waters provides access to the new village of Fall.

Right:
View out across the Kochelsee through which the River Loisach flows. The north of the lake borders on moorland, with the south sheltered by mighty mountains, the best known being the Herzogsstand.

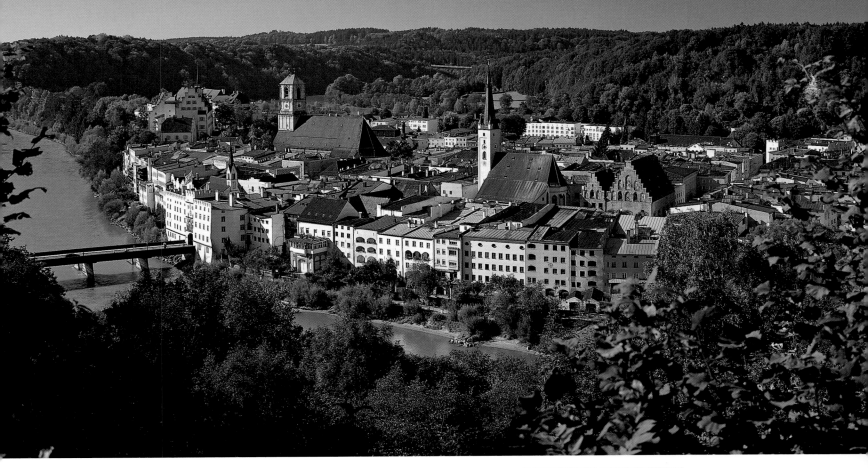

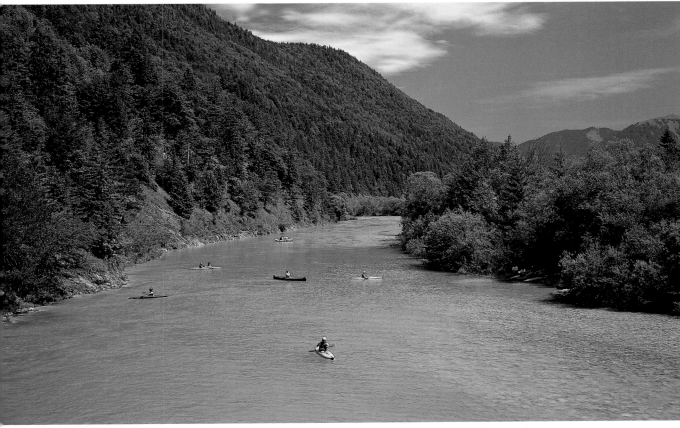

Above:
Wasserburg is almost completely surrounded by the waters of the River Inn. Salt generated great wealth and prosperity for this charming island town, resulting in part in the erection of some of its greatest attractions: the Heilig-Geist-Spital, the town hall, the Frauenkirche, and the castle.

Left:
In the past the River Isar or "Isara rapidus" was considered to be particularly dangerous. It has since been tamed; its bed has been deepened and straightened, its banks reinforced and the flow of water controlled by the enormous Sylvenstein Reservoir. Here canoeists enjoy the calm waters beneath Sylvenstein Dam.

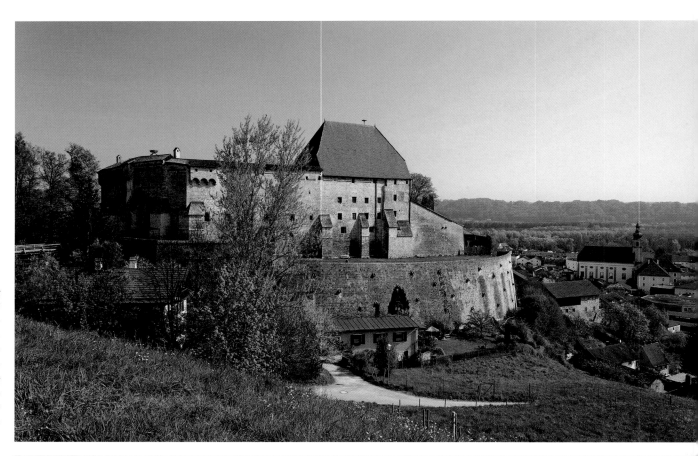

Tittmoning's castle, built between the 15th and 18th centuries, was a stronghold for the prince-archbishops of Salzburg trying to keep the neighbouring Bavarians at bay. The town was at the hub of the salt trade and has retained much of its historic framework.

First recorded as a town during the 13th century, Tittmoning grew up around its main square, Stadtplatz. Shaped like a trapezium, the square with its fountain and celebratory columns is enclosed by elegant town houses embellished with turrets and bay windows.

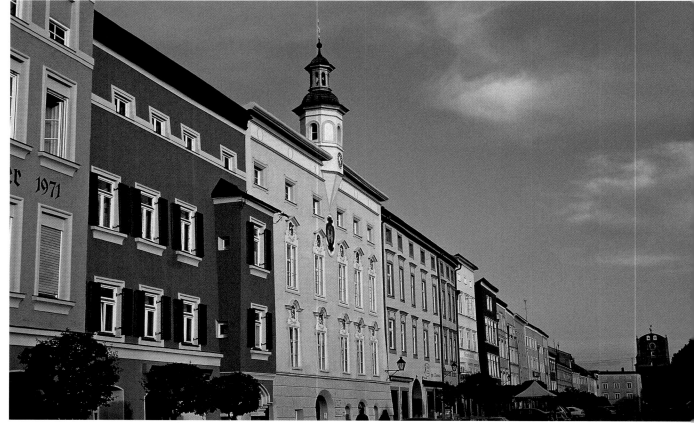

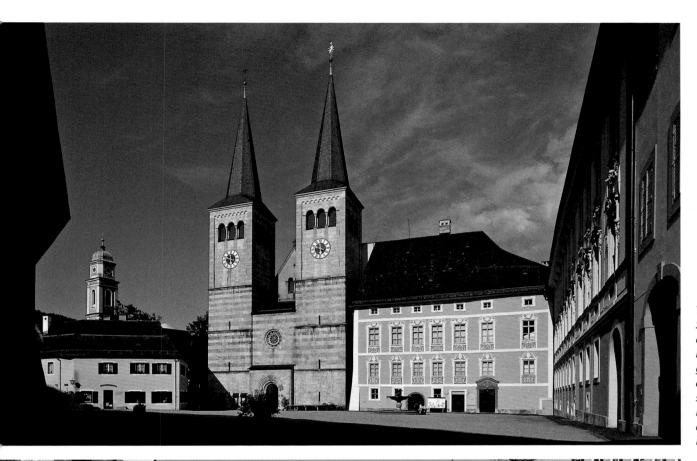

The collegiate church of St Peter's and St John's dominates Schlossplatz in the centre of Berchtesgaden. Its mighty westwork and ornate cloisters to the south of the building are Romanesque; the nave and chancel are from the late Gothic period.

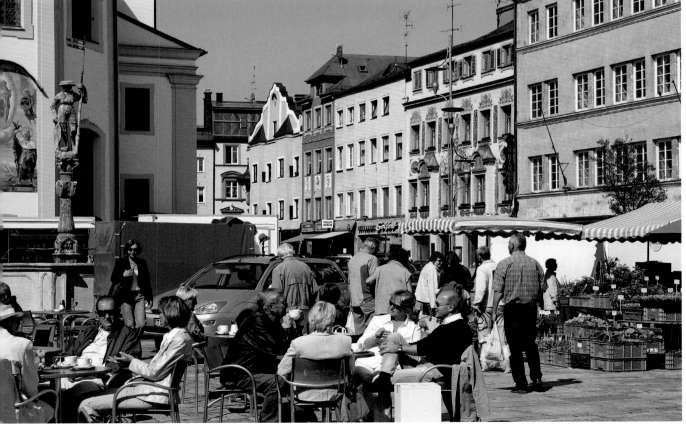

Traunstein also owes its development to the salt trade. Originally a tiny settlement at the point where an ancient Roman road crossed the River Traun, the town first belonged to Salzburg before passing to Bavaria in the 13th century. A market is regularly held on the spacious town square.

117

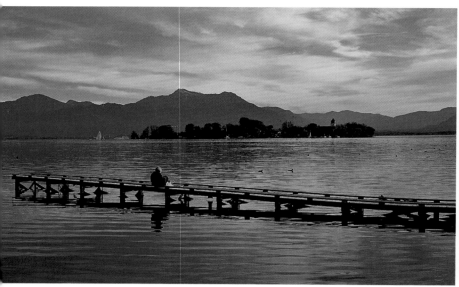

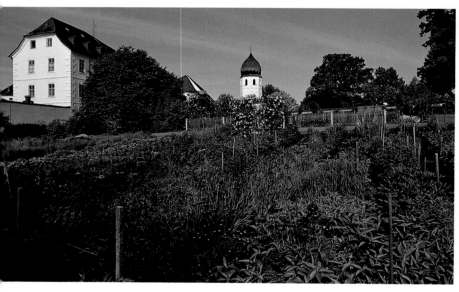

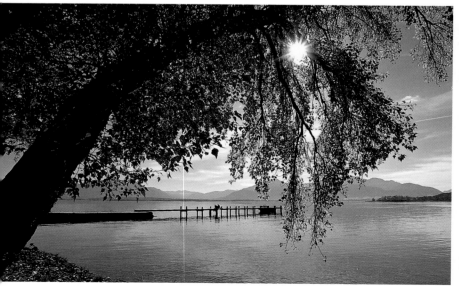

Left:
View from Gstadt out across the Chiemsee with the Fraueninsel in the background. Otherwise known as the "Bavarian sea", the lake was formed by Ice Age glaciers like the many other lakes in this moraine landscape. Over 80 square kilometres (30 square miles) in area, it has a maximum depth of 73 metres (240 feet).

Centre left:
The Fraueninsel on the Chiemsee is not just one the most beautiful but al one of the most culturally significant places in the

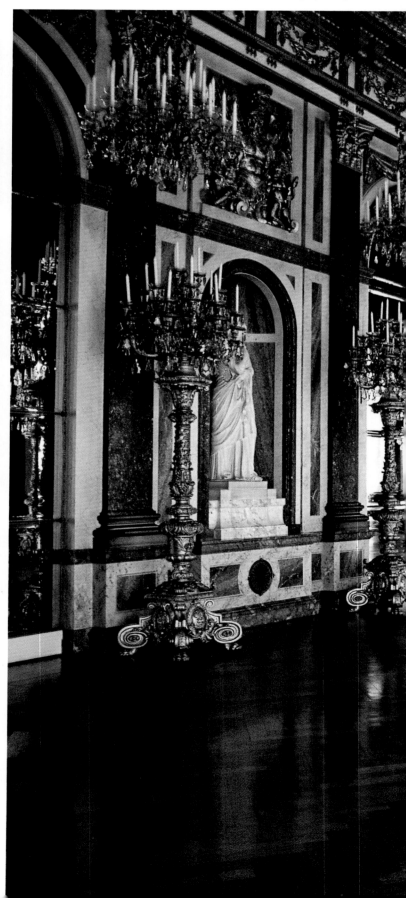

whole of Bavaria. The convent, the first abbess of which was a daughter of King Ludwig the German, still has its original Carolingian gatehouse.

Bottom left:
Excavations have shown that the Fraueninsel was inhabited during the Roman period. In 620 Irish monks are said to have settled here, laying the foundations for the long tradition of the tiny island as a bastion of Christian belief.

Below:
The Hall of Mirrors at Schloss Herrenchiemsee was built between 1879 and 1881. Running along the entire front of the palace, at 98 metres (322 feet) it's even longer than the original at Versailles.

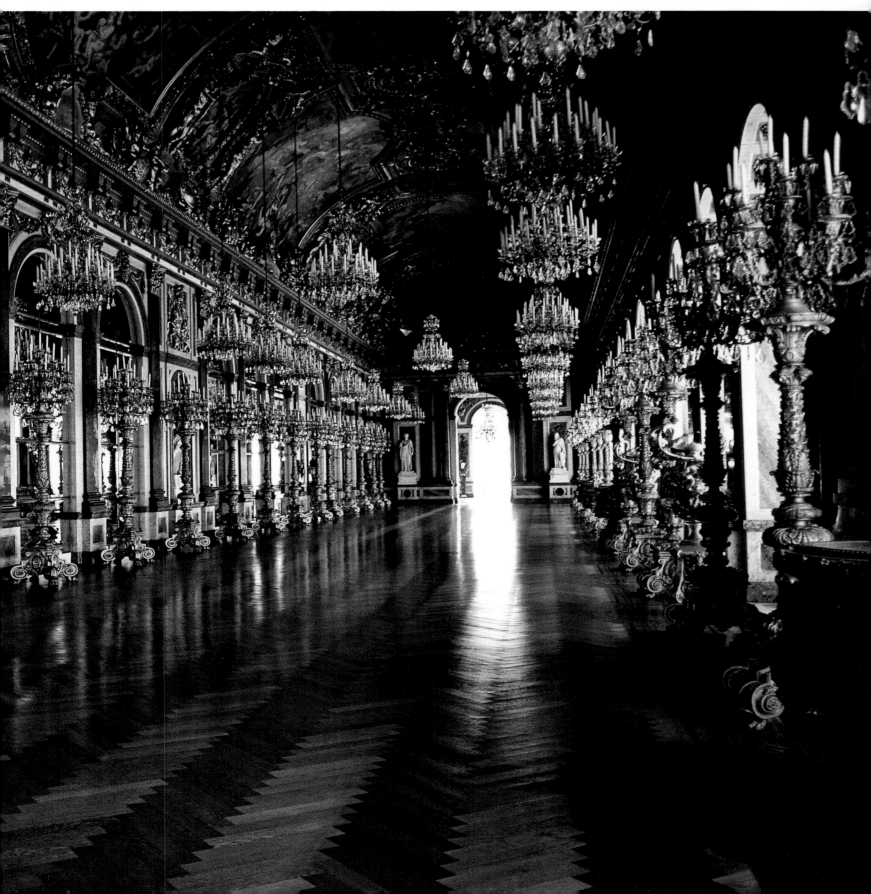

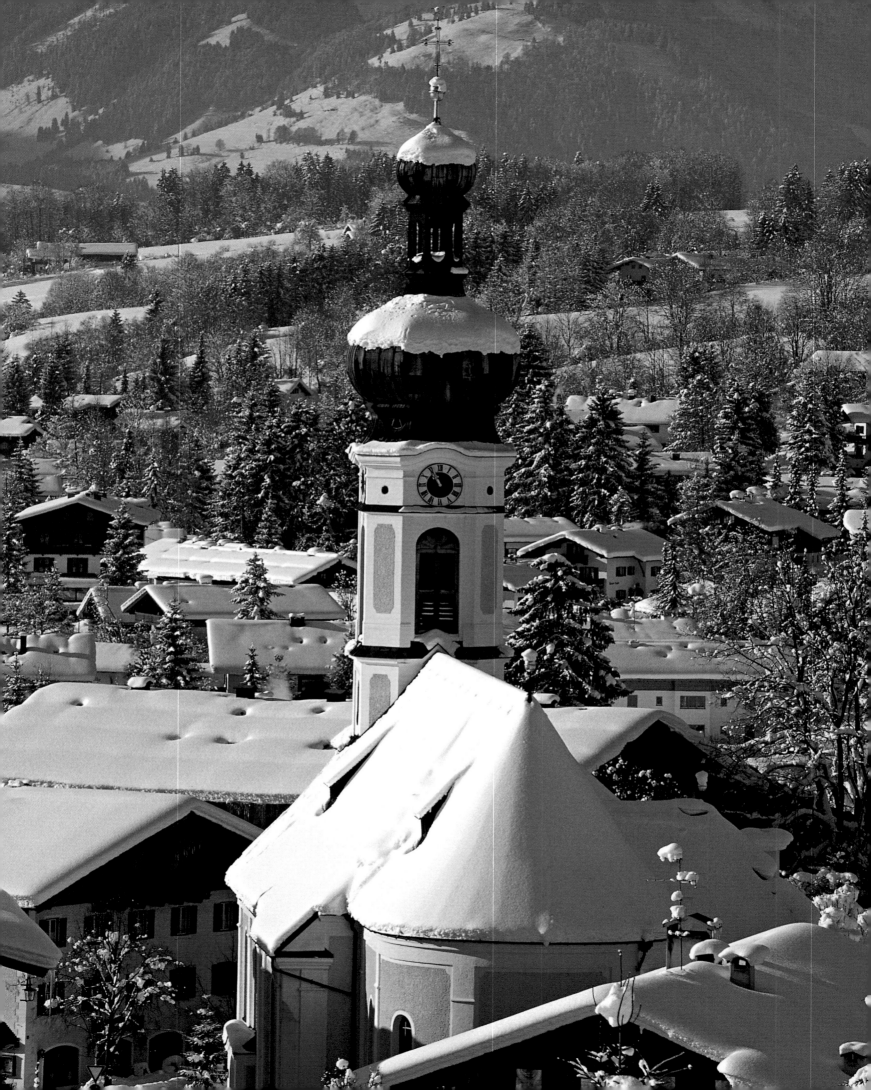

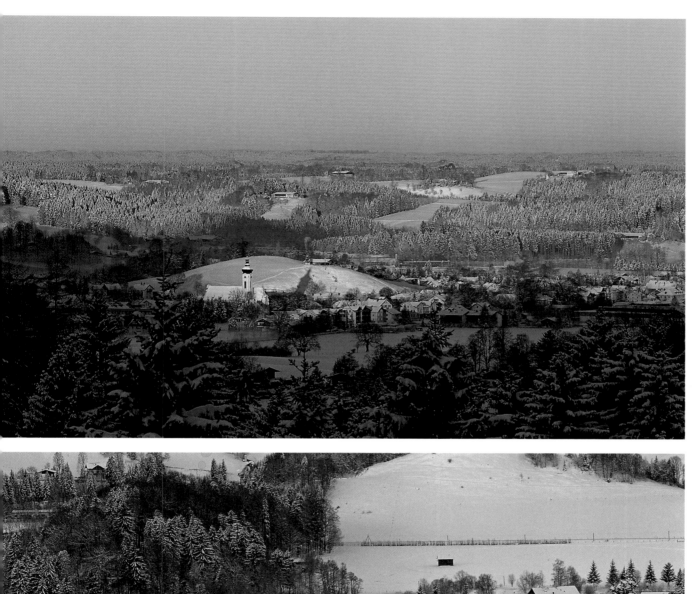

Left page:
According to meteorologists Reit im Winkl is the place most likely to have the most snow in the Bavarian Alps. Winklmoosalm just a few kilometres away is one of its major winter sports centres and home to German skiing champion Rosi Mittermaier.

View of Hausham from the Stögeralm in the Oberland. The region around the Schliersee is ideal for hiking and relaxing in the summer and a popular ski resort in the winter.

Schliersee on the northern shores of the lake of the same name dates back to a 7th-century hermitage which was later a functioning monastery until the end of the 15th century. Festivals such as the Altschliersee Kirchtag and the St Leonard's Day pilgrimage and also the performances at the local amateur theatre are among the town's many attractions.

This snowy landscape – the Gabrielalm in the valley of Längental – is paradise for cross-country skiers and winter wanderers.

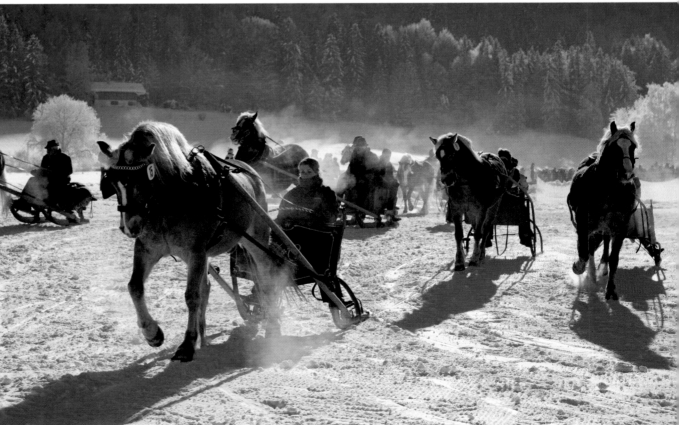

Both horses and riders give their all at the country sleigh races that take place each January in Rottach-Egern. Things are decidedly more idyllic on a romantic sleigh ride through the Tegernsee Valley which in winter are also launched from Rottach-Egern.

Small photos, left:
At the end of January/ beginning of February crowds congregate on the slopes of Schwaigeralm to enjoy the spectacle of the Schnablerrennen in Gaißach, where bold young men in silly costumes on rickety sledges race down the mountainside. There are no penalties for falling off or skidding into piles of snow; on the contrary, the more haphazard descents are rewarded with thunderous applause from delighted spectators.

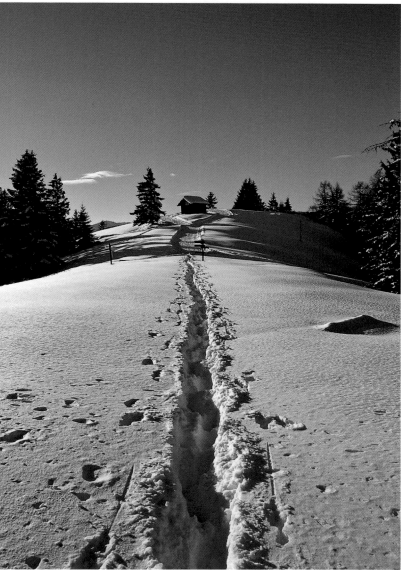

Above:
The Toter Mann with its solitary Alpine hut is an individual mountain rising up 1,400 metres (4,593 feet) above sea level west of the Berchtesgaden Basin.

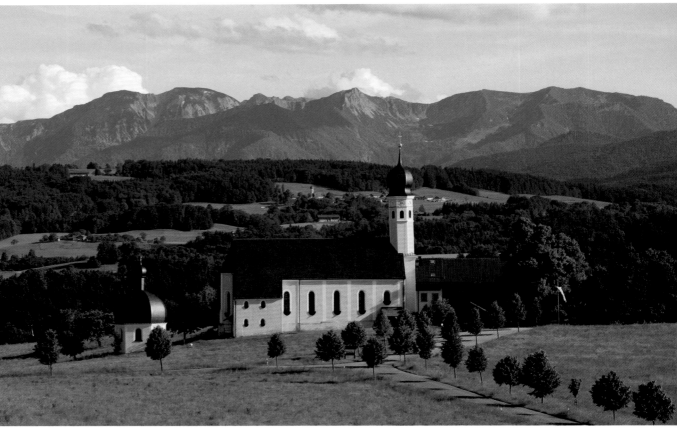

Just a stone's throw from Irschenberg, the pilgrimage chapel of St Marinus-Anianus in Wilparting is a wonderful manifestation of the deep sense of religiousness harboured by the people of Upper Bavaria. Named after two martyrs buried here, the church was built in the 18th century, with the neighbouring chapel dedicated to St Veit 100 years older.

View of Greisbach near Miesbach, a little hamlet in the Leitzach Valley. Behind it the snow-capped peaks of Breitenstein Mountain tower towards the heavens.

Right page:
The Wendelstein is best ascended by rack railway which covers a distance of 10 kilometres (6 miles) to the top of the mountain. The journey ends at the sheer drop of the Schwaigerwand, with Wendelstein Chapel perched precariously on the slopes. Just 100 metres (330 feet) from the summit and undoubtedly one of the most precipitously situated places of worship in Bavaria, the church was built by intrepid engineers in 1889.

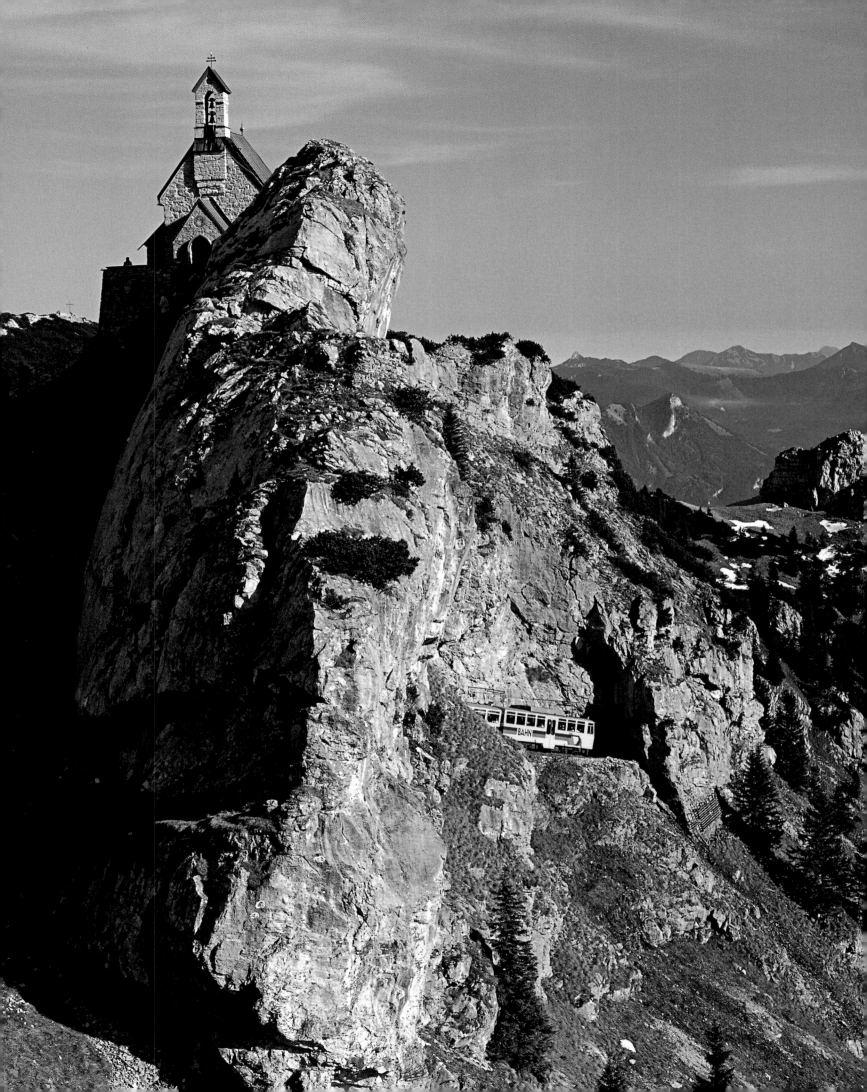

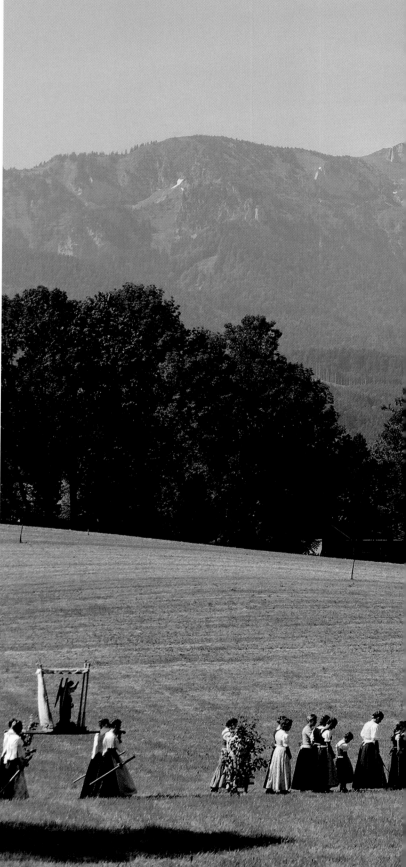

Left:
The traditional firing of canons in Greimharting is just one of the many ways of honouring St Leonard in Upper Bavaria.

Centre left:
A perfect autumn day in the Chiemgau, with two riders in national dress heading for a festive St Leonard's procession.

Bottom left:
Two locals on their way to the traditional pilgrimage in Birkenstein. The little village has an impressive ensemble of religious venues, including a pilgrimage church, a chantry chapel, a hermitage and

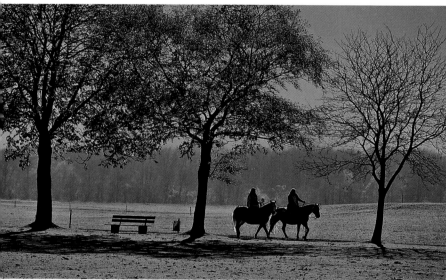

Calvary. The main
church dedicated to the
Assumption of the Virgin
Mary, furnished in the
style of the Rococo, was
consecrated in 1786 and
's modelled on Santa Casa
in Loreto.

Below:
Processions don't always
just focus on the town or
village where they originate
from. In Wackersberg near
Bad Tölz the Corpus Christi
parade also passes
through the surrounding
meadows, enabling not
only the local populace but
also the fruits of the field
and forest to be blessed.

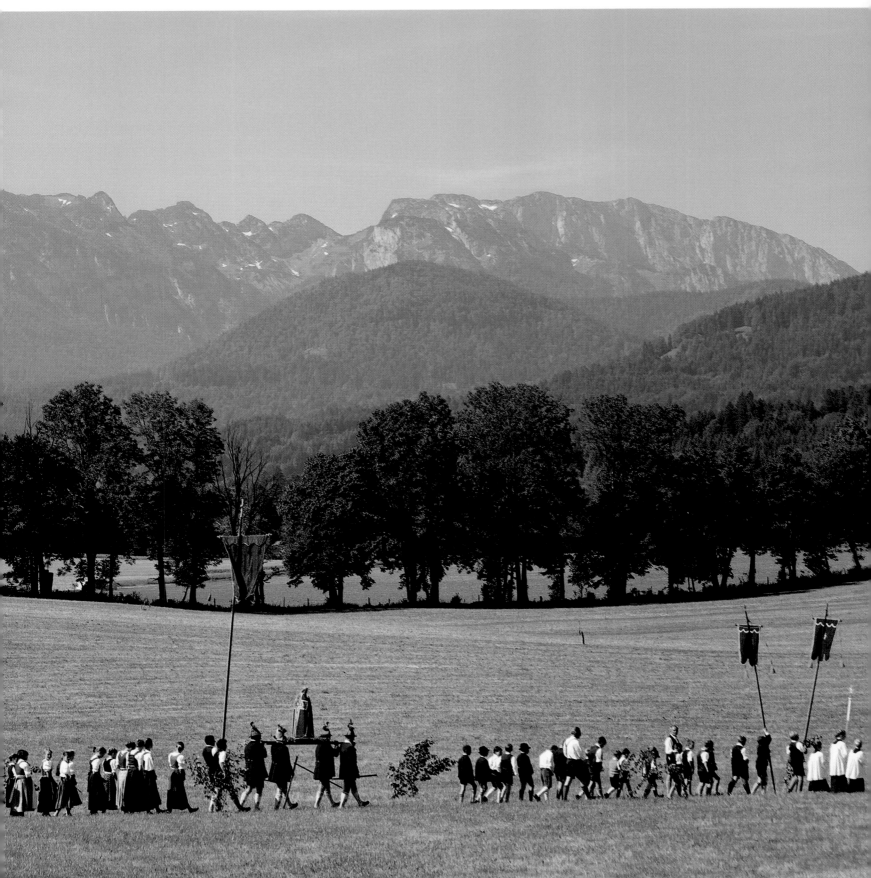

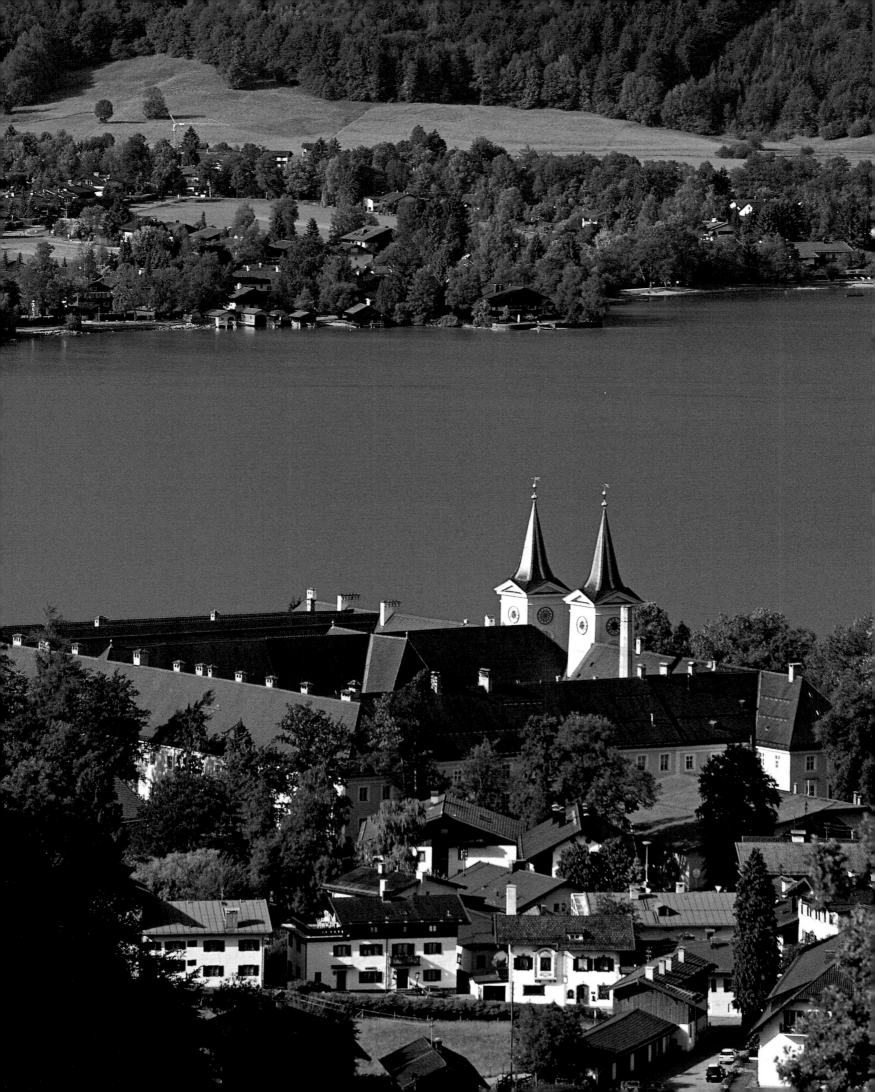

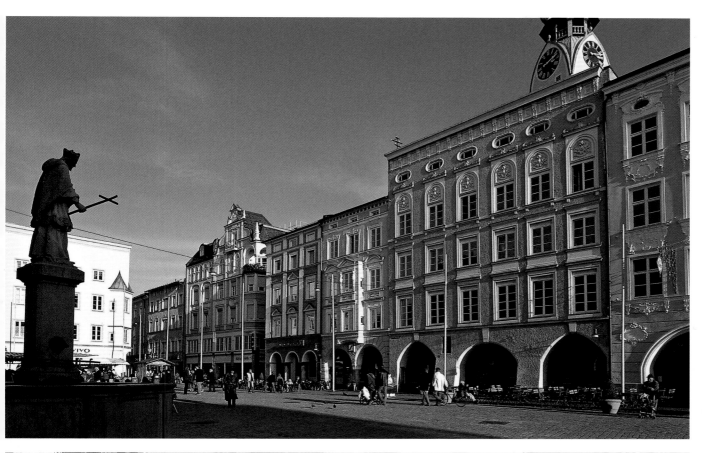

Left page:
The old monastery in Tegernsee was built on a promontory jutting out into the lake. The former monastic and present parish church of St Quirin's dates back to the 11th century, the nave to the 15th. Following the secularisation of Bavaria Leo von Klenze had the monastery refurbished as a summer residence. Today the historic complex includes a popular restaurant.

Rosenheim was first mentioned in 1232 and was granted market rights just under 100 years later. Providing an important means of passage across the River Inn, the town profited from the salt trade. Max-Josefs-Platz is at the centre of town, surrounded by splendid facades and romantic arcades in the indigenous Inn/Salzach style.

Marktstraße is the elegant showcase of Bad Tölz, its princely residences ornately embellished with stucco and Lüftlmalerei frescos. The street slopes down to the River Isar, beyond which is the spa.

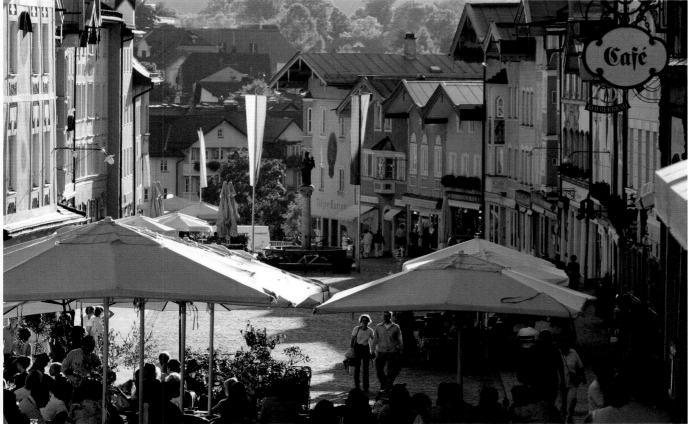

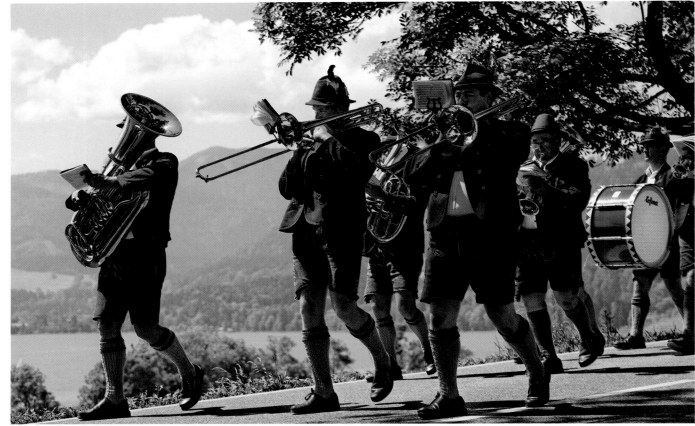

Corpus Christi procession in Gmund on the Tegernsee. Clubs and societies, the town band and of course local church-goers all take part, with men and women walking separately. Their traditional costumes give the event a sense of worth and occasion and the parade's destination of Gut Kaltenbrunn is just as grand, with magnificent views of the Tegernsee to be had from here.

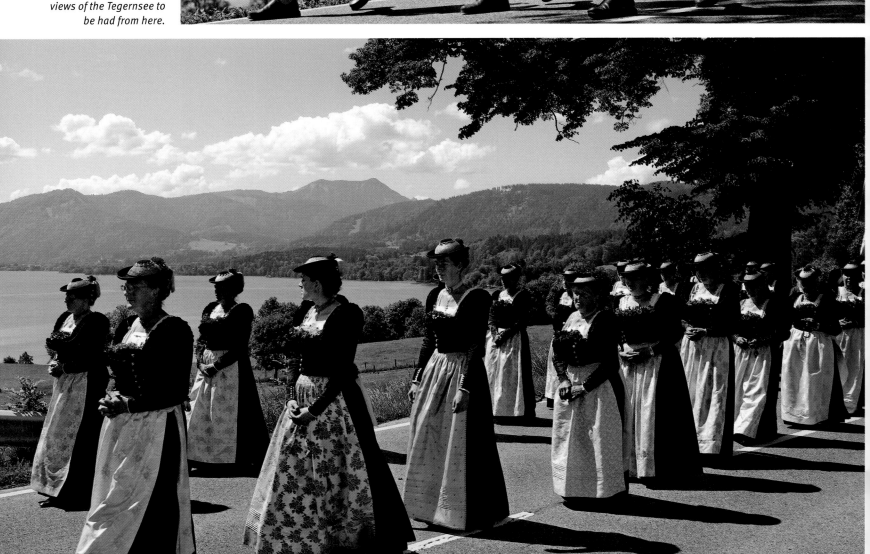

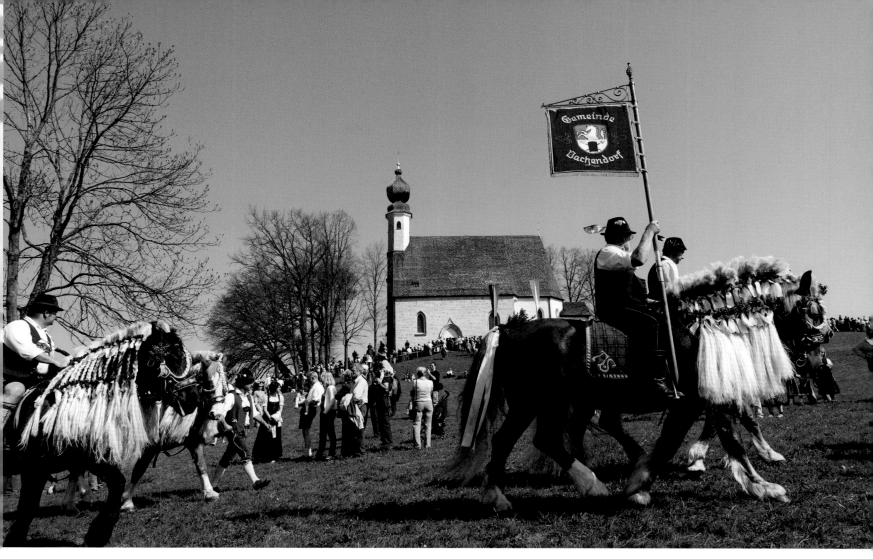

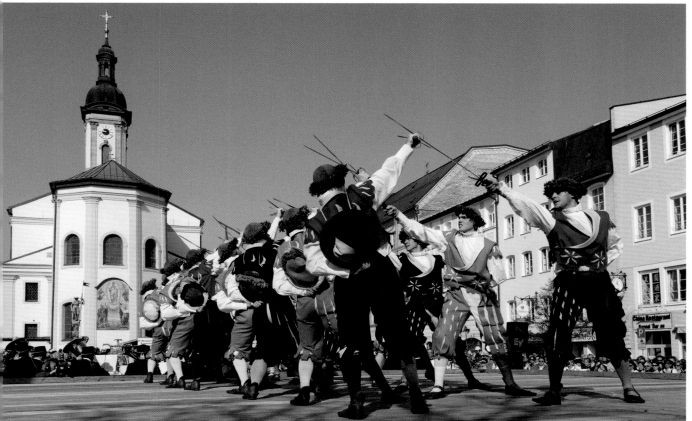

Customs are also religiously observed in Traunstein. Easter Monday, for example, see the occasion of Traunstein's Georgiritt, when elaborately dressed horses and carts, groups in historic costume and music bands parade to the little church in Ettendorf. The procession in honour of St George culminates in a historic sword dance which dates back to 1530 and symbolises the banishing of winter by the arrival of spring.

Erecting the maypole, as here in Königsdorf-Osterhofen, is not just a tricky undertaking; it's also good cause for celebration!

After a night of partying the world may seem a little warped; the revellers of Geretsried-Gelting have always managed to put things back into their right perspective, however, the maypole included.

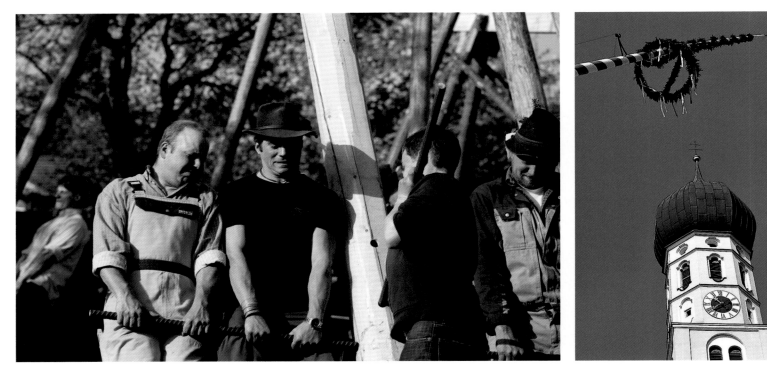

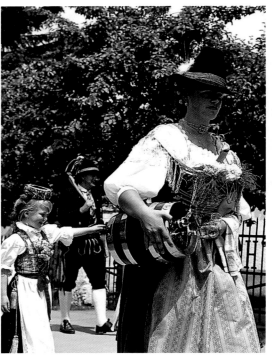

One of the characters on parade at the Loisachgau festival is the traditional lady sutler.

Although these two children may not yet be up to a long march they can still join in the fun at the Loisachgau festival procession.

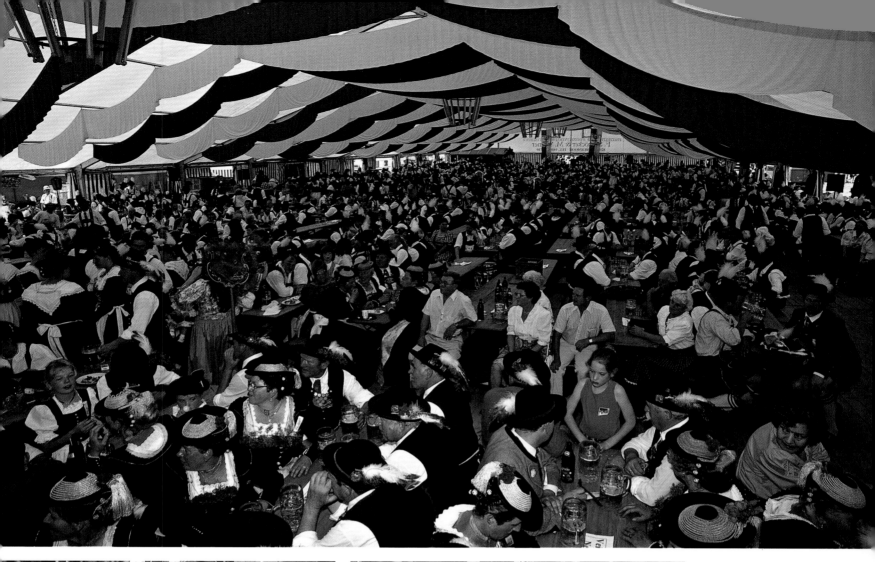

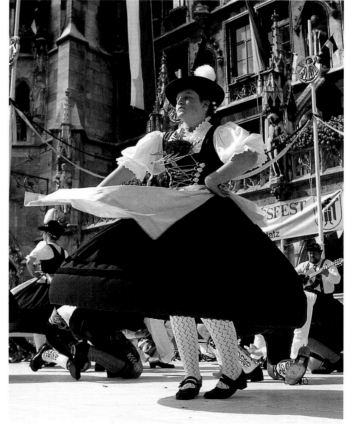

Above:
To prevent months of careful preparation from being spoiled by inclement weather, no self-respecting Upper Bavarian festival would dare do without an enormous beer tent where the fun can continue regardless.

Small photos, left:
Folk dancing and the famous hand-clapping and thigh-slapping Schuh-plattler are a must at any genuine Upper Bavarian festival. It may look easy but getting the skirt of your dirndl to twirl in such an elegant arc requires lots of skill and practice.

Index

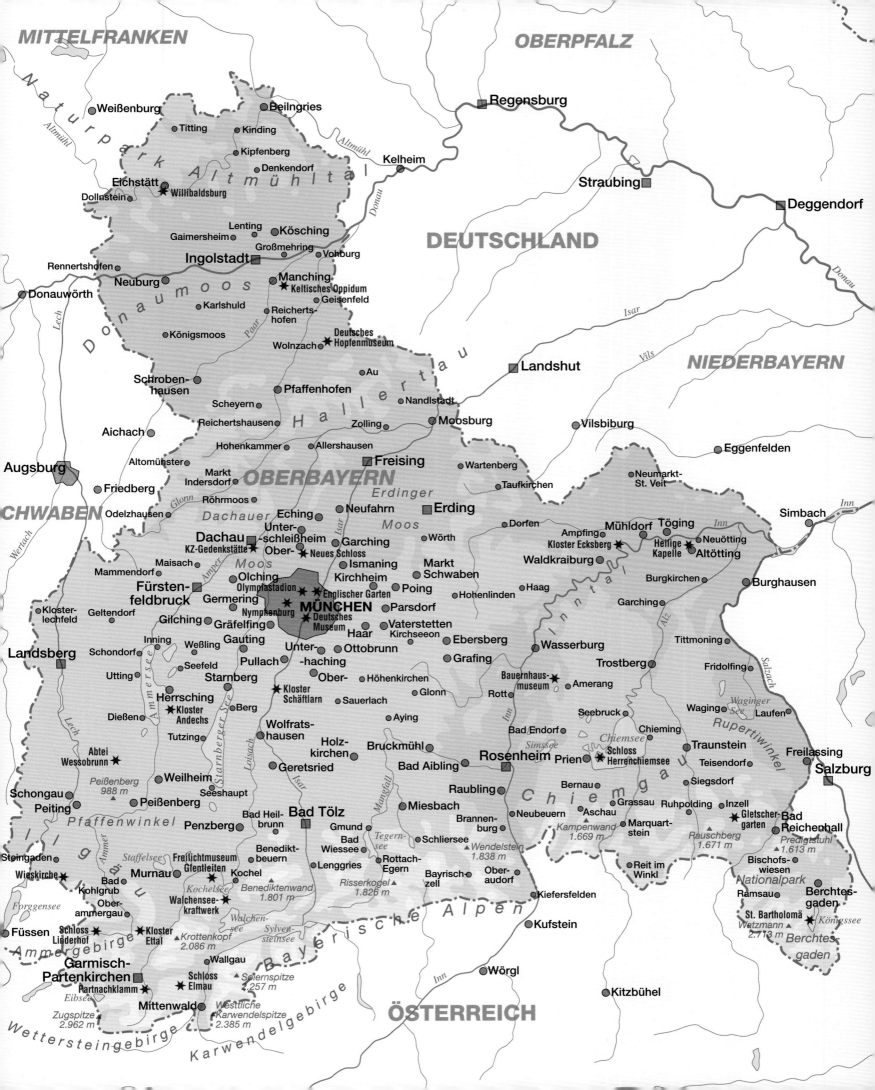

The calm before taking the world by storm. Just a few minutes more and then the band will strike up a rousing tune to the delight of the guests at the Lechgau festival in Apfeldorf.

Design
www.hoyerdesign.de

Map
Fischer Kartografie, Aichach

Translation
Ruth Chitty, Stromberg
www.rapid-com.de

Printed in Germany
Repro by Artilitho, Lavis-Trento, Italy – www.artilitho.com
Printed/Bound by Offizin Andersen Nexö, Leipzig
© 2012 Verlagshaus Würzburg GmbH & Co. KG
© Photos: Martin Siepmann
© Text: Ernst-Otto Luthardt

ISBN 978-3-8003-4082-8

Details of our programme can be found at
www.verlagshaus.com